**AFTER
THE
MACHINE**

Visual Arts and the Erasing of Cultural Boun

D0797106

AFTER THE MACHINE

Visual Arts and the Erasing of Cultural Boundaries

BY **MILES ORVELL**

UNIVERSITY PRESS OF MISSISSIPPI Jackson

Copyright © 1995 by the University Press of Mississippi
All rights reserved
Manufactured in the United States of America

98 97 96 95 4 3 2 1

The paper in this book meets the guidelines for permanence and durability of the
Committee on Production Guidelines for Book Longevity of the Council on Library
Resources.

Library of Congress Cataloging-in-Publication Data

Orvell, Miles.
 After the machine : visual arts and the erasing of cultural
boundaries / by Miles Orvell.
 p. cm.
 Includes index.
 ISBN 0-87805-754-4 (cloth : alk. paper). —ISBN 0-87805-755-2
(pbk. : alk. paper)
 1. United States—Civilization—20th century. 2. Popular culture—
United States—History—20th century. 3. Art and technology—
United States—History—20th century. I. Title.
E169.1.07828 1995
973.9—dc20 95-15919
 CIP

British Library Cataloging-in-Publication data available

For

ARIANA

and

DYLAN

CONTENTS

ACKNOWLEDGMENTS

I want to thank, first of all, the Temple University Faculty Senate for a semester's study leave in 1992 and for a subsequent grant-in-aid of research, without which this book would not have been possible. To colleagues in English at Temple who supported this work at various stages and to former Dean Lois Cronholm and Dean Carolyn Adams, additional thanks are due.

Several of these essays originated as talks, and I am most grateful to the following persons for affording me an occasion to put together my thoughts, and an audience: To Iris Hill, Director of the Center for Documentary Studies at Duke University, for inviting me to talk, early in 1992, at a conference organized to celebrate one of the great works of the century, *Let Us Now Praise Famous Men,* a work that, for years, has colored much of my own thinking about problems of representation. To Rob Kroes and the Netherlands American Studies Association for inviting me to a meeting in 1992 that was the culmination of a project at the Netherland Institute for Advanced Study in the Humanities and Social Sciences (NIAS), devoted to the reception of American mass culture in Europe; and to David Nye, resident for that year at NIAS, for helping me toward an understanding of Disneyland. To Cristina Giorcelli, past president of the Italian Association for the Study of North America and to Rosella Mamoli Zorzi, who succeeded her, for inviting me to think about technology and culture at a conference in Venice (what could be *more* inviting?) in 1993; and to Emory Elliott, who first inspired that invitation.

In addition, I want to thank Mike Weaver, of Oxford, for prompting me, in 1991, to think about Lewis Hine in the context of a special issue of *History of Photography* on Hine. My thanks also to Gail Stavitsky, Curator at the Montclair Art Museum, New Jersey, for inviting me (in 1993) to contribute an essay to the catalogue she was editing on Precisionism (appearing here as "The Artist Looks at the Machine").

Several of the chapters in this volume appeared initially as articles in journals or as chapters in books, and I want to thank the following publishers for permission to reprint them here:

Harry N. Abrams and the Montclair Art Museum, Montclair, New Jersey, for "The Artist Looks at the Machine: Whitman, Sheeler, and American Modernism." A condensed version of this essay appeared as "Inspired by Science and the Modern: Precisionism and American Culture," in *Precisionism in America 1915-1941: Reordering Reality* (1994), the catalogue of a show organized by Gail Stavitsky, Curator, the Montclair Art Museum. A somewhat different version of the essay appeared in *Amerikastudien* (1995), in a special issue edited by Klaus Benesch.

Western Humanities Review, for "The Camera and the Magic of Self-transformation in Buster Keaton" (1973).

Taylor & Francis, London, publishers of *History of Photography*, which first printed "Lewis Hine: The Art of the Commonplace" (1992); and "Walker Evans and James Agee: The Legacy" (1993), which appears here as "'Don't Think of It as Art': The Legacy of *Let Us Now Praise Famous Men*."

National Museum of American Art, Smithsonian Institution, publishers of *American Art*, which first printed "Weegee's Voyeurism and the Mastery of Urban Disorder" (1992).

University of California Press, publishers of *Film Quarterly*, which first printed "Documentary Film and the Power of Interrogation: Kopple's *American Dream* and Moore's *Roger and Me*" (1994–95).

Oxford University Press, publishers of *American Literary History*, for "Writing Posthistorically: *Krazy Kat*, *Maus*, and the Contemporary Fiction Cartoon" (1992), which I have revised slightly in order to incorporate consideration of the completed *Maus II*.

UV University Press, Amsterdam, for "Understanding Disneyland: American Mass Culture and the European Gaze," which first appeared in *Cultural Transmissions and Receptions: American Mass Culture in Europe* (1993).

Associazione Italiana di Studi Nord-Americani, for "Technology, the Imagination, Virtual Reality and What's Left of Society," a slightly revised version of a talk first delivered at the AISNA Biennial Conference, Venice 1993, and printed as "Technology and the Imagination: Convergence or Divergence" in *Technology and the American Imagination: An Ongoing Challenge*, Acts of the Conference of the AISNA, Venice: Supernova, 1994.

I also want to thank here Seetha A-Srinivasan, Editor-in-Chief at University Press of Mississippi, for her fine good sense, her always ready advice, and (not least) her patience.

Thanks also to Wendy Williams for essential and indefatigable assistance in putting the manuscript into final form.

Most of all, I want to thank my wife, Gabriella Ibieta, for her excellent judgment and indispensable advice on these pieces as they have developed, and for her love.

This volume is dedicated to Ariana (now 6) and Dylan (now 3), who love books, who tolerated the writing of this one with reasonably good humor, and who demonstrate to me daily that there is more in heaven and earth than I have dreamt of.

INTRODUCTION

This book grows out of a continuing concern with the relationship between technology and culture in twentieth-century America, a relationship that is of course anything but simple. We can immediately complicate things by considering that "technology" itself may contain multiple significations, from the simple and concrete notion of a way of doing things with machines, to the more general mindset that determines the structure and instrumentality of systems, to the even more abstract notion of a force, a way of effecting change in the world. Taking this broad and variable sense of the word "technology"—as thing, as idea, as abstraction—I explore in this volume some ways that American culture has responded to the machine in the twentieth century. We have all, throughout the twentieth century, been born "after the machine": we live in a culture dominated, for better or worse (or both) by technology, and our cultural forms are embedded in its many significations.

In asserting the "domination" of our culture by the machine, I do not mean to affirm here any totalizing theory of technology, but rather to observe in a variety of instances its pervasive influence on our culture. Let me pause a moment over that last word, "culture": My subjects range from the high end of visual and literary culture, in which the individual aesthetic sensibility captures our attention; to photography, a potentially mass form practiced by individual personalities who may or may not think of themselves as "artists"; to popular culture, the product, usually, of a corporate imagination that succeeds in capturing our collective attention. But, as these studies demonstrate, the boundaries between these categories have eroded in the twentieth century, offering a variety of permutations and borrowings at both ends and across the middle.[1] I do not, for example, see American culture under late capitalism as primarily a function of culturally dominant, hegemonic forces, as some inheritors of Marxism assume (e.g. Frederick Jameson and Terry Eagleton). Nor do I see it as an existentially liberating, undifferentiated simulacrum in which all differences between high and low culture have faded away (Jean Baudrillard). Rather, I see our

culture as a set of differentiated markets that occasionally cross over their boundaries and that incessantly borrow from one another, something like Umberto Eco's fluid system of interchangeable signs. And at times, certainly, one can hear within this set of decentered cultures—as, for example, Jim Collins does (in *Uncommon Cultures*), following the lead of the British culturalist studies school—a kind of Bakhtinian dialogue.

The advantage of offering a set of particular studies is that one can pay more attention to the intractable nature of the particulars themselves. At the same time, underlying these empirical essays is a set of questions involving the problematic relationship between technology and culture: How, for example, has technology served as a catalyst and transformer of the imagination? More specifically, how has the vision of the artist been changed by the environment of technology, which is to say the world constructed by the machine and the world as seen through a machine constructed for that purpose—i.e. the camera? How has the documentary camera, especially, served as a model of intellectual knowledge or, conversely, as an accomplice of technological and capitalistic structures of accommodating and transforming the world? How do the representations of popular culture reflect the evolving nature of technology, in its malign and benign aspects? How does the artist's imagination compete with a popular culture increasingly driven toward a post-industrial world of total representation, theme parks, and virtual reality?

The book begins and ends with chapters in which Whitman figures as a prophetic or inspirational force for the modern artist, and thus argues implicitly my continuing sense of his consequence as a cultural source: in Whitman, the great assimilator of American popular culture and science, we had our first model of an extraordinary, original response to technology (Orvell, *The Real Thing* 3-29). The first chapter, "The Artist Looks at the Machine: Whitman, Sheeler, and American Modernism," examines an artist most closely identified with the machine and its iconic transformation— Charles Sheeler. Sheeler was part of a larger movement—Precisionism— that saw in technology the materials for an American artistic idiom; yet the movement (and Sheeler as well) is more ambiguous in its response to the machine than we may immediately suppose. I explore some of those ambiguities in this opening discussion, which focuses in part on Sheeler's promotion of Henry Ford's River Rouge Plant in the late twenties.

If Sheeler's response to technology occupies the high end of the cultural spectrum, Buster Keaton's occupies the great lower end, for he was surely one of the most popular of screen stars in the silent twenties, as well as one of the most inventive. Keaton's fascination with mechanization pervades

his films and is the subject of the second chapter, "The Camera and the Magic of Self-transformation in Buster Keaton," which focuses on *The Cameraman* and *Sherlock, Jr.* At the root of Keaton's popularity was the central transformative fantasy of his persona from bungler to master; in these two films, as I argue in my essay, the camera is both an icon and a crucial instrument of that transformation. (The Keaton piece is, incidentally, the only one in this volume written earlier than 1990—1973 to be exact—and I offer it in this context because of its special relevance and as a harbinger of these later interests.) Keaton's iconization of the moving picture camera is a beautiful metaphor, literal and symbolic at the same time, of the fascination with technology during the first three decades of the century.

During this time period it was the still camera, even more than the motion picture camera, that served as a central symbol for a kind of mastery over the course of civilization through control over the machine. The camera was, indeed, the ideal machine, celebrated by photographer Paul Strand in his influential essay, "Photography and the New God" (1922). In Strand's historical overview, the inventor and the scientist became, following the Protestant Reformation, the indispensable culture heroes, capable of producing the requisite quantity of goods for large-scale commerce and trade. In the centuries since, the artist, the craftsman, the poet, have become marginalized in this materialistic economy, tolerated by an indifferent society as "entertainment." Meanwhile, the scientist has permitted himself to serve, with "printing presses or poison gas," a social structure that is "fast being destroyed by the perversion of the very knowledge contributed by him." In the mechanism of the camera, however, Strand sees the possibility for a "revaluation of the idea of the machine." Strand means not the "artistic" use of the camera that tried to convert it into an imitator of painting (he scorns the "imbecilic use of soft focus or uncorrected lenses"), but rather a use of the machine that respects its mechanical nature, its dependence on optics and the chemistry of light, metals and paper, and that affirms the value of craftsmanship. The camera thus comes to offer for Strand a "new method of perceiving the life of objectivity and of recording it," one that fuses science and expression.

Strand was well positioned to formulate this ideal, being not only a disciple of Alfred Stieglitz (the latter was one of his early champions) but also of Lewis Hine, his first photography teacher at the Ethical Culture Society School in New York. The chapter on Hine in this volume—"Lewis Hine: The Art of the Commonplace"—initiates a series of discussions of the documentary mode, including photo-journalism, and enlarges the so-

cial meaning of the camera beyond Strand's initial formulation in relatively aesthetic terms. That is, the camera became for the twenties and thirties not only an aesthetic emblem, but a social and political one as well. Though it could not save civilization, as Strand might have dreamed, it was, in the early decades and to some extent even now, one of our most powerful cultural tools, a way of refining and dramatizing social ideas, a way of shaping our emotional response to the world. For Hine, the great documentary photographer of the early decades of the century, it offered, as I argue here, a way of correcting social vision, countering the negative images of immigrant workers who had supposedly soiled the social fabric.

Though he was less active during the 1930s, Hine remained a strong influence on the younger generation of documentary photographers of the Depression era, who were recording the trauma of the times for a mass audience that was having its sensibility and its intelligence formed by photography's intensely absorbing representations of the world. But if the general mode of thirties documentary tended toward the melodramatic, the emotional, the easy juxtapositions of rich and poor, Walker Evans brought to his practice an irony and self-consciousness about the power of the lens that seemed—especially to his collaborator James Agee—exemplary as both a moral and an aesthetic capacity. Their great collaboration, *Let Us Now Praise Famous Men,* is the subject of the next chapter, "Don't Think of It as Art," which explores the classic tension in documentary expression between objectivity and subjectivity in the act of representation. Here I also look at their legacy to the documentary movement, looking ahead to some of the ongoing dilemmas of documentary practice.

Evans kept himself relatively aloof from the popular culture he recorded with such fascination, guarding his privileged sensibility through a distancing formality; not so Weegee, who served the tabloid newspapers of the thirties and forties as the public eye and is the subject of the next chapter, "Weegee's Voyeurism and the Mastery of Urban Disorder." Weegee was the people's official voyeur, and he witnessed the drama, the parades, the tribulations, and the traumas of the city in a way that no other photographer had. Yet Weegee's demotic impulse was countered as well, I argue, by a sense of self-reflexive irony, a knowing consciousness about his peculiar role, and a sensibility that strived for some sign of "higher" culture. The function he served for a city on the edge of chaos was to provide a point of view, a place to stand and look at urban disorder from a safe distance.

There is a progression here: from Hine's examination of individual workers to Evans' scrutiny of a set of families in the South to Weegee's exhibition of the life cycles of the city. The chapter on photographer Sebastião Salgado—"Documentary and the Seductions of Beauty: Salgado's *Workers*"—extends this series to its largest scope, examining a massive project that takes as its subject the changing nature of labor throughout the world. Salgado's investigation into the strata of work, from the pre-industrial to the industrial to the post-industrial, is intertwined with an analysis of the machine as well; for Salgado, looking back with some nostalgia on the factory, we are living in a world after the machine. I am interested in Salgado's argument about technology and work, but I am equally interested in his practice as a documentary photographer, and the essay on him carries forward my examination of the mode itself and its paradoxes, concentrating on the problem of beauty in documentary and on the power Salgado as photographer wields over his subjects.

The question of power is even more explicitly the subject of the next chapter, "Documentary Film and the Power of Interrogation: Kopple's *American Dream* and Moore's *Roger and Me*," a comparison of documentary filmmakers Barbara Kopple and Michael Moore. Their quite different works both take as their subject the fate of the factory (which is to say, the fate of the factory worker) in the global economy that Salgado likewise portrays. Focussing on the labor-management conflict, Kopple and Moore offer congruently sympathetic views of labor; but in contrasting ways they are also simultaneously representing the situation of the filmmaker: Kopple's traditional mode assumes the privileges of the camera while Moore's dramatizes its powerlessness in the face of privilege and class.

The essays on Salgado and on Kopple/Moore begin an inquiry into the conditions of contemporary culture that is carried forward in the three chapters that conclude this volume. In "Writing Posthistorically: *Krazy Kat, Maus*, and the Contemporary Fiction Cartoon," I take as my focus not the visual arts per se, but works of literature that have been strongly influenced by them, more particularly by the twentieth century cartoon form. But the subject is still, if indirectly, the machine in its largest sense, for both Jay Cantor, in *Krazy Kat*, and Art Spiegelman, in *Maus*, are responding to the traumatic reality of the post-World War II world, in which technology and science can astonish us with the magnitude of their destructive powers. Strand's warning of 1922, that technology is indifferent to its uses—printing presses or poison gas—again comes to mind: in the case of *Krazy Kat* it is the atomic bomb; in the case of *Maus* it is the

Nazi war machine that creates the conditions of life—and death. Both Cantor and Spiegelman interrogate the sources of our memory and our distance from the past while they insist on our psychological complicity and re-insert us into history. Both writers are also concerned with the role of art in such a world, and they draw differently on cartoon sources in popular culture to invent an idiom that will occupy a kind of middle ground in American culture, between high and low.

The definition of cultural territory is also at stake in the next chapter, "Understanding Disneyland: American Mass Culture and the European Gaze," which takes the quintessential product of the American corporate imagination, the theme park, and looks at it through the refracting lens of the European intellectual. Among other things, I am interested in how Disneyland is and isn't representative of the larger American culture, and how the space of Disneyland defines an order that is by and large absent from American public spaces. In the Disney theme parks we have a strongly influential, if somewhat improbable, fulfillment of Whitman's vision of a harmonious society mingling in a common space: only Disney has replaced Whitman's democratic vistas with carefully controlled landscapes, governed by the power of computerized automatons and a technology of facsimiles. Ironically, Jo Davidson's statue of Whitman—*The Open Road*—was erected at one of the precursors of Disneyworld, the New York World's Fair of 1939, where it was given a prominent setting nearby the Trylon and Perisphere and not far from the Electrical Products Building and the Hall of Pharmacy.

The final chapter in this volume, "Technology, the Imagination, Virtual Reality, and What's Left of Society," is a recapitulation of the imagination's engagement with technology, beginning with the relatively unified sensibility of the eighteenth century. My main interest here, however, lies in the twentieth century, as I examine the modern writer's sense of the liberating force of technology during the first decades of the century, when a variety of technological models stood as paradigms of social and imaginative power. Moving to the postmodern period, however, when technology has seemed too often out of control, breaking all boundaries of containment, the artist's engagement seems inevitably all but apocalyptic. Certainly that is the case in the exemplary works of Norman Mailer, Don DeLillo, and Donald Barthelme that serve as exhibits for part of the essay. Returning to the issue of facsimiles raised in the preceding chapter, "Understanding Disneyland," I conclude with a portrait of our contemporary world of virtual reality, with its boundaries between the real and the

fabricated "virtually" erased, and I ask: What are the social and cultural consequences of such confusions? Standing as we do at the end of the twentieth century, we are in the enviable, or unenviable position, of at least being able to raise such big questions, and of taking account of life as we are left with it, after the machine.

AFTER
THE
MACHINE

Visual Arts and the Erasing of Cultural Boundaries

1

The Artist Looks at the Machine

Whitman, Sheeler, and American Modernism

We cannot date with exactness the beginning of "modern" culture in America, but surely it was heralded in the most exalted terms as early as 1871, in Whitman's prophetic *Democratic Vistas*: "America demands a poetry that is bold, modern, and all-surrounding and cosmical, as she is herself. It must in no respect ignore science or the modern, but inspire itself with science and the modern. It must bend its vision toward the future, more than the past" (503). "Science and the modern": the two were firmly linked in Whitman's forward-looking vision, in a marriage that captured the optimism of American civilization during the post-Civil War years. Yet Whitman's demand for an art that would be commensurate with "science and the modern" went virtually unanswered for nearly fifty years, until the first decades of the twentieth century, when a group of artists—among them the "Precisionists"—at last began to create a visual and literary culture that responded to the extraordinary transformations of American society under the impact of the machine. But when it arrived, this new world, and the art it inspired, was in some ways far different from what Whitman might have envisioned. For Whitman, it was a matter of incorporating the world of science and technology into a larger aesthetic vision of democratic civilization; for the Modernists of the twentieth century the new world of the machine became far more compelling, and in some ways far more threatening, to behold. An early sign of

things to come is visible in the response of Henry Adams, who, gazing at the huge generating dynamos at the Chicago Exposition in 1893—large beyond a scale imagined by Whitman—saw in them, with awe and some dread, a symbol of the age's most powerful cultural Force, occupying a position as central to our society as the Virgin had been for Medieval culture (Adams 379-390; Tichi, *Shifting Gears* 137-168).

By any measure, the changes during the decades following Whitman's pronouncement of 1871 constituted virtually a rebuilding of the material world, placing the human subject in an environment that was quickly expanding beyond his understanding: not candles or oil in a lamp to light the room, but light bulbs powered by electricity, fed into the house by wires; not the book or the stereographic card in the parlor, but the wireless radio. In the home, as David Nye points out, specialized industrial processes had been in effect since the 1880s, but with electricity mechanization became much accelerated. In 1910 one in ten urban homes had electricity; by 1930 most did, surrounding the consumer with new machines—irons, sewing machines, vacuum cleaners, toasters, washing machines, refrigerators—and transforming the household into a mechanized environment (239; Orvell, *The Real Thing* 141-156).

If domestic space was changing rapidly as a result of technology during the early twentieth century, the workplace was changing even more, with dramatically increasing productivity and equally increasing regimentation of the worker. The use of electrically powered machines in factories grew from 5% of total horsepower in 1899 to over 80% in 1929. The efficiency with which natural resources were used grew also, along with a markedly increased rate of productivity, especially in the years after World War I (Rosenberg 162-163). While mechanization was lowering the prices of consumer goods, it was raising the cost to the worker producing them, at least in physical terms: the factory, under the influence of Frederick Winslow Taylor, was increasingly regimenting the worker's movements in coordination with the requirements of the new productive techniques; driven by the goal of maximum efficiency, the manager's new science of factory management meant increased production, along with increased surveillance and increased exhaustion for the worker (Aitken). For the office worker, too, interactions with the machine—whether telephone, adding machine, or typewriter—enforced a rhythm of repetition and fine coordination.

Outside the home and the workplace, technology was transforming the nature of space, shrinking distances that had once seemed vast, and expanding the size of cities that had once seemed scaled to human dimen-

sions. The railroad had, by the end of the 19th century, created a network of interconnected routes assuring the servicing of commercial markets across the United States. And commuter rails had extended the city beyond its 19th century core to expanded metropolitan regions, embracing suburban communities that became bedrooms to the city's commercial districts (Jackson). After 1900, the automobile—one of the major products of America's manufacturing system—was rolling off the assembly lines in ever increasing numbers: from 4,000 in 1900, to 181,000 in 1910, to nearly two million in 1920 and over four million in 1929. During these same years, surfaced roads increased from 150,000 miles in 1904 to nearly 700,000 miles in 1930 (Rosenberg 114; 115).

Cities grew outward, expanding into suburban regions, and they grew upward, from their pre-elevator six stories to the neck-bending heights of the modern skyscraper. Early experiments in framed iron construction, using diagonal bracing, had begun in the 1880s in Chicago and New York and were raising the height of the urban building to eight, ten, fifteen stories tall. (The steam and hydraulic elevator, followed around the turn of the century by the electric safety elevator, made it possible to actually use these heights as office space.) As the height grew to twenty stories, the masonry walls were eliminated in favor of glass curtain walls, and before the end of the century the skyscraper had pushed as high as thirty stories (Condit 15-20). The tallest building in its time, Daniel Burnham's triangular Flatiron Building (1902) in Manhattan, soon became the subject of some notable photographs by Coburn, Stieglitz, and Steichen, among the first to feature the new skyscrapers in a purely aesthetic context. And gradually, as the New York skyline changed, the great buildings of the early twentieth century—the Beaux-Arts Singer Building (1906-08) and the Gothicized Woolworth Building (1911-13), followed by the exuberantly Art Deco Chrysler Building (1930) and the more restrained Empire State Building (1931)—would become icons of the Modern age, their advertising function as symbols of corporate power soon transformed into more generalized symbols of modern industrial civilization. By the 1920s, their geometric forms were inspiring a range of treatments, from the detailed to the simplified, from the objective to the subjective, and in a variety of media.

But why, during this period of revolutionary change, did it take so long for Whitman's demand to be answered? Why were the arts in general so removed from these transformations in American society? One reason is that the very things that had so excited Whitman—the iron foundries, the tall buildings (tall by nineteenth century standards), the manufac-

tured products displayed in the shop windows, the sailing ships, the steam engines—were generally seen to exist in a totally separate sphere from the world of "art" (Kasson 139-180). Art, within the sanctioned boundaries of the academy and the library and within the pages of such family parlor magazines as *The Atlantic, Scribner's,* and *Harper's,* was idealizing and inspirational, a matter of lofty sentiments and lovely forms—flowers, butterflies, teacups and peacock feathers. Art was, indeed, one of the primary defenses *against* the world outside the parlor—the world of steam engines, railroads, bridges, iron girders, and factories.[1] If the machine was going to be publicly seen, it would have to be dressed up for the occasion like some exotic primitive, the naked functionalism of a steam engine or a sewing machine clothed in a decorative embellishment of vine leaves or classical columns or symbolic figures (Kasson 156 ff.). The Brooklyn Bridge (1869-1883) itself, that monument to engineering genius, had to be clothed in Gothic arches. Americans were learning to live with the machine, but only gradually, by degrees. Only in the design of factory machinery—that is, where public reception was obviously insignificant, where function alone mattered—do we find the nineteenth century developing the stripped down functionalist look; and only after the turn of the century does the vernacular simplicity of purely utilitarian forms begin to appear in the industrial landscape—factories, grain elevators, and eventually oil tanks.[2]

And precisely here—in the machinery and architectural forms of the industrial landscape—did the new Modernist vocabulary find its inspiration and did "science and the modern" as a result begin to find its way into the culture at large. What was needed in order to move what had been "outside" the discourse of Art "inside" of it was a revolution in aesthetic consciousness, which occurred gradually during the first two decades of the century as a result of several complementary factors. One was the discovery by American artists of "modern art"—the works produced in Europe by Cézanne, Matisse, Picasso—that quite simply challenged their whole way of looking at the world. These works were first visible in the United States at Alfred Stieglitz's 291 gallery in the few years before the Armory Show (1913), but the major event was the Armory Show itself, which signalled a momentous cultural shift in perception, from the canons of realism dominating nineteenth century art to the canons of cubism that would dominate the first decades of twentieth century art (Homer 62; 170). The European artists at first were generally content to formulate the new cubist vision in terms of the traditional subject matter of still life— fruit, flowers, table-top arrangements. When Duchamp and Picabia came to

America, they enthusiastically embraced the vocabulary of "the modern" —mechanical forms, elaborately contrived mechanisms, readymades— with a light, metaphorical touch. This opened the way for American artists, in turn, to look at the new subject matter of the city and the machine and to see how the new vision of cubism could be joined to technology and still be consonant with American values and traditions.

The American response was not simply a wholehearted embrace of the new (as it was for the Italian Futurists); it was significantly tempered by an effort to connect the new age of the machine with some cultural tradition that would give it sanction. It was a characteristic of American modernism generally that the search for the new was accompanied by a backward look, a retrospective yearning to identify with the romanticized past; one finds it in Cather, Eliot, Faulkner, Williams, Fitzgerald, and in the intellectuals peripheral to the Precisionist movement, Van Wyck Brooks and Lewis Mumford. For the Precisionist movement especially, a central cultural icon of nineteenth century America was Whitman. Certainly it was fitting that Whitman should assist this new accommodation to science and the modern, fifty years after having demanded it. Whitman would become one of the cornerstones of the "usable past" that the first generation of American modernists were looking for, and he was treated accordingly by Van Wyck Brooks in his 1915 volume, *America's Coming of Age*. Looking for a synthesis in American culture of the opposite poles of theory and action, idealism and business, Brooks found it in the all-synthesizing Whitman: "In him the hitherto incompatible extremes of the American temperament were fused" (79).

But it is important to see exactly how Whitman was being used at this time. He was invoked not only because he offered a model of how one might incorporate the raw materials of America's technological, urban civilization into poetry; he was also, significantly, a model of spiritual transcendence, of the creation of a democratic aesthetic out of the country's otherwise triumphant materialistic civilization. Thus, one year after Brooks's essay, the young John Dos Passos, taking stock of the future of American literature (and his own future), affirmed that the only usable model was Whitman, who might inspire an art worthy of a country that otherwise produced "nothing from amid our jumble of races but steel and oil and grain" ("Against American Literature" 38). And it was precisely in terms of Whitman that Paul Rosenfeld, writing in 1921, celebrated Alfred Stieglitz, whose "subjugation of the complex modern mechanism" of the camera was portrayed as the potential salvation of the United States, "the land most ravished by mechanical civilization." "Save for Whitman," he

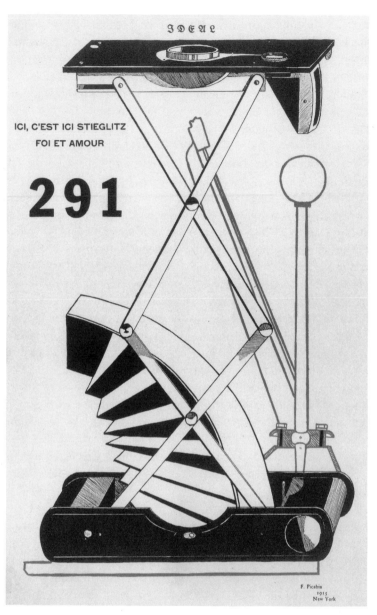

Francis Picabia: *Ici, c'est ici Stieglitz.* 1915. Lithograph. Philadelphia Museum of Art: Louise and Walter Arensberg Collection.

continued, "there has been amongst us no native-born artist equal to this photographer" (Rosenfeld 214-215).

In short, the task of incorporating the modern into American art was not conceived as the simple substitution of one set of imagery for another. Rather, as many of the modernists conceived it, it was a process of opening up a critique of America in terms of its prevailing industrial civilization. To the European, America was a rich, ebullient enfant terrible, a quirky child filled with primitive energy. The American artist was usually more serious, more ambivalent, more worried about the ravages of "mechanical civilization," as Rosenfeld put it. What made Stieglitz such a central figure to this generation of modernists was his symbolic role within the art world: he was not only editor of *Camera Work* and advocate of modern art (Stieglitz had been showing cubists several years before the Armory Show); he was, as a photographer, the master of the quintessentially "modern" machine, the camera. As Paul Strand put it in his famous essay, "Photography and the New God," Stieglitz established "spiritual control over a machine" and thus offered the model for modern civilization. "He it is who is again insisting, through the science of optics and the chemistry of light and metals and paper, upon the eternal value of the concept of craftsmanship" (151).

Stieglitz's photographs, even before the Armory Show, had systematically opened up subject matter that previously had been excluded from the discourse of high art—the construction of the new skyscrapers from the ground up, the railroad trains· in the yard, the skyline of commercial Manhattan as seen across a busy East River harbor, the ocean liners and airplanes that were symbols of the new age; and in *The Steerage* (1907), Stieglitz had created an image that symbolized the instantaneous moment of the new photographic art, a way of encompassing the new materials within a complex formal space. (The first "cubist" photograph, it was called.) But Strand, in his experiments of 1915-1916, carried the process one step further, incorporating the more radical techniques of cubism to create photographic images that were themselves more purely abstractions (Pultz and Scallen; Orvell, *The Real Thing* 198-226). Focussing his camera on the new machines—the wheel of an automobile, the interior of a camera, a lathe—Strand examined the textures of the objects up close, looking at their surfaces and their materiality with a sense of wonder; but he also played with perspectives and angles in such a way as to deform the natural context and logical use of the object, creating in its place a new aesthetic significance.

The camera, in the hands of the modern artist, was functioning as an

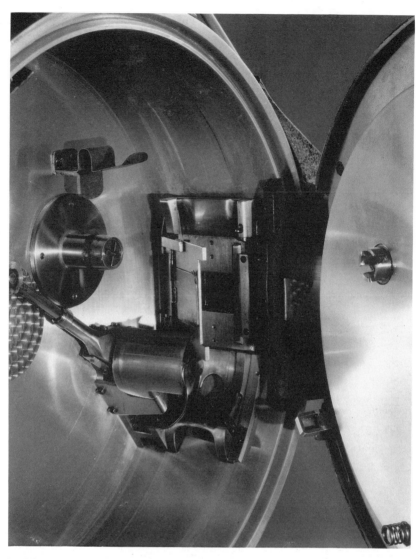

Paul Strand: *Akeley Motion Picture Camera, New York, 1922.* Copyright 1971, Aperture Foundation Inc., Paul Strand Archive.

instrument for reforming perception, a way of relating the new vision to technology and art, which became the foundation of Precisionism and of the American contribution to international Modernism. Rather than seeing technology as a force that intervened between the individual and reality, the machine became a way of creatively "deforming" reality and even of

mastering it. Technology became a creative force for the artist by being defined as a new "screen" or "filter" through which the world was experienced: Jean Epstein, writing for *Broom* in 1922, put it this way: "The machine technology of civilization, the innumerable instrumentations that encumber laboratories, factories, hospitals, photographic studies, and electrical shops, the engineer's table and the architect's drawing-board, the aviator's seat, the moving picture theatre, the optician's show window and even the toolkit of the carpenter permit an infinite variety of angles of observation. . . . And all these instruments: telephone, microscope, magnifying glass, cinematograph, lens, microphone, gramophone, automobile, kodak, aeroplane, are not merely dead objects. At certain moments these machines become part of ourselves, interposing themselves between the world and us, filtering reality as the screen filters radium emanations. Thanks to them we have no longer a simple, clear, continuous, constant notion of an object. . . .The world for people today is like descriptive geometry, with its infinite planes of projection" (6-7; Tashjian 120). (Epstein's formulation is almost literally illustrated in some of Charles Demuth's paintings—e.g., *My Egypt* (1927)—where the architectural image is overlaid with a screen of fractured lines and geometric shapes.)

Behind the idolization of the camera was the more general goal of ending the seeming hostility between science and art. But the point was not simply to bring "science and the modern" into art; the point, as Strand and others saw it, was to create almost a new way of seeing and knowing the world. Thus, Strand urged the destruction of the "wholly fictitious wall of antagonism" between science and expression (151). In its most extreme form, the work of industrial construction was itself viewed as the highest art, with the engineer as the new artist. It was in this spirit that a writer in the avant-garde magazine, *The Soil*, declared, in 1916, "I have already turned from an Art Exhibition to marvel at the co-ordination and the real art of a steam shovel, ripping out great handfuls of boulders and earth . . . There are splendid curves in steam lines, in belts, and in all moving machinery" (Vos, 17). Ten years later, Jane Heap, introducing the special issue of *The Little Review* that served as the catalogue for the "Machine-Age Exposition" (1927), affirmed, "There is a great new race of men in America: the Engineer. He has created a new mechanical world, he is segregated from men in other activities . . . it is inevitable and important to the civilization of today that he make a union with the architect and artist. This affiliation will benefit each in his own domain, it will end the immense waste in each domain and will become a new creative force" (36).

The "union" that Jane Heap spoke of had one year earlier been formu-

lated in similar terms by Lewis Mumford in his influential *The Golden Day*, and once more Whitman was used as precedent and authority, for the poet's function had been defined by Whitman as giving the final form to a culture, the symbolic and ethical form that would "complete" science: "the highest and subtlest and broadest truths of modern science wait for their true assignment and last vivid flashes of light—as Democracy waits for its—through first-class metaphysicians and speculative philosophy— laying the basements and foundations for these new, more expanded, more harmonious, more melodious, freer American poems" (134). Mumford— using Whitman—was thus finding a place *within* American culture for the artist, affirming the artist's importance at the same time that he was confirming the significance of modern science. One of the clearest expressions of this characteristic definition from within the Precisionist movement appears in the statement by Louis Lozowick, "The Americanization of Art," written for the Machine Age Exposition catalogue (1927). Lozowick reads the history of America as "a history of gigantic engineering feats and colossal mechanical construction." While he acknowledges that the American cultural heritage may lack "the weight of established tradition," there is still an "extravagant abundance" of material for the artist to work with. (This was, again, a return to the largely unheeded declaration by Melville and Whitman, that America's culture was a rich field for the artist just because of its materialism and its lack of the more conventional aesthetic traditions.) Lozowick goes on to argue—again echoing Whitman—that the American environment—skyscrapers, grain elevators, steel mills, oil wells, copper mines, lumber yards—is "not in itself art but only raw material which becomes art when reconstructed by the artist according to the requirement of aesthetic form. The artist cannot and should not, therefore, attempt a literal soulless transcription of the American scene, but rather give a penetrating creative interpretation of it, which, while including everything relevant to the subject depicted, would exclude everything irrelevant to the plastic possibilities of that subject" (18). Lozowick's own prints best exemplify this goal: his engagement with the machine was nearly total, but his respect for the mass and weight of the industrial world was never overwhelmed by his own plastic invention of form. Emphasizing the geometrical forms of the industrial landscape and the city of skyscrapers, Lozowick's angle of vision exploits the drama of scale— looking up at the massive girders of bridges or at huge cylindrical gas tanks, or else looking down on the massed forms of buildings. Surrounding the static industrial structures are moving automobiles, airplanes, an occasional pedestrian. The scene takes place in a moment in history: Lozowick's world is in motion.

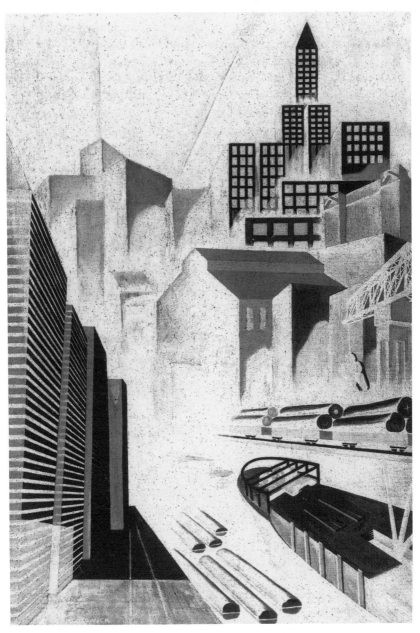

Louis Lozowick: *Seattle*. 1926-1927. Oil on canvas. Hirshhorn Museum and Sculpture Garden, Smithsonian Institution, Bequest of Joseph H. Hirshhorn, 1966. Photographer: Lee Stalsworth.

Not so with Charles Sheeler, whose work is far more a meditation on shapes and form that removes the object from the realm of history and time. It is in Sheeler that Precisionism finds its most powerful and in some ways its most enigmatic figure. For Sheeler the *construction* of the image is of paramount interest, just as it is the construction of material things that interests him as subject matter. Following his early exposure in France to the new art of Picasso, Braque, Matisse, and especially Cézanne, Sheeler began painting landscapes and still lifes in two dimensions, as cubistic problems of color and abstract form. And his fascination with the clean lines of his Doylestown home—the stairways and windows and doors photographed and sketched from various angles—trained his eye in linear formal problems. Yet another powerful influence was the camera, taken up in 1910 for commercial reasons, first in photographing buildings for Philadelphia architects, then in recording objects for galleries and museums (Stebbins and Keyes 2). Not surprisingly, Paul Strand's early cubistic experiments had a strong influence on Sheeler's own urban designs, and one can see Sheeler in 1920 (e.g. in *Church Street El*) paring away the ornament from his painted skyscrapers, turning them into the stripped down functionalist forms they would eventually in fact become later in the decade (as, for example, in Howe and Lescaze's *Philadelphia Savings Fund Society* [1931] or Raymond Hood's New York *McGraw Hill Building* [1931]). Sheeler quickly learned to exploit the "distortions" (to use Epstein's term) of mechanical seeing, resulting in a variety of paintings in which the subject was seen through the close up (*Upper Deck,* 1929; *Yankee Clipper*, 1939), the reflection (*Self-Portrait*, 1923), the distorted juxtaposition (*American Interior*, 1934). The camera anchored Sheeler in perceptual realism, giving to his depictions of the object a three-dimensional solidity at the same time that he exploited its distorting vision.

The new camera-seeing is fully visible as early as 1921, in the film that Sheeler made with Paul Strand, a seven-minute production that was exhibited briefly—to enthusiastic reviews—at Broadway's Rialto Theater, under the title, *New York the Magnificent*. *Manhatta* (as it is now known) is heavily influenced by Strand's vocabulary and marks a turning point in Sheeler's own development, establishing his strong interest in the representation of the modern city. It is also notable for its clear demonstration of the importance of Walt Whitman to the modern artist, for the film is intercut with titles drawn from several of Whitman's poems, the particular lines serving as a thematic heading for the visual imagery. But it is unclear whether or not Strand and Sheeler themselves inserted the Whitman lines;

and it's debatable whether or not the inclusion of Whitman adds to or subtracts from the film.[3] Certainly, as Jan-Christopher Horak argues, the visuals echo the Whitman lines; but they tend to stop the flow of the film, interposing the experience of Whitman's poetry in a distracting way. Moreover, functioning like captions, they make us search for the confirming scene in the lines that precede it, thus literalizing and constraining the visual imagery. In contrast to Whitman's ever-changing catalogue of urban events and scenes, Strand and Sheeler's *Manhatta* has a somewhat static quality, as the camera seems to "watch" the city from dramatically selected aesthetic viewpoints; but the images represent the urban scene on an awesome scale—bridges, skyscrapers—emphasized by aerial views of the harbor and shots looking up at the giant skyscrapers of 1920. The use of Whitman indicates just how strong a presence he was in the art world of the twenties, and one might see the underlying intention to be to "dress up" the imagery, to elevate it by invoking a poet who by now had become less revolutionary than revered. Ironically, however, it is as if the prophet of "science and the modern" were now being used to soften the effect of the actual modern city, a city that as pictured is far beyond what even Whitman might have imagined.

Sheeler's engagement with science and the modern reaches its most complex and ambiguous state in the photographs he made at Henry Ford's River Rouge plant and the paintings that followed. In 1927, Sheeler, who had been regularly employed for years by the Philadelphia advertising firm of N.W. Ayer & Son, was commissioned to make a series of photographs to be used in Ayer's promotion of the new Ford factory—and its new car—at River Rouge. Sheeler continued to work for Ayer and Ford for a couple of years after the Rouge assignment, and he returned to the subject in several of his most important paintings, among the most outstanding examples of Precisionism. In the Rouge paintings, in which Sheeler's engagement with "science and the modern" was complete, he created a series of icons of American industry that have been read as celebrations of Ford and, by implication, of American capitalism. But there is more to the series than at first meets the eye, and understanding Sheeler's place within the discourse of modernism requires looking closely at the work and at the subject, the Ford factory.

The Rouge factory, designed to build the new Model A that was replacing the outmoded Model T, was an industrial city on a scale far beyond Ford's old Highland plant, and far beyond anything previously conceived. With 23 main buildings, 70 lesser structures, 93 miles of railroad tracks, 53,000 machines, and 75,000 employees, it was a site for production that

began with raw materials to create steel and ended with cars (Lucic 90). The man behind this enterprise was, at this time, among the most celebrated in the world, his mythical dimension having far outstripped his humble self. As one early biographer put it, "Henry Ford is the most discussed man on earth to-day. He is also the richest man on earth. And more than that, he is the richest man who has ever lived. But best of all he is the most unassuming and simple-mannered man in the light of his great power that I have ever met" (Stidger vii).[4] Ford entered the pantheon in January of 1914, when, faced with a huge turnover in his workforce and inspired by principles of justice and fair compensation that may have been awakened by his recent acquaintance with Emerson, he doubled his wage from $2.50 per day to $5 per day, and shortened the work day from 10 to 8 hours (Lacey 110-117).[5] Of course it was not quite that simple: to make the $5 one had to demonstrate one's worth not only in the factory but in the home, under the watchful eye of Ford's moral police, the Social Department. Still, it was an act that jolted the industry and all of America, making the Ford company seem the embodiment of industrial democracy, a kind of technological utopia that would spread the wealth to all. From an economic standpoint, it gained Ford a much steadier workforce and it argued the point pragmatically that mass production required mass consumption. Gramsci would take these moves as the textbook case for the creation of hegemony.[6]

But given Ford's own requirement that the purchaser buy with cash on hand rather than credit, one can safely say that Ford's own genius lay more in mass production than in consumption. To Ford, the goal was the constant perfecting of the manufacturing process, not the constant innovation of the finished product. Starting with the best possible design of the automobile, based on its function and purpose, Ford shaped around it the organization of the factory and the merchandising of its products. With efficiency the primary virtue, all waste—excess weight in the vehicle, unused byproducts in the process—were to be eliminated. Waste was also excess force used by the man in performing the job, and Ford subscribed to the principles of "Scientific Management" as Frederick Winslow Taylor had developed them, matching the man to the machine and the machine to the man in as perfect a wedding as possible. From Taylor's point of view, the manager's function was to discover "scientifically" the most efficient movements for the worker and thereby increase productivity; lofted by his success, Taylor made no attempt to conceal his contempt for the worker. ("The man who is physically able to handle pig-iron and is sufficiently phlegmatic and stupid to choose this for his occupation is rarely able to comprehend the science of handling pig-iron") (Boorstin 765). Ford was

somewhat more diplomatic in his own phrasing, admitting that he himself found repetitive labor "terrifying," but that "The average worker, I am sorry to say, wants a job in which he does not have to put forth much physical exertion—above all, he wants a job in which he does not have to think" (Ford with Crowther 103). Ford would give him that, and, with the help of the Social Department, was in the business of creating not only the perfect car but the perfect society.

Of course "perfection" in this regard might mean the robotization of human functions to nearly insufferable degrees. Chaplin's crazed tramp on the assembly line in *Modern Times* (1936) is perhaps the most famous image of somatic dysfunction, his finely tuned movements repeated to the point where he himself becomes a lunatic automaton. To Gramsci, Taylorization and Fordism were merely the "most recent phase of a long process which began with industrialism itself," and included the Puritanical repression of the body inside and outside the workplace (Gramsci 290; 291). [In Dos Passos' *The Big Money*, a foreman in an airplane factory that is competing with Ford—who was also producing airplanes during the twenties —complains to his boss about the "damned efficiency expert." His boss says the expert's a "genius at production." "Maybe, but he don't give the boys any chance for reproduction" (Dos Passos, *The Big Money* 277)].

What is striking about the series Sheeler did in 1927 is the complete absence of the famous assembly line and the nearly complete absence of the worker from the scene of production. Instead, Sheeler shows us the exteriors and interiors of buildings that carry the manufacturing process along, concentrating for the most part on the production of steel from raw materials—e.g. *Coal Bunker Building and Coke Ovens*, *Gas Mains*, *Slag Buggies and Blast Furnace*, *Boiler with Electrical Control Panel*, etc.— and omitting the later stages of car production. "My program as mapped out now," Sheeler wrote to Walter Arensberg, "will consist of photographs of details of the plants and portraits of machinery as well as the new Ford (take my word and order one now) and also the Lincoln" (Stebbins and Keys 26). (Sheeler took his own advice and bought himself a Lincoln, with great pleasure.) Deliberately concealing the harsh reality of assembly-line production, Ayer/Sheeler emphasize instead the mystery of the machine, dramatizing the abstract geometrical shapes, the intricacy of overhead lines and conveyor belts, the massive shapes of huge presses, generators, and rail carriers (Smith 15-55). In a way, Sheeler is sustaining, though revising, the nineteenth century relation between technology and art, maintaining the purity of the artwork as a defense against the severities of in-

dustrial life, but doing so, paradoxically, by aestheticizing industry. What's more, Sheeler creates for us an experience of the technological sublime, the awesome power of the machine when viewed as a creative force, so overpowering as to be slightly terrifying.[7] Where human beings do appear they seem dwarfed by the giant machinery, purely ancillary to the kettles, furnaces, ladles, and dynamos they serve. Sheeler's work here is quite different from the contemporaneous imagery of Lewis Hine, who, in *Men at Work* (1932) consistently dramatized the worker rather than the machine.[8] In Hine's photographs for General Electric, American Airplane Corporation, and other companies, and most notably in his series on the construction of the Empire State Building, the skill and courage of the worker is the intended point, even when the machine might visually overpower the human scale. Sheeler's treatment of the giant Ford machines is not unlike Strand's early close-ups of much smaller machine forms: careful control of highlights and internal light sources, dramatic shadows, emphasis on form rather than a description of function, a sensual treatment of surfaces and materials. The world of Ford according to Sheeler is essentially an aesthetic universe of calm and order, worlds away from the description of the Rouge factory in even so adulatory a biography as William Stidger's (1923), where the author is reminded at once of Rembrandt and of Hell:

> Down the incline we went from the high heights of the blast furnace into the furnace room itself; and from there to the great furnaces of the power plants and from thence to the foundries where great molten kettles of white-hot iron were swinging on great runways propelled by huge black men from the sunny south; men, who in the blare and glare of splashing, simmering, smoldering iron, open furnaces with streams of molten, running iron, look like figures from some grim, Rembrandt picture.
>
> From the top of that bridge down the elevator into the furnace room of the blast furnace, through the power plants, into the foundry reminded me of a journey that Dante once took with a certain guide who showed him exactly the same kind of things Mr. Smith [his Ford guide] showed to me (114).

Sheeler's River Rouge plant is in some ways the utopian counterpart of the image of the city created by the Machine Age's most famous architectural delineator, Hugh Ferriss. (Both Sheeler and Ferriss were involved in organizing the Machine Age Exposition.) In *The Metropolis of Tomorrow* (1929), Ferriss created a series of poetic black and white drawings that depict a city of awesome skyscrapers, pyramids, bridges, and towers, the whole governed by an austere and sublime geometry that removes man to

the margins of the spectacle. And like Ferriss, Sheeler placed the spectacle of the Rouge within a quasi-religious framework: "Every age," Sheeler affirmed, "manifests itself by some external evidence. In a period such as ours when only a comparatively few individuals seem to be given to religion, some form other than the Gothic cathedral must be found. Industry concerns the greatest numbers—it may be true, as has been said, that our factories are our substitute for religious expression" (qtd. in Rourke 130).[9]

Going so far, Sheeler went even farther, when he wrote for the March 1931 issue of the new *Fortune* magazine a statement introducing a reproduction of one of his paintings based on a Rouge scene, *American Landscape*: at the Ford plant "is to be seen the machine working with an infallibility which precludes human competition. Noticeable is the absence of debris. Everything in the path of the activity is in the process of being utilized . . . it becomes evident that one is witnessing the workings of an absolute monarchy. It confirms a preference for that type of government with the proviso that the monarch be of the calibre of Henry Ford" (qtd. in Smith 127). Ford represented not so much the businessman-capitalist (though he was that) as the engineer, the problem-solver, the rational

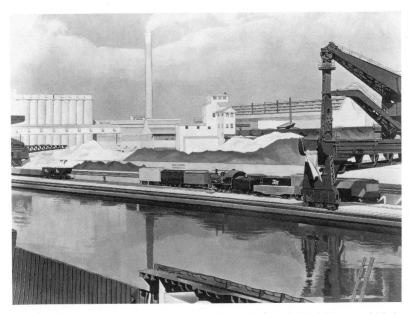

Charles Sheeler: *American Landscape*. 1931. Oil on canvas. The Museum of Modern Art, New York. Gift of Abby Aldrich Rockefeller.

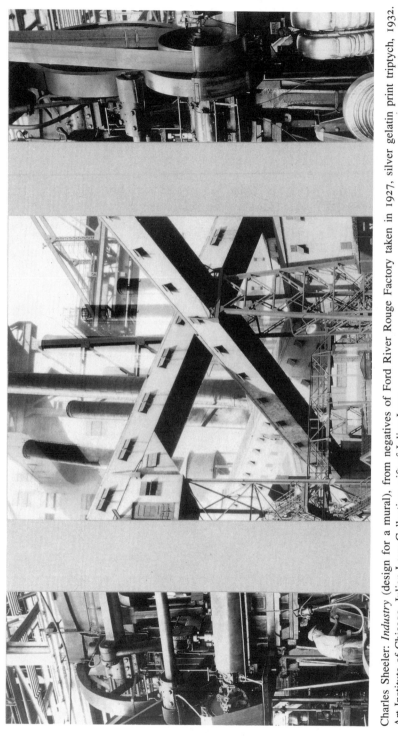

Charles Sheeler: *Industry* (design for a mural), from negatives of Ford River Rouge Factory taken in 1927, silver gelatin print triptych, 1932. Art Institute of Chicago, Julien Levy Collection, gift of Julien Levy.

pragmatist, a type that was first importantly celebrated by Thorstein Veblen years before Ford was a household name: "those gifted, trained, and experienced technicians who now are in possession of the requisite technological information and experience are the first and instantly indispensable factor in the everyday work of carrying on the country's productive industry" ("Technicians" 440). Veblen was looking at technology as an essentially progressive force, abolishing custom and habit, indeed a democratizing force, knowing "neither manners nor breeding" ("Discipline" 338).

Ford's virtues of order, efficiency, and managerial expertise had widespread popular appeal, especially during the teens and twenties, when Progressive intellectuals like Walter Lippmann and Herbert Croly looked to a disinterested managerial elite to solve the problems of government, with Ford and industry as a model (Lucic 79-80). These utopian ideals would flourish briefly in the Technocracy movement of the Depression, as a response to the proven disorder of the marketplace. If Sheeler's response to Ford—forgetting the labor practices, the strikes, the Ford police, the social campaigns—was thus a positive one, it was not far from the popular response to the myth of Ford (Smith 15-55).

Perhaps the clearest icon of Precisionism (and of Ford) is Sheeler's photographic triptych, *Industry*, which uses photographs from the River Rouge project and was made for a 1932 exhibition of mural proposals at the Museum of Modern Art. Sheeler used several pre-existing Rouge photographs for this work: the narrow side panels are taken from a single print, *Stamping Press*, divided vertically, while the central image uses *Criss-Crossed Conveyors*, with a background composed of a combination of two other photographs—the smoke stacks of *Power House No. 1* and a reverse image of *Pulverizer Building* (Stebbins and Keyes 32-33). The triptych is interesting as a formal composition, a play of verticals, horizontals, and diagonals. (The central X-shape of *Criss-Crossed Conveyors*, incidentally, may allude to Stieglitz's criss-crossed lines in *The Steerage*—gangplank, smokestack, ladder, upper deck.) But it is also interesting conceptually, for it represents a play of opposites: the two side panels *break apart* the single image, while the central panel *puts together* three images. As a representation of "industry" this is just right, for Sheeler's artistic process imitates the industrial process of breaking down raw materials and synthesizing components into a new whole. In effect, the *Industry* triptych is a *conceptual* work: the *idea* of the work is an essential component of our understanding; it is not just a representation of machinery and it is not just a play of forms.

In fact, we need to look at Sheeler's work generally more as *conceptual*

art than as formalistic construction. Sheeler's paintings of the Ford plant during the early thirties are no less interesting in this regard. In each case— for example, *Classic Landscape*, *American Landscape*, and *City Interior*— Sheeler depicts with "photographic realism" scenes that are based on his earlier photographs of the industrial plant. But all three, again, can be seen as conceptual works, where an *opposition* is crucial to the motive—an opposition between the title and the image that establishes an irony. Yes, this is the new world, but it is a new world that is evoked in terms of what is *not* there. The *Classic Landscape* (1931) is conceived along "classic" lines: Sheeler depicts silos of a cement plant (the equivalent of classical columns) in the middle ground, while the rail tracks carry us from the foreground to the right side of the picture, to a sharply vanishing point. But it is devoid of the human presence and human scale, which were at the center of classical civilization. In *American Landscape* (1930) we again see the cement plant in the middle ground, but we are looking at it from a vantage point on a salvage ship, with the river flowing through the foreground of the picture; across the river is a rail track, with cars, cranes, and the tiny figure of a man running. Sheeler incorporates the natural landscape—sky and river—but it is an American landscape that has been coerced into the industrial scheme: the water reflects the industrial structures, the sky takes its clouds from the smokestack. *City Interior* (1935) depicts the massive shapes of industrial buildings and overhead structures, at the center of which, starting at the bottom of the picture and running to the exact center, are the clean lines of railroad tracks, a few human figures, and a railroad car in the distance. It too employs an irony: the Rouge plant is "like" a city, in terms of its structures, transportation, planning; but there is nothing of the *civitas* here, there are few people and hardly any movement. It is a dead city. All of these paintings have been taken as analytic representations of the "new world" of industrial America, a world of order and productivity; yet I believe they represent an ironic commentary on this new world, as close to "social comment" as Sheeler cares to come.[10]

Sheeler's use of ironic titling—anticipated by Demuth in such earlier works as *Incense of a New Church* (1921)—seems deliberate in these industrial paintings, and is not with Sheeler a constant habit: none of the still lifes of conventional subjects are ambiguously titled, and even the "cute" titles of the domestic interiors—*Feline Felicity*, *Home Sweet Home*, *American Interior*—though slightly distancing, seem essentially harmonious with their traditional Shaker subjects rather than oppositional. But at least three other paintings also carry a pointedly ironic—and oppositional— meaning, sustaining a reading of them as conceptual works: *View of New*

York (1931), which shows us the interior of the artist's apartment, with a window opening out onto the view of New York which is *not* shown; the earlier *Self-Portrait* (1923), which places a telephone where the figure might otherwise be, and which offers us only a section of a human subject (the head cut off), viewed darkly as a reflection in a window behind the telephone; and *The Artist Looks at Nature* (1943). The last is the most important and, far from being the anomaly it often is taken to be, reflects generally on Sheeler's artistic habits.

The Artist Looks at Nature does indeed place the artist within a natural landscape, though a strangely discordant one, with walls sectioning off the grassy areas, which are at different levels. At the upper left is the corner of a house; at the lower right, opposing it, Sheeler has painted in (with slight modifications) his own earlier photographic self-portrait (*Self-portrait at Easel* [1932]), though now the figure of the artist is moved from an interior setting to the edge of a sheer drop, looking at the bizarre landscape before him.[11] Yet what is striking about *The Artist Looks at Nature* is the relationship between the painting as a whole and the drawing the artist is creating. Though it is usually assumed there is no direct connection between the two, in fact there is: the crayon interior has the same general form as the landscape before the artist—the same division of space down the middle, the same central shape (the window in the drawing "equals" the stair-like wall in the painting), the same emphasis on horizontal forms across the top of the two images, and the same use of the lower right space. In the drawing it is left undrawn—it is the space *for* creation; in the painting it is the space occupied by the figure of the artist who is making the drawing— it is the space *of* creation.

What is being represented here is the relationship between art and reality: the artist does look at nature, but what he makes of it is another story, that in this case "follows" the shape of the world before him, but transmutes it into a quite different image. The artist's freedom thus to manipulate reality is his method of production, though he seems bound by the structures of nature before him. To look at nature is to look "inside"— inside oneself, into one's past, into one's interior spaces. Sheeler made this point literally when he said (before painting the picture): "Photography is nature seen from the eyes outward, painting from the eyes inward. No matter how objective a painter's work may seem to be, he draws upon a store of images upon which his mind has worked. Photography records inalterably the single image, while painting records a plurality of images willfully directed by the artist" (Rourke 119). (Cf. *View of New York*.) The conceptual dimension of this painting is thus a play of opposites that takes

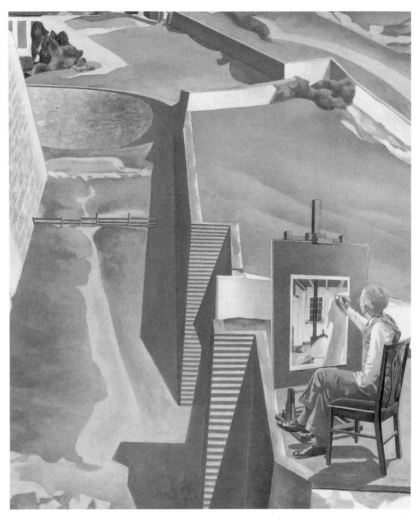

Charles Sheeler: *The Artist Looks at Nature*. 1943. Oil on canvas. Art Institute of Chicago, Gift of the Society for Contemporary American Art.

us back again to the River Rouge paintings, where the artist had used photography to offer a seemingly objective image, but had in effect turned inside and away from the scene, in insisting—by his titles—that we also imagine the aesthetic and cultural *types* embodied in his titles and against which we must perceive the rendered scene.

At the center of the Machine Age lay a division of labor and a division of society: between those who worked with their hands and those who

thought with their heads. The American industrial system as conceived by Ford and Taylor believed these divisions to be eternal and eternally right, and the case of the Soviet Union, as Ford saw it in 1923, proved the point: as soon as Russia "began to run her factories by committees, they went to rack and ruin . . . As soon as they threw out the skilled man, thousands of tons of precious materials were spoiled." All the more reason to defend the division within American industry, a division that is represented by Ford, however, as a unity threatened with division: "There is in this country a sinister element that desires to creep in between the men who work with their hands and the men who think and plan for the men who work with their hands. The same influence that drove the brains, experience, and ability out of Russia is busily engaged in raising prejudice here" (Ford with Crowther 5). But Ford's utopia of the factory conceals a division within the individual, between the head and the hand, a division that all art, in so far as it involves a thinking head and an acting hand, tends to heal. One reason Sheeler is so interesting is that his engagement with the factory was immediate in terms of the photographic record (what is out there for the hand to touch) yet conceptually rich and complex in other ways (what the head thinks). It may be no accident that both Ford and Sheeler were deeply fascinated by the crafts of pre-industrial America, as if for both of them, so equally immersed in the machine (though of course in different ways) it was essential to keep the spiritual and cultural ideal in constant view: the production of hand-made goods that resulted from the joining of hand and head. You couldn't go back to that earlier time, they both knew. But you couldn't forget it either. So Ford created his Greenfield Village, filled with hand-made antiques and folk objects; and so Sheeler—while immersed in the imagery of technology and the city—was also deeply involved with the aesthetic of Shaker craft, and many of his paintings—including those of his own home—reflect the integration of hand and head that is embodied in these nineteenth century artifacts, not to mention their pre-industrial functionalist form.

These paradoxes persist: in 1944, as World War II was reaching its climax, America's premiere business magazine, *Fortune*, commissioned Charles Sheeler to do a series of still life photographs related to great nineteenth century American cultural figures. In the May 1944 issue, Sheeler's still life dealing with Henry David Thoreau—who had sought to define a society's spiritual ideals against the oppositional values of materialism—was published. Sheeler did another photograph for this series, not published until after his death, that is even more interesting for our purposes, for it brings us back again to Whitman, *Walt Whitman Relics*.

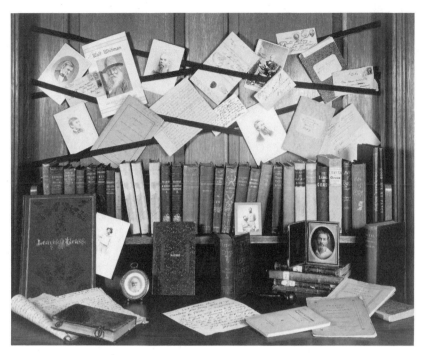

Charles Sheeler: *Walt Whitman Relics.* 1944. Gelatin silver print. The Museum of Modern Art, New York, Gift of the photographer.

It is a photograph of a still life arrangement, with books, photographs, and memorabilia (from the Houghton Library collection), all relating to Whitman, displayed in the manner of a nineteenth century rack picture and table top arrangement, such as William Harnett might have painted. Whitman again: "America demands a poetry that is bold, modern, and all-surrounding and cosmical, as she is herself. It must in no respect ignore science or the modern, but inspire itself with science and the modern. It must bend its vision toward the future, more than the past." The Modernist movement, including the Precisionists, was precisely an effort to answer that call for a "bold" art equal to the country itself; but by the time the artist had moved "science and the modern" from outside the discourse of art to inside, technology had come to seem not only a defining attribute of American culture, but a dangerously dominating one. And Whitman, once sounding the barbaric yawp that was so offensive to the genteel tradition, had become himself a safe part of that tradition, as Sheeler reconceived it. Whitman, in the end, became for one of the preeminent Modernists a symbol of both the modern and of the past and of that moment of optimism

when the vistas of American democracy seemed happily created by the forces of industry and technology. Inspired by "science and the modern," the artist of the twentieth century would find himself in a far more complex world than Whitman could have imagined, a world of technological power that was at once sublime and threatening, revealing in a variety of ways how vulnerable was the human figure to the awesome force of the machine.

2

The Camera and the Magic of Self-transformation in Buster Keaton

In a 1922 fairy tale called "The Diamond as Big as the Ritz" F. Scott Fitzgerald sends his schoolboy hero, John Unger, on a vacation visit to the palatial home of his chum Percy Washington. Early in his stay John is invited to take a bath. It is superlative: water rains down on him from a fountain, soap spurts in from walrus-head jets, paddle wheels churn the water to a rainbow of pink foam, and an attendant asks deferentially, "Shall I turn on the moving-picture machine, sir? . . . There's a good one-reel comedy in this machine today" (85). But who needs a second dream when one is already submerged in the first? With epicurean concentration John declines. Yet for most people during the twenties films were indeed a magical luxury, the shadowy embodiment of untrammeled fantasy.

Working in a medium that is by nature dream-like, Buster Keaton is the Walter Mitty of cinema. No one has been as great a success at both failing and succeeding; these poles of fantasy shape the plots and determine almost every action in Keaton's films, and it is for this reason that they struck a deep and instinctive chord in the popular audience. And too the extravagance of his failure and success lies at the root of Keaton's sense of the comic; for the world of comedy is the world of the impossible, and the law Keaton intuitively follows is that normal capability will not make us laugh, whereas inordinate incompetence—or competence—will. (A man

putting on his trousers is not funny, whereas a man who can put them on in half a second is as funny as a man who takes half an hour.) Yet paradoxically everything Keaton does—whether in defeat or triumph—looks natural: there is always an essential and unchanging Keaton persona—effortlessly agile, gracefully clumsy.

Keaton's failure and success concern nothing so necessary as money; unlike Chaplin's tramp, Keaton always has a job of some sort. In several films he is a man of substantial wealth; in others he is decidedly not, but there is always at least a dollar in his pocket, or a piggy bank that can be broken open for its treasure of dimes. What concerns us in every case is rather his fortune in the abstract sense—one might say the "metaphysical" dimension of his success or failure, his way of existing in the world, and, a corollary, whether or not he gets the inevitable girl.[1]

Keaton made, during the twenties, roughly a score of shorts, followed by ten features, and between the two forms one may draw some distinctions. One is that the shorts are usually based on a situation, an environment, a single prop, while the features build around one or more props a linear story line. A related, but more significant difference, is that in the shorts Keaton is either extraordinarily inept or extraordinarily agile, either obtuse or clever; and one can more or less divide them according to whether they derive their comedy from Buster's puzzlement and inadequacy (e.g., *One Week, Electric House, The Boat, Daydreams, The Blacksmith*) or from his grace, skill, and luck (e.g., *Paleface, Playhouse, Cops, Scarecrow, Neighbors*). In the features, however, there is in every case a transformation, or metamorphosis, of the self, and it is always from ineptitude to mastery. This is the essential Keaton fantasy, the pervasive structure of his comedy. During the course of his adventures the hero undergoes a trial moment that he never fails; his success wins him the girl, yet winning her seems almost incidental; what is really important is mastering the world by a metamorphosis of the self from inept and clumsy to a self that is daring, resourceful, and ingenious. Thus in *Our Hospitality* the awkward and alien Northern youth manages supremely to save himself and his Southern girlfriend from the perils of a waterfall and win acceptance in her family. In *The Navigator* the rich boy who needs a chauffeur to drive him across the street in the beginning of the film survives ingeniously (with the girl he wants to marry) on a drifting and deserted ocean liner. In *The General* the rejected Confederate Army volunteer wins back his locomotive from the Union troops, and wins too the gratitude of the Southern militia—and naturally the girl he has been courting. In *College* the physically inept egghead coaxes his crew to victory, using his rear end

to replace a broken rudder, and enacts a timely, steeplechase rescue of his sweetheart, who is being threatened by a bully. And so on.

Keaton's performances during the climaxes of these films seem the expression of an inherent capability called forth by the moment, yet they border on the superhuman, and are at times nothing less than astonishing. *Steamboat Bill Jr.* is particularly interesting in this regard, for Buster's metamorphosis is preceded by a sequence that is frankly supernatural.[2] Keaton plays the fastidious weakling son of a robust steamboat captain, scorned by his father for his apparent ineptitude. At the moment of complication in the plot (the father in jail for assaulting a rival captain, Buster in the hospital after being knocked down by a car) an extraordinary cyclone sweeps through the town, and in the process, Buster is transformed. First, a series of unusual disasters encroach upon his person—the entire hospital building is plucked away, one whole side of a house falls on top of him— but Buster, as if surrounded by a protective aura, is immune from harm. Next he wanders into a deserted theatre, where he tries to escape raging nature by diving into the world of "art"—a peaceful landscape painted on a screen—but there is no escape: painted nature falls at his feet. Straying backstage among the theatre props, Buster finds himself in the equally alien world of magic: a dummy casually turns toward him as if to speak; Buster explores a magician's circular curtain and vanishes inside, reappearing in a box. Outside again, a house drops out of the sky on top of him; a facade splinters and dissolves behind his back. As if initiated into the wondrous by these natural and supernatural marvels, Buster is at last literally transported from the ravaged town by clinging to a tree which is uprooted vertically from the ground and carries him toward the waterfront —where Buster's now fully assumed genius will enable him to rescue practically the whole town as they float down the rising river, clinging to bits of flotsam. Among those rescued—by ingenious contrivance and physical daring—are Buster's father (now more than willing to bless his son) and his father's rival, willing now to approve the marriage of his daughter and Buster.

Steamboat Bill Jr. makes plain what is only implicit in some of the other films: that the transformation of the hero is magical, the expression of a fantasy of omnipotence. Two other films—*Sherlock Junior* and *The Cameraman*—confirm the pattern and are of special interest to an analysis of Keaton's art in being themselves self-analytical, or self-reflecting. In *Steamboat Bill Jr.*, as in all of Keaton's films, the camera eye is the indispensable organizer of the miraculous: what appears on the screen as the spontaneous order—or disorder—of the world is the result of painstak-

ing prearrangement, calculation, and editing. Yet we are never aware of the camera. In *Sherlock Junior* and in *The Cameraman*, however, the plot turns on the virtues of the camera, defining it as the necessary angel in Keaton's metamorphosis, the means whereby dreams are, by turns, created and verified. In these two films Keaton is bringing to popular cinematic art at the height of the silent era an experimentation in reflexive form that has distinguished fiction from Cervantes to Sterne to Lewis Carroll and the numerous twentieth-century practitioners of self-conscious narration. (With the introduction of sound around 1930, and the concomitant stylistic timidity of film, the movies would have to wait more than thirty years until Fellini and Antonioni and Godard would rediscover the rich possibilities of this kind of formalistic invention.)

There are two distinct levels of action in *Sherlock Junior* (1924)—that of everyday life, and that of movie-life, with the latter enveloped by the former, like a tale within a tale, or a dream within a dream. In everyday life Buster works in a movie theatre as a projectionist and janitor. From the first moments of the film, however, we are made aware of his fantasy life, for we come upon him sitting in the theatre after the show reading a manual on how to become a detective. But his first criminal investigation only demonstrates how unequal he is even to the simplest task, for he is himself incriminated, on the evidence of a pawn ticket, for the theft of his girlfriend's father's watch. The actual culprit—who had placed the ticket in Buster's pocket—is the girl's other suitor, a husky reptilian type, who had pawned the watch and bought the girl a box of candy four times larger than the one Buster could afford.

Ignominiously expelled from the girl's house, Buster returns to his job as projectionist at the movie theatre, where a film called "Hearts and Pearls" is playing—"Hearts and Pearls, or The Lounge Lizard's Lost Love," as the billboard outside the theatre has earlier forecast. While the film is on, Buster falls asleep, and it is then that the astonishing central core of *Sherlock Junior* commences. Two contrary dreams of the self are, in succession, projected into the "screen"—the first an embodiment of blundering failure, the second of practiced success. The sequence begins with the first dream-self, the exact replica of the sleeping Buster, separating itself from the sleeping projectionist and becoming intensely interested in the romance on the screen. Indeed, as this dream-Buster watches, the hero and heroine on the screen are metamorphosed into his own girlfriend and the rival, though their class and station have been elevated from Buster's lower middle-class everyday world. When the rival makes advances, the dream-self, conscious of its surrogate status, tries to rouse the

real Buster, and, failing that, himself rushes down the aisle, climbing over the piano player and literally into the screen. He is promptly thrown out, however, by the rival. Yet once more he gamely crosses the barrier between the real world of the audience and the world of the movie and this time becomes the victim of the alien laws of space and time of that latter world. As the scenes shift rapidly from one locale to another (without, it must be said, any apparent logic) Buster, himself immutable, is successively disoriented: he goes to knock on the front door and the scene changes abruptly to the garden. He moves to sit down on the garden bench and falls into a city street full of traffic. After several more startling transitions he is back again in the garden. Throughout this sequence the proscenium arch of the movie theatre is visible as a frame for the screen, making us aware that we are watching a film (within the film) and "explaining" the failure of the inept dream-self to cope with this world of rapid cuts. The sequence is full of pratfalls and absurdities but it is perhaps too brilliant in its conception, too puzzling in its mechanics, to be actually funny. (Woody Allen, a professed admirer of Keaton's, created an even more elaborate version of this same cinematic trope in *Purple Rose of Cairo*.)

Not so with the performance of the second dream-self, which occupies the greater part of *Sherlock Junior* and is marked not only by startling wit but also by inspired slapstick. Following a blackout, the scene in the inner film reverts to the interior of the girl's house, but now the camera moves closer to the screen within the movie theatre, the proscenium arch disappears, and we are completely within the world of the film Buster is sleeping through. In this inner story—paralleling the outer one—a string of pearls is stolen by the burly rival, who is working with a gang of thieves, and the girl's family calls in a private investigator: in walks Sherlock Junior, famous detective, played of course by Keaton. If the first dream-self was the victim of the nature of film, this second is a master, fully at home in the world of illusion. (Indeed, when we see him at home, preparing to track down the thieves, Sherlock is fixing his dapper suit in front of a mirror which, when he steps through it, we discover was an archway; in the next room he unlocks a huge wall safe and steps through the door into the outside street!)

In grappling with the thieves Sherlock has every advantage of superior physical skill, uncanny intuition, miraculous luck, and the magical resources of cinema. With ease he eludes the various traps they have set for him (falling ax, poison, exploding billiard ball) when he is initially called in on the case. And in a later sequence he steals a ride from one of the

Sherlock, Junior. All photographs in this chapter courtesy of Museum of Modern Art.

crooks who is on his way to the hideout and brazenly follows him into the thieves' den, whereupon he snatches the pearls and makes what is undoubtedly the most astonishing escape in movie history: Sherlock dives through a hoop that he and his assistant, Gillette, have placed in the cabin window, and with one motion gets up from his somersault fully clothed in the costume of an old lady. As he walks away with an aged gait, he is unhappily discovered by the crooks, who chase him into a closed yard. But the assistant is there again, this time disguised as a peddler, and motions for Sherlock to dive through a suitcase display of ties that he is holding in front of him. Sherlock does, and makes thereby a second stupendous escape, this time seeming to pass straight through Gillette's chest and through a wall standing behind him! No trace is left, his puzzled pursuers discover, as they search the wall—which suddenly revolves on a vertical axis, liberating Buster and imprisoning the thieves behind it.

There follows an extended sequence, the climax of the film, when Buster sets out, with the pearls, to rescue the captive heroine. His assistant picks him up on a motorcycle but himself soon falls off, leaving Sherlock (unaware of Gillette's fate) riding alone on the handlebars. Through streets

The Camera and Self-transformation in Buster Keaton **33**

and intersections he goes, dodging traffic, upsetting pedestrians, crashing through a picnic ground. He approaches a tree that is blocking the path a moment before it explodes before his ongoing cycle (two workmen have been planting dynamite). He travels across an elevated roadway (in a very long shot) with a gap in the middle that is bridged by two vans of perfect height passing underneath just at the instant Buster crosses over their roofs. He approaches the end of the roadway, which seemingly ends in mid-air—but collapses just at the moment Keaton reaches it, becoming thereby a ramp to the continuing road. After narrowly missing a speeding train and several other vehicles, Buster at last crashes the machine into the cabin where the girl is being held and knocks out cold her evil captor. The girl and her rescuer rush off in a motor car, successfully escaping their pursuers when, apparently safe at last, the car goes off an embankment into a river. Here "Hearts and Pearls"—starring Sherlock, at least—ends, with Buster swimming ashore, towing the Heroine under his arm. It is a breath-taking trajectory and raises coincidence to a divine principle. The superior Sherlock, unlike the earlier dreamed self, is a master of the illusions of the cinema and "uses" them for purposes of highest justice and personal gratification. There is no logical transition from the first, bewildered dream-self to the second, masterful one (as there is none, really, in the other stories of transformation Keaton made) except that both are exorbi-tant expressions of the fantasies of failure and success.

Sherlock Junior ends with the projectionist awakening from his dream world in the very real projectionist booth. But while the fantasy of "Hearts and Pearls" has been going on, Buster's innocence has been discovered, and his girlfriend comes to the theatre asking forgiveness and offering her love. No longer the suave Sherlock, Buster turns to the continuing film for inspiration and shyly mimics the screen hero's enthusiastic kiss and proffer of a wedding ring. The inner film cuts to a final image of the screen pair dandling babies as Buster, watching in embarrassed puzzlement, scratches his head. Once again an abrupt shift of scene has left him nonplussed, though now, his girlfriend won, he stands his ground.

In the later *The Cameraman* (1928) it is not the camera's potential for creating illusion that is exploited but its capacity objectively to record—to verify—the truth of events. Interestingly, there is one segment in the film where trick photography is used—during a screening of Buster's initial efforts as a newsreel cameraman. (The results: a woman diving into and—by reverse motion—out of a pool; a battleship—by double exposure—floating down a busy city street; and a quartered screen filled with cha-otically speeding traffic and pedestrians.) But during this sequence, al-

Sherlock, Junior.

though Keaton obviously uses the illusionistic capacities of the camera, his purpose is to illustrate the ineptitude of the novice cameraman, who had no control over the movement of images on the screen. Given the context of the film, this segment is not "magical"; it is just "wrong." In general in *The Cameraman* the camera does not call attention to itself by unusual shots or tricks of narration; for the camera is already "in" the film as an object in the story, and tricky photography would distract us from its already self-conscious presence.[3]

The center of *The Cameraman*, then, is not the projection of Buster's contrary fantasies—as in *Sherlock Junior*—but rather the verification of his performance in the real world. But it is the splendid idea of the film that Buster will play a newsreel cameraman, who is, by definition, merely a witness to others' performances, and the dialectic between detachment and involvement will provide the climax of the film.

Within the first few minutes the dominant motifs are already visible. Thus we initially see Buster as a tintype photographer who is pushed up against a pretty girl in a press of newsmen: after the crowd disperses, he persuades the girl to let him take her photograph, but is so dazzled by her

charms that he is paralyzed. To make even a tintype requires a certain distance from the subject that Buster is unable to gain. Only after several moments of abstracted contemplation is he able to slip back again into his role of photographer and complete the picture. Related to this tension between involvement and detachment is the motif of performance, which appears moments later when Buster delivers the print of the photo to the girl, whose name is Sally. As he stands in front of her desk—Sally is a receptionist at a newsreel company—Buster is again speechless with adoration, but this time, with deliberate casualness, he takes a coin out of his pocket and performs a sleight of hand trick. This done, he puts on his hat— or tries to: his arm is around the bulky tintype machine and he cannot reach his head. Here in capsule is the essence of Keaton's comedy: the superior dexterity of the magic trick, the clumsy inability to perform simple things.

Two later scenes in *The Cameraman* are based on these same polar sources of comedy and extend the theme of performance—the first demonstrating athletic virtuosity, the second physical incompetence. The first is set in Yankee Stadium, where Buster, determined to impress Sally by becoming a newsreel photographer, has gone to photograph the action. The vast deserted stadium (naturally the Yankees are not playing at home that day) provides the perfect setting for Buster to perform a baseball fantasy. We soon realize, as he pantomimes the action, that he is pitching with three men on base and no outs. The ball is (apparently) hit sharply to the mound and Buster initiates a triple play, thus retiring the side! A moment later he comes up to bat himself and hits an inside-the-park home run, climaxed by a safe slide into home. It is a marvelously compact scene, on the edge of comedy and suspense. And how entirely characteristic that Buster's performance should embody the most exciting moments possible in baseball. It is the ultimate fantasy, played out with solitary gusto—as if spurred by the witness of the unmoving camera Buster had placed near the pitcher's mound—and it ends when the caretaker at the ball park reappears, just as Buster is graciously accepting the "cheers" from the crowd. The suspended moment ends, and Buster, embarrassed and self-conscious, once again returns to the everyday world.

The baseball fantasy is performed with all the abandon and grace that are impossible for Buster to manage in the second performance scene when, with Sally looking on in the public swimming pool, Buster attempts the high diving board. If the baseball scene is the fulfillment of a dream wish, the swimming pool scene, balancing it, is the fulfillment of the cameraman's worst imaginings and fears. "I'll show you some real fancy

diving," he says, and proceeds to totter nervously at the edge of the high board, eventually falling off clumsily—and losing his over-large bathing suit when he lands. Indeed, throughout the pool scene Buster appears the small fry, continuously threatened by the school of stronger, more agile young men who vie for Sally's attention.

The principal thread in the film of course, is Buster's persistent effort to succeed as a cameraman, an effort that is cast in the standard formula: "No one would ever amount to anything if he didn't try," Sally says; to which Buster responds, after successive failures, "I'll make good next time." Buster gets his best chance when Sally gives him a tip that there will be some interesting action to film at a forthcoming Chinatown celebration. There is: Buster becomes witness to an explosive war between two rival Chinese factions. As the bullets and bodies swirl around him, the camera-man remains the detached professional, jockeying for the best angles from which to photograph the action, all the while cranking the talismanic camera. Several times the border between involvement and detachment is comically breached—as when Buster replaces a knife in a combat-ant's hand (to maintain the pitch of the film) or when Buster is himself attacked—ineffectually—by three Chinese. But all the spectacular camera work shortly seems wasted, for when Buster returns to the newsreel studio, it appears that he had forgotten to load the machine with film.

The consummate detachment of the cameraman in Chinatown is bal-anced by the climactic scene in the film, when Buster abandons the camera and himself participates crucially in the action being photographed. Buster has gone to film a yachting regatta, accompanied by a monkey he has acquired from an organ grinder. With the monkey at the rudder, Buster rows close to the action, but is towed by the racing officials out of the way and onto the beach, where he sets up his tripod. While he is shooting the race a motorboat comes into view, occupied by Sally and a rival camera-man, Stagg, who is also a rival for Sally's affections. The showoff Stagg makes a sharp turn which throws both him and Sally out of the boat. Stagg swims to shore by himself, while Buster rushes to rescue Sally in his rowboat. He smashes into the encircling motorboat and swims with Sally back to shore, where he leaves the girl and dashes to a drugstore for a stimulant. While he is gone, the saurian rival comes over and, as Sally revives in his arms, disingenuously takes credit for the rescue. Buster returns with his armful of medicine bottles and sees the two walking off arm in arm.

Buster returns to his old job in apparent defeat, but unbeknownst to him the monkey has filmed the entire scene. When it is shown at the studio for

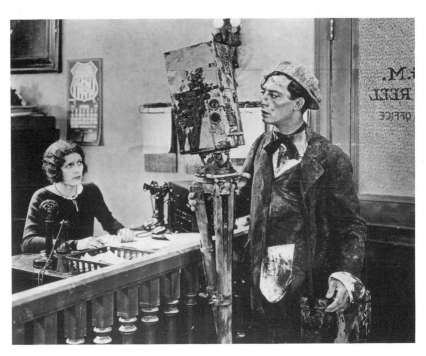

The Cameraman.

a laugh (Buster had given it to them for nothing) the truth is revealed: first the scenes from the Chinatown war come on the screen (the monkey had taken the film out after the shooting and it was loaded anew into the camera for the regatta); then, much to the surprise of Sally and Stagg, who is sitting beside her, the whole story of the boat rescue appears. The head of the newsreel company acclaims the "camera work" in the shots (apparently including the monkey in his praise) and orders Sally to find Buster and offer him a job. (Appropriately, the quality of the film Buster and the monkey took seems much smoother, more like "art," than the scenes where we saw the footage actually being shot.) When Buster learns the news he is elated, and as he and Sally walk back to the office, he graciously acknowledges the wild cheers and masses of confetti that are showered upon him from all sides. Fantasy merges beautifully here with Buster's actual triumph, lending to his absurd mistake—the crowd is in reality cheering Charles Lindbergh, who is at this moment coming up just behind Buster on the street—a wonderful irony.

Buster's success, it is important to note, has been twofold: he has won a job, and he has won Sally. His performance as a cameraman has been

professionally hailed (though without due credit to the monkey), and his genuine heroism has been recognized. The first accomplishment is the product of superior detachment, the second the result of abandoning that detachment and involving himself as an actor in the "scene." The medium of film is thus implicitly the unimpeachable witness, the recorder of actuality, though at the same time it is the instrument by which Buster's fantasy is in fact realized. (*Sherlock Junior* is, one might say, an inversion of these parameters: though he gets the girl in the end, there is nothing heroic about Buster; the self is metamorphosed only through the medium of the dream-film.) It is an additional irony of *The Cameraman* that as Buster accepts the cheers of the crowd, the image on the screen is unobtrusively blended with actual newsreel footage of Lindbergh's festive parade, thus placing the cinematic Buster—the newsreel cameraman—in juxtaposition to the actual Lindbergh. One may also relish the further irony that when Keaton made this film on location in New York City, he was so often mobbed in the streets by people who recognized him—thus rendering impossible the depiction of his presumed anonymity—that he had to shoot the bulk of the New York scenes at the MGM studio.

Apart from the clarity of its reflection on the relationship between the camera and performance, there are other reasons why *The Cameraman* holds a special place in the Keaton canon. It was the first film Keaton made with MGM, following the disbandment of his own studio, and it was the harbinger of the crippling difficulties Keaton would run into with the studio system. Only after the long delayed and less than helpful contribution of the scriptwriters, after repeated skirmishes with the studio bureaucracy, was Keaton able to persuade Irving Thalberg to give him autonomous control of the film, control that he was never to have again at MGM. Is it for this reason—owing perhaps to a certain uncanny prescience on Keaton's part—that there are scenes in *The Cameraman* that seem peculiarly autobiographical, the product of a kind of twilight nostalgia? Whatever the cause, *The Cameraman* is in certain respects Keaton's most personal film. The Yankee Stadium fantasy, for example reflects Keaton's own zest for baseball (he organized studio teams in Hollywood throughout the twenties) and may also obliquely reflect on the fact that Keaton came to MGM with a specific "no baseball" clause in his contract—though this was later rescinded, it must be said, by L.B. Mayer (Blesh 71). The swimming pool scene seems equally personal, recalling, as it does, the summer days when Keaton was a teenager in Lake Muskegon, Michigan, and would entertain his friends with inspired aquatic clowning.

One is even tempted to read into one of the funniest scenes of *The*

Cameraman a sardonic emblem of Keaton's problems with MGM. Prior to the swimming pool scene, Buster changes into his bathing costume in a tiny cubicle which is claimed, a moment after Buster enters it, by a husky man who stubbornly refuses to leave. So Buster and the man change together in the closet-like space, becoming entangled in one another's underwear, suspenders, trousers, and limbs. It is a wonderfully comic image of harassment and claustrophobia (and, by the way, one of the very few scenes in which Buster's face expresses outright anger) and it is perhaps merely a nice coincidence that the man who plays the stubborn intruder—and who later went on to become a character actor—was the unit manager on the film. Yet the overall plot seems to have a personal inflection that is less immediate and happier. Keaton himself suggested the idea for the story, which, with its own triumphant conclusion for the film-maker, is a transparent image of Keaton's own success during the twenties. Even the winning of the girl, obligatory as it is, finds its parallel in Keaton's own life, for hadn't Buster met his wife, Natalie Talmadge, on the movie set of his first film, Roscoe Arbuckle's *The Butcher Boy*? Needless to say, *The Cameraman*—with its heavenly victory—stops where angels fear to tread: Buster's own marriage did not, as we know, continue happily ever after.

But Keaton was also aware of how his own life could imitate art, as when he reflected on how miserable was his performance in confronting Nicholas Schenk, when the latter pressured him into breaking up his own company and signing with MGM: "I was flustered. It was all too much like my own scripts" (Blesh 299). Given the context it is understandable that Keaton should characterize his films in this way. What is less easy to understand is the tendency of many commentators to think of Buster as the personification of failure—forgetting the metamorphosis of the self that is in every feature. Thus Arthur Knight: "Keaton was . . . a poignant automa-ton caught up in a world that was beyond his understanding" (121). And Rudi Blesh takes as his epigraph Paul Gallico's epitome of Keaton as "Frustration's Mime, pursued, put-upon, persecuted by humans as well as objects suddenly possessed of a malevolent life and will of their own." Perhaps this tendency so to characterize the Keaton persona merely points to the familiarity of failure, and confirms by implication the fantastic, unbelievable quality that attaches to the metamorphosis of the self. Though it must be said as well that in some of the features the final moments, following the magical transformation, return Buster to his everyday self and constitute, in varying degrees, a comic anticlimax. Such is the case in *Sherlock Junior*, as I have noted; it is also true at the end of *The Navigator*,

when, however, the imminently drowning couple are suddenly rescued by a surfacing submarine—a deus ex aqua, as it were. And it is most startlingly true of the brief epilogue that is attached to the triumphant ending of *College*, when, in the space of seconds, the happily married couple pass through family life and old age, ending up in adjacent graves! Art is short and Life is long.

Yet there is, to return to *The Cameraman*, a moment early in the film that is both short and long, brief but quintessentially self-defining. It occurs when Buster is in the offices of the newsreel company for the first time and encounters The Movie Camera. He examines the object curiously and with an instinctive interest that must have marked Keaton's own first exposure to the machinery and processes of filmmaking in Arbuckle's studio ten years before. Examining the camera now, in *The Cameraman*, as if for the first time, Buster catches his finger on something, then opens the side—and puts his head inside, as far as he can, while turning the crank on the outside.

That is the whole story of course, the key to Keaton's work as a filmmaker: put the eye *inside* the camera, exploit as fully as possible the illusion of reality that can be created by assuming the point of view and virtues of the moving-picture machine.

In *Sherlock Junior* and *The Cameraman*, the movies had provided Keaton with both medium and metaphor for his exploration of the special nature of his own art, his own life. They stand today as masterpieces of the silent screen—complexly self-conscious, deeply funny dreams of the self's metamorphosis; yet Keaton's mirror was at once self-reflecting and a mirror for the masses, clear and otherworldly, encompassing in a single comic figure images of extravagant failure and extravagant success. In *Sherlock Junior* and *The Cameraman* that mirror seems almost to look at itself.

3

Lewis Hine and the Art of the Commonplace

The attention Hine has received in the last fifteen years has demonstrated unequivocally the central place he holds in the history of reform photography.[1] The major figure after Riis, Hine serves as a link to the great FSA photographers of the thirties, who knew his work and followed his example, however different the circumstances of their own production. Lacking a Roy Stryker to shape his own production, Hine was able to develop in the first decades of the century a range of practice and a sophistication about the uses of texts and images that have captured much critical attention. For Alan Trachtenberg, for example, whose distinguished essay on Hine in the Brooklyn Museum exhibition catalogue (1977) marks a turning point in our contemporary interest in the photographer, Hine is above all the discloser of a social reality that had been hidden from view: "The naming of the guilty is precisely the work of Lewis Hine in his child labor pictures, and the caption is central to his endeavor, to his *art*" (133). For Maren Stange, who analyzes the way Hine's pictures sometimes support and sometimes act against the text, "the essential meaning and importance of his achievement may be in the clarification of reform ideology and process it offers because it partly denies and opposes them even in the act of confirming and publicizing them" (66).

The historicizing of Hine has added a welcome dimension to our under-

standing of his importance. But in focussing so intently on the historical Hine, we've come to take for granted, at times to overlook, and even deny, the aesthetic innovation that was integral to his social and cultural achievement. Thus, for example, John Tagg, who admirably illuminates the photographs within the continuum of ideology, argues that Hine had to "shed the pictorialism he learnt with his early photography in order to command a new rhetoric in keeping with the obdurate, intransigent nature of the problems he wished to picture" (196). More typically, however, Hine's early pictorialism is simply ignored as a source of his art, as Hine comes to represent the relatively naive, straightforward camera worker, a tradition that dates perhaps from Elizabeth McCausland's 1938 "Portrait of a Photographer," a "rediscovery" of Hine published in *Survey Graphic* that sought to bring him out of the sorry neglect he had been suffering during the Depression. In contrast to the more conscious integration of social and aesthetic elements that McCausland claims for the thirties photographer, Hine is portrayed, patronizingly, as a sincere and energetic, but technically unsophisticated man with a camera and a purpose: "When he became school photographer in 1905, he didn't know anything about cameras, lenses, techniques. Even today, at sixty-four, he will say with a naivete both lovable and sad, 'How is it that you make so much better prints than I do? Is it because your enlarger is better than mine?'"[2] Though Hine's artistry is always acknowledged to some degree, there lingers still, in our contemporary consideration of him, the remnants of McCausland's view of Hine as aesthetically ingenuous; and not surprisingly he has served more than once as a foil to the aesthetically self-conscious Stieglitz. The two are thus made to represent, for the early twentieth century, the two putative polar aspects of documentary and aesthetic photography.

But this opposition, as natural as it may seem at first, misrepresents the degree to which Hine was himself consciously and deliberately working out of an aesthetic fashioned partly out of pictorialism and partly out of nineteenth century literary realism. And if it seems logical, even inevitable for us now to contrast Stieglitz and Hine, it was not always so: on the contrary, an appreciation of Hine published in 1920 in the popular *Literary Digest* opens with a parallel between the aesthetic Stieglitz ("one of the leaders in the new photography") and Hine, offering the former's photograph of a railroad yard, *The Hand of Man,* as a demonstration of a Whistlerian treatment of an ostensibly unpromising subject. Hine "achieves some of the same results, tho he makes a more modest claim than the 'art photographer'[sic]." And the article goes on to observe (quoting a review

of a recent Hine show), how Hine's prints of various trades "stand out from the occasional print, a triumph in spacing, lighting, and always in significant expression" (Hine "Treating Labor" 32).

Hine's purposes always were, admittedly, far distant from Stieglitz's—his own photographs of railroad yards were more purely descriptive rather than metaphorical—but his artistic resources have been as a consequence underestimated. And he himself may have contributed to this habit by refusing the label of "art photographer" as assiduously as he refused that of "commercial photographer." Hine's own preferred term, "interpretive photographer," has never really caught on in descriptions of his work, yet it was there from the beginning of his career and was an attempt to define, even at the start, the peculiar synthesis of aesthetic and social purposes that he was aiming at.[3] One of the earliest uses of the term occurs in an article Hine wrote for *The Photographic Times* in 1906, called "The Silhouette in Photography." Having himself taken up photography only two or three years before, Hine addresses the beginning photographer, the "novice," from an assured position: "A good photograph is not a mere reproduction of an object or group of objects—it is an *interpretation* of Nature, a reproduction of impressions made upon the photographer which he desires to repeat to others" [emphasis added]. Though less mystical in phrasing, Hine is not far from Stieglitz's notion of the photograph as an "equivalent" of some inner emotional state. Stressing the importance of arranging "lines and masses of light and shadow," Hine speaks of the "artistic photograph" as the photographer's ultimate goal ("Silhouette" 488-499). Elsewhere, during the same early years, Hine emphasized the importance of studying existing models in Western art—"photographs and paintings"—in order to derive aesthetic principles for photography, thus sustaining the pictorialist effort to view photography as continuous with the fine arts, "for in the last analysis, good photography is a question of art" ("Photography in the School" 230). A number of negatives in the Eastman House Collection show Hine experimenting with various traditional pictorialist subjects—bucolic farm scenes, pastoral landscapes; they also reveal the pains he could take, later on in his career, when he would shoot a variety of images of a single subject or setting before the now well-known image would emerge.[4]

Hine reflected on his own aesthetic practice in an address he delivered in 1909, at the height of his early period, before the National Conference of Charities and Corrections. Here, Hine defines for photography a practical aesthetic with two new major components: the first is that a picture can be more effective than the reality would have been, that through its selection

and emphasis and its exclusion of the irrelevant, photography could powerfully simplify vision and lend it semantic force. It is this aspect of illustration that makes the picture a "symbol that brings one immediately into close touch with reality" (111). The other main component of Hine's early aesthetic, joining the adaptation of pictorialist principles of composition, is the emphasis on the art of the commonplace, a tenet of late nineteenth century literary and visual realism that Hine borrows explicitly from George Eliot. Hine concludes his address to the Conference by citing a long passage from *Adam Bede:*

> Paint us an angel, if you can, with floating violet robe and a face paled by the celestial light; paint us a Madonna turning her mild face upward, and opening her arms to welcome the divine glory, but do not impose on us any esthetic rules which shall banish from the reign of art those old women with work-worn hands scraping carrots, those heavy clowns taking holiday in a dingy pothouse, those rounded backs and weather-beaten faces that have bent over the spade and done the rough work of the world, those homes with their tin pans, their brown pitchers, their rough curs and their clusters of onions.

"Therefore," Hine's Eliot concludes, "let us always have men ready to give the loving pains of life to the faithful representing of commonplace things" (113). If this passage was not already in Hine's mind for several years, it was a perfect one for him now to invoke as a summary of his working principles. And in fact he had already used the type of the Madonna in his own photographs of immigrants and the urban poor as a way of adding aesthetic—and therefore social—legitimacy to the depiction of the underclass.

In an article on "Photography in the School" (1908), Hine had printed a photograph of a mother with two children, with the caption, *A Tenement Madonna. A Study in Composition*, and he identifies his model here as Raphael's *Madonna of the Chair*: "In every way possible," Hine writes, "the beautiful and picturesque in the commonplace are brought out" (231). Hine's treatment is too studied, in fact, too deliberately modeled on the original, and includes a round format. A somewhat more natural pose—child sitting in mother's (or grandmother's) lap, hands to face, gazing at the camera—is printed as an illustration to Miriam Finn Scott's "At the Bottom," and here again Hine uses a round format and vignettes his subjects in order to isolate them aesthetically. Still more effective is the image Elizabeth McCausland prints as an illustration to her encyclopedia article on Hine in *The Complete Photographer*.[5] Entitled, *Ellis Island*

Ellis Island Madonna. From *The Complete Photographer* 6 (1942): 1980.

Madonna the image pictures a mother and child, huddled in their native costumes, but here it is the background—eliminated from the previous images in the name of a "higher art," one presumes—that makes the picture work: the two are pictured against a wire mesh fence, with the faces of other immigrants, on the other side of the barrier, blankly staring across the space (McCausland "Lewis W. Hine" 1980). In all of these images, the Madonna obviously functions as an art symbol; its original import—as a religious representation that spiritually legitimated and ennobled the lowly—had long before Eliot been washed away. Hine's effort is therefore to reinvigorate the original source, to renew the energy of the type.

Yet the Madonna images seem finally rooted in an art-historical vocabulary which is at odds with Hine's deepest originality. The portraits that are most effective in Hine's early work are the worker-portraits that, standing behind the work of Strand and Evans, endow their commonplace subjects with a dignity not in terms of an art historical tradition, but in terms of a new vocabulary of representation that erased the existing ethnographic and documentary traditions of portraiture and established a new procedure for representing working class character. Rejecting the existing model offered by Jacob Riis's urban studies—in which the subject is presented as a pathetically dazed and all but moribund victim of the horrific environment surrounding him or her; and rejecting too the condescendingly "picturesque" portrayal of urban types in a humorous and self-caricaturing studio pose—as in the work of Sigmund Krausz of Chicago (Hales 226-229)—Hine sought a portraiture that amalgamated elements from two more positive approaches available in the early 1900s.

At one extreme was the ethnographic portrait, which represented a subject from an exotic culture by portraying, usually, a full-standing figure in native dress, posed within a seemingly indigenous setting, surrounded by native implements, flora and fauna, architectural details. In such examples, often featuring young females striking modestly sexual poses, the title might be—as in George F. Paul's "With a Camera in Mexico"—"Cordoba Type" or "Yucatan Type" or "Pachuca Type." (Edward Curtis's series of North American Indians, though more varied and imaginative, would fall into this genre.) Here, the individuality of the subject is submerged within the "type" he or she represents. At the other extreme stands the commissioned studio portrait, in which the subject's individuality is emphasized against an often neutral background. Any hint of sexuality is eradicated from the subject's pose, unless it lingers in the symbolism of a held bouquet of flowers or some other innocuous accoutrement. Instead,

the photographer attempts to capture the specific individuality of the subject through a summary pose that represents an idealized characterization.

Amalgamating both of these extremes, Hine established a model for representing the Other that was both aesthetically and politically unprecedented, for it treated the socially "inferior" worker with the respect usually accorded the subject of a commissioned portrait. Two major series, taken during the first decade of Hine's practice, are noteworthy here: the Ellis Island portraits, and the portraits of industrial workers.

The Ellis Island series, taken from 1904 through 1909, was begun initially while Hine was at the Ethical Culture School, many of whose pupils were from Jewish immigrant backgrounds, as an effort to instill a respect for contemporary immigrants. In these images, the bureaucratic environment of the immigration center is often visible along with the baskets, valises, boxes, and bundles that the immigrants are carrying with them into America; but Hine's subjects are portrayed with a serious demeanor and have an air of confident self-possession that is all the more striking given the state of dispossession they are dealing with.[6] The most famous of these portraits, *Young Russian Jewess at Ellis Island, 1905*, portrays a standing figure, without any encumbering baggage, and consequently possessing even more dignity and less immediate concern than some other subjects; the calm of her face as it catches the full light, arrests our attention, and especially her striking eyes; meanwhile, her dark clothing, made in the old country, is at odds with the vague but discernibly institutional background. Looking slightly off center, her frontal pose emphasizes the open and trusting look that Hine presents. To appreciate how radical Hine's aesthetic treatment was at this time, compare the dehumanizing rhetoric of his contemporary, Henry James, who was likewise fascinated by the immigrant faces of the Lower East Side, though the "swarming" masses appeared to his vexed taste as something ridiculous, something comical, as if he were "at the bottom of some vast sallow aquarium in which innumerable fish, of over-developed proboscis, were to bump together, for ever, amid heaped spoils of the sea" (131). Hine seemed incapable of that condescension, let alone ridicule.

A similar strategy is evident in Hine's series of industrial portraits, again featuring immigrants. Hine took many such photographs as illustrations for a variety of sociological texts, but occasionally, as in a piece that appeared in *Charities and the Commons* as "Immigrant Types in the Steel District," a series of portraits might appear without text. Hine's subjects are presented explicitly as types—"Croatian," "Lithuanian," "Italian," "Russian," etc.—but the pictorial treatment emphasizes the individual

Young Russian Jewess at Ellis Island, 1905. Courtesy George Eastman House.

personality of the worker. Taken close-up (chest and head) and with a solid background, these images preserve an ethnic character at the same time that they offer us faces at specific psychological moments—smiling, cautious, proud, indifferent. Just how unique Hine's treatment was at this time can be seen by comparing his own photographs to the implicit attitudes of texts published in the same progressive journal. Thus, an article following the "Immigrant Types" and containing illustrations by Joseph Stella, aims to "present the immigrant Slavs as they have not yet been generally seen— as human beings even if crude, with some virtues along with their widely recognized vices . . . " Though evidently trying to be positive, the writer's common prejudice intrudes in the characterization in a way that is not the case in Hine (Koukol 589). When paired explicitly with a text, Hine's photographs of workers sometimes sustain an uneasy alliance, as when they illustrate an article on "Wage Earners of Pittsburgh," in which the text by John R. Commons, appraising the struggle between capital and labor in one of America's most productive industrial centers, addresses the problem of unskilled workers with sympathetic concern yet in terms not always flattering to Hine's subjects: "Two-thirds of the steel workers are unskilled, and thousands are as dumb as horses in their ignorance of English, if we may judge by the kind of 'gee,' 'whoa,' and gestures that suffice for commands" (1054-55). Against this dehumanizing rhetoric, Hine's portraits—for example, *A Pittsburgh Miner*—show us proud and self-possessed workers, pictured as individual studies against a plain background. The grit and grime, the accoutrements of the job, are all visible, yet the expression allows the subject a dignity that transcends the common prejudice.

If Hine was thus developing, in the first decade of his practice, a visual rhetoric that could endow workers and immigrants with the dignity and individuality usually reserved for subjects of commissioned portraits, he was evolving as well at this time a negative rhetoric, whose function was to depict the cruelties of child labor. Here the representation of background —whether the endless rows of bobbins in the cotton mills, or the darkly sulfurous atmosphere of the coal mines, or the hot tubular nightmare of the glass factory—is a crucial element in the photograph, and Hine's art is to present information dramatically, clearly, and with simple undeniability. The close-up portraits of this type show us faces old before their time, made stupid by repetition, unhealthily disfigured, pathetically deprived of the normal pleasures of childhood, pleasures that Hine had, incidentally, earlier depicted in his various articles on the uses of the camera in schools.[7] These industrial images—deliberately designed to shock us—

A Pittsburgh Miner. From "Wage Earners of Pittsburgh," by John R. Commons, *Charities and the Commons* 21 (1909): 1053.

rise at times to a kind of negative sublime bordering on the grotesque, as in the collective portrait, *Breaker Boys in Coal Chute, South Pittston, Pennsylvania, January, 1911*, in which the individualized expressions on the shining, blackened faces of the youths, a few of them smiling, lend an eerie light to the otherwise coal-dark scene picturing what appear to be denizens of another world.

In the photographs discussed thus far, Hine's rhetoric serves a generally clear political purpose—to humanize an immigrant population or to present certain working conditions as themselves dehumanizing. In yet another grouping of images a different purpose and a different aesthetic are visible. If the portraits and work-site pictures, taken often in poorly lit interiors using flash illumination, have an inevitably posed, at times static quality, these other pictures feature a quite different, dynamic quality. Taken in the open air, they capture the movement of the subject, caught in dynamic gesture that sums up the purpose and passion of the moment. And often Hine uses the space around the subject as a significant visual context, drawing our eye to the central human figure and away from it to the abstract play of lines and planes surrounding it. (Here, Hine anticipates some of the best street photography of later decades—Aaron Siskind and Helen Levitt, Robert Frank and Garry Winogrand [Kaplan 9].) Take, for example, the often reproduced *Italian Immigrant, East Side, New York City, 1910*, showing a full-figured woman walking in mid-stride, carrying a pile of clothing to or from a piece-work business establishment. Another woman, on the right, is likewise carrying a basket on her head. A sign stands out on the right, advertising fruit, candies, etc., above it another telephone sign. Hine took a number of photographs in the streets of such figures, carrying goods on their heads, but none in which the figure is given so much space and occupies it so confidently. Moreover, the timing of the image is such that a street lamppost appears to rise directly behind the figure, appearing as a vertical line exactly in line with the vertical of her body as she strides. In the background, slightly out of focus, is a line of tenement buildings, as the woman appears to be rounding a corner and is taken in the open space of the corner. (Hine evidently loved corners and often uses the contrasting planes of space—near and far—as a setting for his street pictures.)

Hine was alert as well to the fortuitous incongruity that would present the fortunes of life in a passing moment: *Dannie Mercurio, Washington, D.C., 1912* is one example, with its contrasting figures of genteel lady, pictured in buxom profile at the moment of her awareness of the camera, while a few feet away the newsboy, papers in hand, comes toward us. The

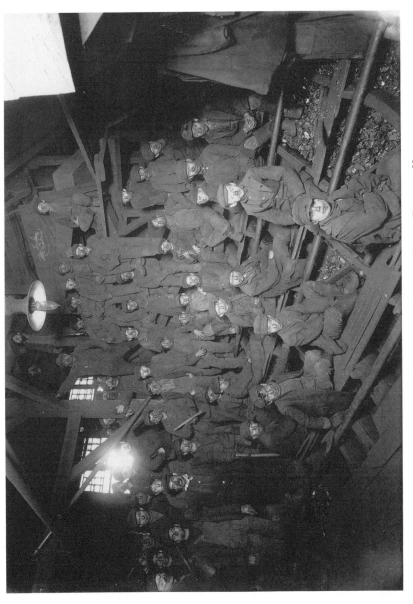

Breaker Boys in Coal Chute, Pennsylvania, January 1911. Courtesy George Eastman House.

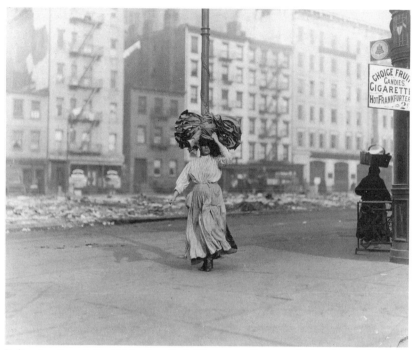

Italian Immigrant, East Side, New York City, 1910. Courtesy George Eastman House.

lines of the sidewalk and the street form a graph-like setting for this display of social disparities. Hine took many photographs of newsboys, most often during the night shift, in order to illustrate the moral and physical dangers of such child labor; their culture of camaraderie and their often brazen personalities evidently fascinated him. In this day-time photograph, Hine was able to capture the difference in social status as a difference in physical vectors, as the two figures move away from one another, one out of the frame, the other toward the viewer.

Hine is properly associated with images that depict the horrors of child labor during the early decades of the century, yet he created some striking images of children at play in urban areas that carry an equal conviction, complementary to the former, about the values of space and fresh air and sunlight. One remarkable example, *Playground, Boston, c. 1909,* shows a group of children playing happily on a playground structure—swings, balance ladders, bars—set in the middle of an open field, with a clear horizon behind it. The playground equipment—verticals, horizontals, diagonals— forms a kind of abstract play of lines, amidst which the children, pausing momentarily to acknowledge the camera, are pictured. In many such ex-

amples, Hine's eye for the way figures arranged themselves in space would result in pictures that would dramatize the unself-conscious motions of daily life and give them a significance beyond the moment. Thus elevating the commonplace incidents of everyday life into the realm of symbolic representation, Hine fused his early pictorialist sensibility with the democratizing impulse of nineteenth century realism, and in doing so lay the foundations for the great documentary and street photography of the mid-twentieth century.

Our understanding of Hine must include not only an appreciation of individual pictures and the aesthetic space they opened up in the field of documentary photography, but also an awareness of the larger visual units that Hine was composing in his photographic work, a subject beyond the scope of the present essay. Yet it's clear, especially in the many pieces where Hine's own designing hand may be perceived, that the overall layout of the page was a matter for constant experimentation, allowing Hine's innovative practical aesthetic a full field of play. Hine's "Time Exposures" have been amply commented on, but his other ways of arranging picture and text have yet to be fully explored—the photograph as testamentary evidence for a textual claim; the photograph as independent

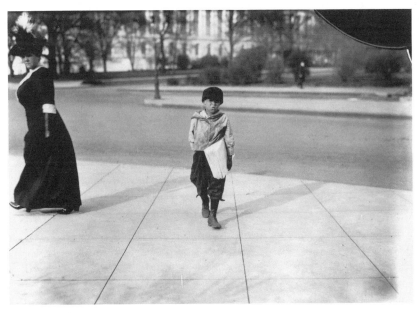

Dannie Mercurio, A 'Newsie, Washington DC. Courtesy George Eastman House.

Lewis Hine **55**

aesthetic presence; images used as illustrative pictures for a running story told in the captions, and other innovative practices that anticipate the editorial layouts of a later photojournalism (Kaplan 9). In any case, the clarification of Hine's ideological matrix should not dull our appreciation of an artist whose political effectiveness derived precisely from his carrying into the reform movement an aesthetic sensibility that remained fully active while it deepened and developed the art of the commonplace.

4

Don't Think of It as Art

The Legacy of *Let Us Now Praise Famous Men*

Has this fate befallen Agee and Evans? Has *Let Us Now Praise Famous Men*, at last, become famous? Were they alive to witness their present celebrated status, the authors would, I imagine, have mixed feelings, for they were anything but reverent toward the institutions that typically, in our society, seek to conserve the values embodied in great works of art. Even to call *Famous Men* a great work of art makes one nervous, given Agee's warning:

> Above all else: in God's name don't think of it as Art.
> Every fury on earth has been absorbed in time, as art, or as religion, or as authority in one form or another. . . . Official acceptance is the one unmistakable symptom that salvation is beaten (15).

Thus, as he elsewhere puts it, "Kafka is a fad; Blake is in the Modern Library; Freud is a Modern Library Giant" (14).

Given such suspicion of canonization, we might say that at least in its early reception *Let Us Now Praise Famous Men* met its just dessert: it was ignored, unsold, unread. Following initial reviews that were at times irritated with the self-indulgent Agee, at other times respectful of his genius, it disappeared from public consciousness. But with the republication of the book in 1960—following Agee's Pulitzer Prize for *A Death in the Family*—*Famous Men* acquired a following for a new generation of

readers—many of them young activists intent on changing society—for whom it seemed to speak of the moral and social complexities of the time. As John Hersey reports in the introduction to the latest edition of the book, a number of student workers in the civil rights movement of the sixties, coming to the South from outside the region to help with voter registration, had brought Agee along—attracted, as Hersey puts it, to Agee's "irony and idealism and guilt" (xxxvi).

But the legacy of *Famous Men* to those who would improve society is, we must admit, an ambiguous one. On the one hand Agee affirmed, in many ways, that "murder is being done, against nearly every individual in the planet," and that there is "cure, even now available, if only it were available, in science and in the fear and joy of God." This passage concludes with Agee's disgust at his inability to blow out the brains of the reader who takes the whole subject too lightly (307)—hardly rhetoric calculated to win friends and influence people. And what exactly would Agee have us *do*? After all, the author affirms a few pages later that "'adjustment' to a sick and insane environment is of itself not 'health' but sickness and insanity" (310). And throughout the book Agee argues not how impoverished are the lives of the tenant farmers but how rich they are, how filled with a kind of divinity that is in so many ways superior to his own over-educated self, which, for all its "advantages," is compromised in a thousand ways.

What then does it mean to change such lives for the better?

This is of course one of the central paradoxes of *Let Us Now Praise Famous Men*: The very premise of "reform"—that we the reformer are better, have something to offer, to those who are therefore in need of our help—is utterly undermined. One might more naturally think such a book leads to a program of mea culpas, to paralysis, to, at best, a joyful meditation, rather than to any kind of constructive action in the world. (Indeed, we may recall that the book ends with Agee and Evans falling asleep on the Gudgers' porch.) The importance of *Famous Men* politically has to do, I think, not with any practical urge to improve the lives of its subjects, but rather with the clarity with which it raises the fundamental problem of all social action: the relationship between the "reformer" and the "beneficiary" (both words within quotation marks).

Agee and Evans had come to Alabama as outsiders, and in a sense the social worker, the documentary writer and photographer, from whatever place, even the same place as his subject, is always an outsider. And the problem they addressed in *Famous Men* is at the core of efforts by all outsiders to come to know, let alone to change, the lives of their subjects—

by what right do we do so? For Agee and Evans, there was, finally, no right, and their book is at least partially a confession of guilt as well as failure. But if we presume a right, by virtue of our conviction that some things—like good health, the right to vote—are simply absolute goods, then how can we effect our goal of helping others with caution (for our best intentions are no guarantees of successful outcomes) and with respect (for we are dealing with people's lives, self-esteem, whole personalities). Even "good health" is fraught with problems of interpretation, let alone good housing, good education. We can see how much of a quandary liberal philosophy is in, if we take Agee and Evans literally, for how easily can the complexities of helping others, as Agee defines them, yield to the seemingly higher moral ground of respecting who they already are, and consequently of doing nothing, of letting every man, woman and child, sink or swim by their own devices in our shark-infested waters.

If the book's legacy to the social movement is thus ambiguous, its legacy to the documentary movement is no less so, for it poses again and again questions that would undermine its own existence: by what right, with what purpose, do we even observe others less fortunate than we are (even assuming for a moment that they are less fortunate). What indeed is the purpose of documentary?

However much documentary has sought to expose conditions of deprivation to an audience that lives, essentially, outside of the problem, the documentary has also provided a kind of entertainment, the titillation of revealing sights previously unseen, and always of course at a safe distance. There may even be something vaguely pornographic in documentary, a fascination with those whose morals are considered more lewd than ours, whose sexualities are more primitive.

Agee and Evans were certainly not immune to this tendency; indeed, they seem at times to carry it to its painfully minute extreme. Agee renders for us not simply the "lives" of his subjects—lives in abstract, that is; he renders the smells of their kitchens and bedrooms, the grime on their tables, the odors of their clothing, which he has inspected at close range. ("It's not going to be easy to look into their eyes," he says after one of his inspections.) But does the fact that he exhibits such guilt at these revelations grant him immunity from being simply a spy on our behalf? Documentary art is a cruel master, but we all serve him and gladly. And surely Evans served him as assiduously as Agee, taking the occasion, while his human subjects were working in the fields, to organize the objects in their rooms, creating still life arrangements that enforce an image of beauty and

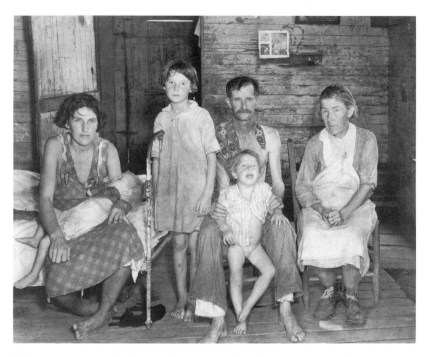

Walker Evans: *Bud Fields and His Family, Hale County, Alabama, Summer 1936.*
Courtesy Library of Congress.

stillness and order in the lives of the occupants, an image that derives as
much from Evans' world as from theirs (Curtis).

Yet for all that, there is a virtue in *Let Us Now Praise Famous Men* that
is found in no other book of its time and that places it in a unique position
with respect to the documentary movement that follows it. The documen-
tary works of the thirties—most notably Dorothea Lange and Paul Schus-
ter Taylor's *An American Exodus* (1939) and Margaret Bourke-White and
Erskine Caldwell's *You Have Seen Their Faces* (1937)—had not ques-
tioned the legitimacy of their good intentions or their techniques. Bourke-
White's photographic style—rapacious and intrusive—made caricatures
of her subjects, while Caldwell's captions turned them into rural types
from his own works of fiction; Lange and Taylor were far more scrupulous
in their documentation of pictures and sources and in their textual juxta-
positions, but they too had so controlled the production that their subjects
become inevitably instruments of their creators' purposes. By contrast,
Evans and Agee brought to their work a level of moral sophistication that
essentially changed the nature of documentary—or should have—forever:

Walker Evans: *Washroom and Dining Area of Floyd Burroughs' Home, Hale County, Alabama, Summer 1936.* Courtesy Library of Congress.

Walker Evans: *Lucille Burroughs, Hale Country, Alabama, Summer 1936.* Courtesy Library of Congress.

whatever else he may have been guilty of, Agee evinced a respect for his subject that was paramount. Whatever else he may have done in picturing their surroundings, Evans' portraits of the tenant farmers gave them to us with a dignity that was no subtraction of their humanity; these images allowed the farmers to confront the viewer as they were confronting Evans and his camera, on the level of equality, not of subjection. We know that Evans took many photographs of his subjects that did, we might say, victimize them in one way or another; but the virtue of his collaboration with Agee is that the selection of prints for *Famous Men* (in their various stages) supported Agee's attitude (Evans).

In fact, Agee and Evans' collaboration marks a turning point in the history of documentary, from work that automatically assumes a superiority toward its unfortunate, impoverished subject, to work that, on the contrary, seeks to understand, to appreciate, even to praise and celebrate, its subject. Agee and Evans did something on the formal level which was also a new thing in documentary form: they separated the texts from the photographs. The intention here was to grant a kind of equality to both components of the book, to break the domination of one over the other and thereby to allow both to exhibit their full complexity. And they went even farther than they might have, in offering no captions whatsoever for the

Walker Evans: *Fireplace and Objects in a Bedroom of Floyd Burroughs' Home, Hale County, Alabama, Summer 1936.* Courtesy Library of Congress.

photographs, with the effect being that one is forced to look at the images with a kind of purely visual intensity, devoid of the supporting crutch of text or caption. Or that, at least, might be the desired effect. What happens in actuality is in a way even more interesting: first one studies the images, then one reads the text; but while reading Agee's descriptions of the built environment of the tenant farmers—their rooms, clothing, walls,

Wright Morris: *Bedroom with Portrait, Home Place*, plate 18 from *Wright Morris Photographs & Words*, The Friends of Photography/Matrix, 1982. Courtesy of the photographer.

decorations—we are sent back to the photographs with a changed consciousness of what we are looking at. The end result, in short, is that the text and images are indeed interactive in *Famous Men* but not in the easy way that obtains in most photo-documentary texts, in which the arrangement dictates an order of perception.

The presentation of photographs without any captions remains an unusual documentary practice today, but even more unusual is the deliberate structuring of images to compose a self-contained photographic narrative, as is the case in *Famous Men*, where the three sections dealing with each of the three families form a kind of parallel, followed by a section that places their lives in a larger geographical and cultural perspective. Yet in other ways, the Evans of *Famous Men* (I mean to distinguish his work for this volume from his other work, which can be quite different) has clearly been a deep inspiration to many photographers: some, like Wright Morris, have explored Evans' descriptive mode by meticulously recording the vernacular still life; his *Bedroom with Portrait, Home Place, 1947,* organizes the textures of wallpaper and floor covering within a severe rectilinear geometry, while juxtaposing the child's portrait of an earlier generation with the clothing dropped casually on the chair in front of it. Others, like William Christenberry, have taken the relatively austere physical facts of Alabama that we find in Evans, and transformed them, through the richness of color, into a cherished landscape; Christenberry's *Church, Sprott, Alabama, 1971,* clarifies the symmetry and white simplicity of the building while placing it within the contrasting context of a surrounding dark forest and a fanciful shadow, off to one side. Still others, like Alex Harris in *La Loma New Mexico, October 1972*, evoke—as did Evans—the memories and associa-

William Christenberry: *Church, Sprott, Alabama, 1971*. Kodak Type C print: original in color. Courtesy of the photographer.

The Legacy of *Let Us Now Praise Famous Men* **65**

tions embedded in photographic memorabilia, calendars, and religious icons, while employing an artful juxtaposition of the living reflection of the woman in the mirror against the frozen "mirrors" of photographic reproduction. Meanwhile, Chauncey Hare (in his 1978 volume, *Interior America*), has seemed to model himself on Evans' direct meeting with his subjects, though in Hare's case his ironic use of the individual's surrounding environment has often been at the latter's expense.

Agee's collage-like text—composed of quotations, lists, meditation, description, prayer, prose-poetry, analysis, dialogue, question and answer—has offered a precedent that few, wisely, have chosen to follow. But in other ways, one might point to his prose as a model for a newly self-conscious mode of non-fiction writing, sometimes called the new journalism, that seeks to render persons and scenes with an intensity more usually found in fiction. Some of the most deeply affecting passages of *Famous Men* are surely those in which Agee reports his initial engagements with the three farmers he will come to know so well or with the black Southern Americans of whom he asks directions and from whom, he recognizes, he will be forever separated by social barriers that are agonizingly impenetrable. Some of that lucid and complex observation of moral behavior will be

Alex Harris: *La Loma New Mexico, October 1972.* Gelatine silver. Courtesy of the photographer.

captured after Agee, in different ways, by social observers like Joan Didion and Norman Mailer, who will also richly detail the confrontation of consciousness across social gaps.

Yet in other ways, *Let Us Now Praise Famous Men*, though entirely one of a kind, has provided a model whose spirit of inventiveness at least can be emulated. For surely one pays homage to such a book not only by following its mode or manner or subject matter, but by producing something that seeks to invent in the same spirit that Agee and Evans did. Two opposite extremes might be cited here: Susan Meiselas' *Nicaragua* (1981) occupies one extreme, in which the powerful photographs are presented without captions in the first half of the book, while part two comprises a collage of quotes from real, identified persons involved in the Nicaraguan revolution, accompanied by captions to the photographs, which are reprinted as running margins, followed by a final chronology. In her documentary, the author is, we might say, everywhere present by virtue of the arrangement of materials, but nowhere visible. Just the opposite is the case with Danny Lyon, who offers us a much more subjective, much more interpretative photographic record of his subjects—whether bike riders, prisoners, or the urban dispossessed—and who integrates the visual imagery into a first person narrative that often borders on fiction (*Bikeriders*; *Destruction of Lower Manhattan*; *Conversations with the Dead*). These two approaches to documentary—extreme objectivity, extreme subjectivity—are opposite responses to the problem of how to construct meaningful records of experience outside ourselves, and in a way they flow from the example of Agee and Evans, which contained within itself both extremes together —a maximum of strictly objective description and quotation; and a maximum of intensely subjective, first-person narrative.

Agee's use of the first person, often including an account of how and why he has chosen to present his materials in the particular way he does, was part of a deliberate effort to construct what he thought of as a new kind of narrative, one that embraced the seemingly contrary purposes of art and of science. For Agee the representation of the other must, necessarily, incorporate the perceiving self, for, as he put it, "I know [Gudger] only so far as I know him, and only in those terms in which I know him; and all of that depends as fully on who I am as on who he is" (239). This move to incorporate the observer into the report of the thing observed derives in part from the new understanding of scientific method that Heisenberg had brought about earlier in the century, and it is a mode of narrative that had already begun to influence the arts—witness Dziga Vertov's films in the twenties, Andre Gide's reflexive narratives, the poetry of Wallace Stevens

and the fragmented structures of Faulkner; but Agee was virtually alone in bringing this kind of consciousness into documentary, which was presumed to be a relatively "straightforward" account of things. His genius was precisely to have made complex, immensely complex, the whole enterprise of giving an account of things, and by so doing to make obvious how simplified, how simplistic, all previous documentary efforts were by their exclusion of, among other things, the affective presence of the observer.

This notion, that we can no longer assume the observer to be a simple mirror of reality, is one of the fundamental insights in contemporary anthropology, which insists that the ethnographic record is unavoidably at least partly fiction. Thus, Jay Ruby and Barbara Myerhoff, among others, insist that the observer must in some way make allowance for his or her own presence in the record by knowingly framing the record. The foundation for such reflexive ethnography was *Let Us Now Praise Famous Men*, whose republication in the sixties coincided with a surge of reflexivity not only in anthropology, but in all of the arts, from François Truffaut to John Cage to Andy Warhol.

But the effort to avoid converting the subject into an instrumentality of the documentarian's vision has also, in the years since Agee and Evans, taken forms quite different from *Let Us Now Praise Famous Men*. Agee's text gave us some sense of how his subjects spoke and thought, but most of the conclusions were circumstantial and inferential: "There will be no time in this volume to tell of personalities," he declares at one point in talking about little Pearl's fondness for clothes (280). By contrast, several other documentarians, after Agee, have given us, at the other extreme, a good deal of the personalities of their subjects. I am thinking of the extraordinary renditions of the lives and voices of their subjects by Oscar Lewis, Robert Coles, and Theodore Rosengarten. With the narrative skill of the novelist, yet all unobtrusive, these "observers" give life to persons whose lives would otherwise go unnoticed and unrecorded. To Agee, the representativeness of the subject was inherent in the material culture of their lives, which was rendered with minute exactness; to these others, the representativeness of the subject is rendered by giving the subject a voice, by acting as a kind of intermediary, a midwife of sorts, to the moral sentiments, life history, feelings of their subjects. In a way, the model for this kind of report is not Agee (though surely his deep respect for his subjects is exemplary) but Evans, who stood before his portraits in the attitude of one who was listening with the deepest of concentration and asking, simply: tell me who you are.

Robert Warshow, one of the sharpest of critics of popular culture during the years following World War II, reflected in 1947 on "The Legacy of the 30's," and his critique of that legacy is relevant to our own assessment of Agee and Evans, I think. "The most important effect of the intellectual life of the 30's and the culture that grew out of it," Warshow wrote, "has been to distort and eventually to destroy the emotional and moral content of experience, putting in its place a system of conventionalized 'responses'" (38). Warshow was concerned with the way mass culture substitutes formulas for the detachment of art, thus relieving us of the "necessity of experiencing one's life directly." Though Warshow doesn't concern himself with documentary, he might have, to the extent that the documentary forms of the thirties, too, often substituted aesthetic and political formulas for the more rigorous understanding of social reality.

Agee was himself so far from relying on such formulas that he seems to have wanted to virtually reinvent the English language in order to render the authenticity of experience. Yet *any* language would be a mediation of experience that Agee would much rather give us first hand. "If I could do it, I'd do no writing at all here. It would be photographs; the rest would be fragments of cloth, bits of cotton, lumps of earth, records of speech," and so on, he says in an oft-quoted passage early on in the book (13).

Agee raises here a point that—were we to take it seriously—would be a legacy to end all legacies: recognizing that photography and literature are relative liars, that our best strategies of representation are inescapably impoverished, we must, to follow this logic, cease and desist altogether from the documentary act. And this has indeed been an argument entertained by one of the strongest recent theorists and artists in the documentary mode, Martha Rosler. In her own anti-documentary dealing with the Bowery, she juxtaposes a series of words describing various shades of intoxication with a series of photographs depicting the physical space of the Bowery—lots of bottles, storefronts, broken glass, rubbish. But to avoid the objectification that results from depicting the human subject, Rosler rigorously excludes all persons from her imagery. And to drive the point home in absolute terms, she calls her work: *The Bowery in Two Inadequate Descriptive Systems (3 Works)*. For Rosler, documentary ought to give way to "the clearest analysis that can be brought," and she couples the 1981 printing of *The Bowery* with a long essay on the subject, called *In, Around, and Afterthoughts (On Documentary Photography)*.

The purity of Rosler's logic is attractive, but one wonders why analysis should be any less guilty of the compromises of mediation than documentary. Rather, I think, Rosler's critique makes even more clear, by indirec-

tion, how great was the achievement of Agee and Evans. Recognizing the inevitable failure of representation, they created, nevertheless, modes of representation that rendered their subjects with a freshness and inventiveness that can still astonish, fifty years after the book's publication. Taking rigorously and seriously the position of outsider, they managed to convert the fallibilities of the outsider's perspective into new strengths. And if, as Reynolds Price has recently reminded us, what the outsider sees is different from what the insider can possibly see, then these two ultimate outsiders, these "spies," as they called themselves, brought us—without any right to do so—a kind of knowledge that would otherwise have escaped us all, including their subjects (32-9). On such knowledge we begin to build an understanding of ourselves as well as of the cultural Other.

5

Weegee's Voyeurism and the Mastery of Urban Disorder

On the back of each photograph, he would stamp, "CREDIT PHOTO BY WEEGEE THE FAMOUS," as if by saying it often enough he would make the claim true. And somehow it worked: a news photographer by the name of Arthur Fellig, who specialized in murders and fires and who had previously thought of himself as Mr. Anonymous, managed to create a persona that, by the mid-forties, had come to stand for the very thing he depicted in his work—the disorder of the modern city, in all its violence and passion. And, simultaneously, "Weegee" had also come to represent an attitude toward urban disorder, a strategy for coping with the anxiety of the cultural moment. When his masterpiece of popular art, *Naked City*, came out in 1945, at least some reviewers certified the fame he had so presumptuously anticipated. "A magnificent album of snapshots and love letters," the *Saturday Review of Literature* called his book of New York photographs, a "wise and wonderful book," presenting all of a great city "without shame and without shudder" (Sussman 17). The year before, Weegee had lectured at the Museum of Modern Art, and after the publication of *Naked City* an exhibition of his work was held there as well, confirming a notoriety that was reaching beyond the circle of photo-journalism: Weegee was, it seemed, an Artist.

Certainly not, however, an elite artist: rather, a kind of urban primitive, an innocent, a night prowler, an observer who became identified, by his

audience, with his subjects. After the success of *Naked City*, high society fans would prize the opportunity to ride around with Weegee on one of his nocturnal tours of duty, as thrilled to be with the photographer as to see what he was seeing. And Weegee played the showman's role to the hilt: in touring the country to promote *Naked City*, he often rode around in a police car in the early morning hours, taking photographs of local disasters and crimes that he would claim to have predicted. Embracing the full implications of his name, Weegee was not merely a recorder of images, but a visionary, and he loved the appellation, spelled in his own way, that evoked the psychic powers of the Ouija board and testified to his ability to produce a shot of some ghastly event before anyone else even knew about it.[1] And though Weegee would sometimes push his luck in trying to demonstrate his putative powers, the real source of his timing was a simple but resourceful use of a police radio (he was, in 1938, the first photographer granted the privilege of having one), which the dutiful Weegee kept on at night while he half-slept, monitoring emergency calls like a hunter waiting for his prey. With his car specially equipped for photographic service, Weegee would often score first with the picture services and the New York newspapers; for millions, the city was being visually filtered, if not created, through Weegee's eyes. Shortly after *Naked City* was published, the aura of the title and of Weegee's world was such that it spawned a Hollywood movie and subsequently a television series based on the movie.

The roughness of Weegee's appearance was no mere pose, but it was a persona that, once having mutated into it, he deliberately perpetuated. In the many photographs of the photographer himself (he loved to be photographed) we often see the same persona—two days' beard, a constant cigar, blunt features, a warm, at times leering expression, clothes that look slept in. (Later in life, when he could afford it, he had London tailors make his suit two sizes too large, to achieve the same look, at a higher level.) Moreover, Weegee affected in his autobiographical asides and authorial persona a kind of anti-intellectualism, making fun of social pretension, of humbug, of a "high" culture symbolized by the *New York Times*, which— gallingly to Weegee—had no interest in his sensationalistic pictures. Yet at the same time, the photographer from the slums of New York admitted to listening to New York's all-night classical music station on his car radio in the early hours of the morning, his working hours. Indeed, we don't fully understand Weegee's ambition unless we acknowledge that this son of a peddler (his father became a rabbi late in life), himself had an aspiration toward "high art" that is central to the cultural role he defined for himself.

Weegee's reputation, ever since his notoriety in the forties, has contin-

ued to embody the contradictions between high and low art that enfold his career. Almost alone among photographers who originally competed for a showing in the city newspapers, Weegee has exerted a continuing fascination as a popular photographer; yet his reputation as a photographer with a serious and distinctive vision continues to grow as well.[2] Within the singular body of his own work, he has seemed to embody the very contradiction of photography itself, as both a medium of mass communication and a serious art form. He has also stood for decades as a precursor of a group of post-World War II photographers who would pick up on the rougher edges of urban street life that Weegee specialized in, and would emulate the spontaneity and irony of his eye.

Earning his living after 1935 as a press photographer, Weegee's subject was to a large extent the sensational life of the city that emblazoned the front pages of the tabloids: the burning building, the night time rescue of a bewildered occupant by a fireman; prostitutes and transvestites carted off in a paddy wagon; the arrest of suspected criminals, covering their faces against the prying eye of the press camera; and, most consistently, the corpses of gangsters littering the streets, their blood staining the pavement. In addition, Weegee was always on the lookout, at parades, parks, beaches, concerts, movie theaters, nightclubs, taverns, public gatherings of all kinds, for the bizarre shot that would hold the reader's eye as it skimmed the newspaper—the giant inflated hand of a Mickey Mouse float at a Thanksgiving Parade; a lady's stocking stuffed with dollar bills; Ethel, Queen of the Bowery, raising a toast at Sammy's Bar, smiling despite her black eye; couples locked in a deep embrace, whether in the booth of a bar, in a darkened movie theater, or on the beach at night; a shrouded girl being fired out of a cannon at the circus; the rear ends of two zebras; the dusting of store window mannequins on a Sunday morning.

What raised Weegee's work above the superficial quality of most photojournalism was not only an eye for the unusual, but a consistent and coherent vision. Weegee had worked for over ten years, beginning in 1924, as a darkroom technician at Acme Newspictures (later known as United Press International Photos), where he had processed thousands of "newsworthy" images—shadows on the wall of Plato's cave—with what effect on his mind and eye one can only imagine. Weegee mastered the terms of this black and white world, exploiting in his own pictures a two-dimensional photographic language in which the subtle gray tones of the fine print were eliminated by the habitual use of the harsh flash bulb, which furnished a simplified syntax of high contrasts that tended to flatten the space between

foreground and background and rob his figures of a more molded, three dimensional light.[3]

The result of his years in the darkroom was to turn Arthur Fellig into a kind of photographic Bartleby. But where Melville's character, working in the dead letter division of the Post Office, metamorphosed into a paragon of nihilism and despair, Weegee's irrepressible buoyancy would transform him into a kind of comic nihilist, a connoisseur of urban chaos. It wasn't subtlety Weegee was after in his pictures, but rather a quality of the bizarre. Occasionally one is aware of an ironic interplay between figure and context—as in the picture of the policeman covering a corpse with newspapers on the street, while the movie marquee in the background overhead announces the appearance of Irene Dunne in *Joy of Living*; but more often the essence of a Weegee photo is the clear recording of a significant and unexpected action: a mugger dressed as a woman removing a lady's wig from his head; a religious Jew carrying a Torah from a fire, wearing winter gloves; a man in a suit asleep on a staircase; a woman sitting alone on a lifeguard station on a beach at night; a man smiling beatifically in a tuxedo at a parade. One looks at these photos again and again as moments isolated from the flow and flux of everyday life that contain a drama we can only guess at.

Several of Weegee's most famous shots do actively solicit our sympathy—the famous picture of the children sleeping on the fire escape or the various homeless vagrants Weegee photographed with unflinching detail—and it was typical of the response to Weegee in the mid-forties to turn him into a social documentarian photographer, a champion of his subjects: William McCleery, the editor of *PM Picture News* (where Weegee was staff photographer for five years) introduced *Naked City* in 1945 by saying that Weegee's "heart and imagination" had made it possible for us "to see his city and believe it, and love it—and yet want to make it better" (McCleery 7). And Russell Maloney, reviewing the book for *The New York Times Book Review* (which reproduced as "art" three photographs it wouldn't have printed as "news"), saw Weegee as giving a kind of human significance to the multitude of faces we see in New York and which we normally blot out. "The camera reminds us that the nameless stranger looking over our friend's shoulder as we chat, or staring down from the open window, has a face and is, in fact, another one of God's creatures" (5). This reaction to Weegee doubtless follows the public's habituation to a photography of ritualistic social sympathy during the Depression, created partly by the celebrated work of the Farm Security Administration, who with good conscience manipulated their subjects in

the name of social betterment. Anyone looking at the destitute through the eye of a camera, by definition had a heart. And Weegee himself went so far, on one occasion in *Naked City*, as to advertise his own sentiment: "I Cried When I Took This Picture," Weegee wrote as a caption underneath the tragic image of a mother, wrapped in a black shawl, embracing her daughter as the two of them look up at a burning building in which another daughter and her young baby are hopelessly trapped. Yet Weegee's empathy is problematic. To the extent that he tells us—in words rather than in pictures—that he was the man, he suffered, he was there, Weegee can distract from the more authentic passion of his photographic subjects, cheapening their pain by drawing attention to his own reactions.

Surely he understood the life of the New York tenements, for he had himself grown up in an overcrowded cold water flat with shared hall bathroom on the Jewish Lower East Side, to which his family had emigrated from Austria when Usher Fellig (anglicized to "Arthur") was seven years old. Freezing cold in winter, hot in the summer, the apartment drove its occupants to sleeping on roofs and fire escapes, and some of Weegee's most famous pictures would later record similar scenes. Weegee sold candy during the day to supplement the income his father derived from peddling and stayed up late at night reading first Horatio Alger, then— deciding the success manuals were "phony"—detective Nick Carter. Weegee left home as soon as he could, choosing to live on the streets and in flophouses, preferring to sink or swim on his own. And it was years before he did swim, working his way through a variety of odd jobs, including, most significantly, photographer's assistant and, later on, darkroom technician. Throughout the main part of his professional life, even after the success of *Naked City*, Weegee would maintain the somewhat impermanent, nomadic life he had early mastered.

But if Weegee has been seen as the brutal primitive, or the photographer with a great heart, he has also been seen, contrarily, as cold and unfriendly to his subjects. Walter Rosenblum—who knew Weegee—reviewed a collection of the photographer's work in 1985 and called attention to what he termed a hostile component of Weegee's camera vision. Rosenblum cites a page from *Naked City*, featuring three photographs recording the death of a derelict who, "aroused from his position in the sidewalk, wanders into the street, is hit by a passing taxi cab, and is given last rites." "Where was the photographer?" Rosenblum asks, seeing Weegee's refusal to intervene as symptomatic of, and anticipating, a later generation of television camera men who would be fascinated by images of destruction and self-destruction—e.g., a man setting fire to himself—without intervening to

I Cried When I Took This Picture

Mother and daughter cry and look up hopelessly as another daughter and her young baby are burning to death in the top floor of the tenement . . . firemen couldn't reach them in time . . . on account of the stairway collapsing.

"I Cried When I Took This Picture" (p.74). All images by Weegee which appear on these pages are Copyright 1994, International Center of Photography, New York, Bequest of Wilma Wilcox.

For the first time, an accident is photographed before and after it happened.

A man is seated on the sidewalk taking it easy. . . .

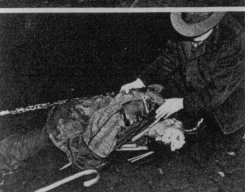

He gets up to cross the street and is hit by a taxicab. . . . The poor man was a peddler of pencils. His cane was broken and his stock of pencils lie beside him.

A passerby has put a handkerchief to his forehead to stop the flow of blood.

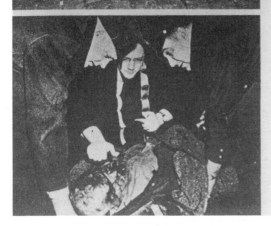

A passing priest gives the injured man the last rites of the Church.

"For the first time" (p. 206)

rescue the "subject" (40). But the quality of anomie Rosenblum identifies in our own day may be prematurely ascribed to Weegee, who after all, was merely capitalizing on his luck in having taken a picture of the derelict minutes *before* the accident occurred. Surely Weegee had wandered off the scene during the accident itself and came back to catch the aftermath when he heard the commotion in the neighborhood. True, he presents the sequence in *Naked City* as a manifestation of his "psychic" powers ("For the first time an accident is photographed before and after it happened" [206]), but that is part of the showman's legerdemain and not, I think, a failure to intervene during the actual event. Yet Rosenblum's larger point is worth pondering, for there is a kind of coldness in Weegee's extremely privileged eye.

Actually, both the sentimental and the hostile components of Weegee's vision are better seen as part of a larger whole that defines the core of the Weegian photographic act: an unadulterated voyeurism that both enacts and represents the act of looking. As such it stands almost as a rebuttal to the official culture of sympathy that characterized the culture of the New Deal, including the fiction and photography of social concern. In fact, Weegee operated as a kind of tour guide to New York, offering the privilege of looking at the bizarre world of urban misfortune and pathos without making any serious demand for involvement or action. Weegee served a world that was, indeed, growing tired of such demands, and his cultural function was in part to provide a kind of entertainment that was integral to the economy of the urban newspaper of the thirties and forties.

The city as pictured by Weegee was a place of disorder and upheaval— violence, accidents, fires, gang wars, social deviance, privation and isolation, conditions that were not the result of temporary economic problems or that were remediable by acts of benevolence; rather, disorder seemed to spring from the natural and human world, it was part of the human condition, which for Weegee seems to oscillate between lonely isolation and the fleeting comforts of the quick embrace. At the same time, the city was an ongoing carnival of individual and collective passion—parades, glamorous stars, opera openings, crowded saloons, parties and park benches. Both extremes fused, in the popular world of the newspapers, into a diffuse concept of urban life as spectacle. Weegee's response to this world, a response that would strike a deep and resonant chord in the popular marketplace, was to view it as a carnival of human comedy, and to look at it with a combination of cynicism and sentiment. Both parts of the Weegee sensibility are essential, as essential as the same polar qualities in the typical thirties "tough guy," who likewise fulfilled a cultural need by

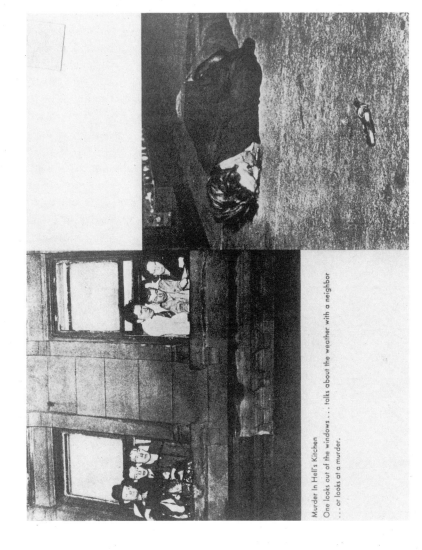

Murder in Hell's Kitchen
One looks out of the windows . . . talks about the weather with a neighbor
. . . or looks at a murder.

"Murder in Hell's Kitchen" (pp. 80-81)

embodying, in fiction and film, a persona that, despite its sensitivity, was obdurate enough to endure.

Indeed, what Weegee is implicitly portraying throughout *Naked City* is also the larger representative act of surviving the disorder of the modern city. Again and again, Weegee's tone, in his captions and textual introductions to each chapter, suggests a hardness in the face of violent catastrophe: showing us a window full of curious onlookers, staring at a murder victim, Weegee says: "One looks out of the windows . . . talks about the weather with a neighbor . . . or looks at a murder" (80). At other times, Weegee's irony borders on cynicism and a strange kind of joking: beneath a photographed statement showing a payment to Weegee of $35 for "Two Murders," the photographer adds, "Twenty-five dollars was for the murder picture on the right . . . the other picture they bought was only a cheap murder, with not many bullets . . . so they only paid ten dollars for that" (78).

And there is, as the complement of the callousness, the controlled sentimentality that comes to the surface on still other occasions, most interestingly, and fully, in the opening text to chapter one, "Sunday Morning in Manhattan." Here, Weegee begins with a meditation on, and a photograph of, the Sunday newspapers, which are thrown on the sidewalk in front of the newsstands; he thinks of the "lonely men and women who live in furnished rooms" who buy two papers—the thick *Times* and the tabloid *Mirror*, and who go back to their rooms to read and "drive away loneliness." But, Weegee conjectures, one tires of the vicarious stimulation of the newspapers, one tires of reading: "One wants someone to talk to, to argue with, and yes, someone to make love to." As if trapped in self-reflecting loneliness, Weegee's next thought is: "How about a movie— NO—too damn much talking on the screen. 'But Darling I do love you . . . RAHLLY I do,' . . . then the final clinch with the lovers in each other's arms . . . then it's even worse, to go back alone to the furnished room . . . to look up at the ceiling and cry oneself to sleep" (14). The movies provide an escape from loneliness but in the end they deepen the viewer's isolation: Weegee's vicarious rumination represents with a secure yet casual power the alienation of mass culture, whose products create an insatiable desire, and whose satisfactions are at best temporary. So too, the voyeuristic photographic moment as Weegee represents it—a microcosm of the psychological process of mass culture—is at once a bonding and a separating.

For Weegee the act of voyeurism is rich and complex, and *Naked City*, his first and best collection, is his most sustained treatment of it. The whole

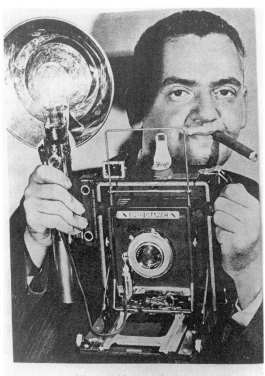

Weegee and his Love — his Camera

"Weegee and his Love—his Camera" (p. 10)

of the volume, comprising eighteen chapters of varying length, is a carefully plotted, carefully structured sequence of pictorial narrative and text, with each chapter thematically developed. The title itself suggests the photographer's act of unmasking, of stripping away the covering surfaces of urban life and exposing the underlying reality in all its rawness. And the frontispiece photograph of the photographer aptly establishes the theme of looking: it is a portrait of the artist staring straight out at us, yet at the same time holding in front of him his Speed Graphic camera, with flash attachment—at once a barrier and a mediating instrument. The caption reads, "Weegee and his Love—his Camera," which seems like a casual and ironic overstatement, but—given the character of what follows— carries an undertone of erotic substitution that really is at the center of Weegee's sensibility, in which the act of looking is a substitute for a kind of deeper communication. Out of this "union" of camera and man, not accidentally, "A Book is Born," as the preface is titled.[4]

Weegee's Voyeurism and the Mastery of Urban Disorder **81**

If the act of looking is central to Weegee's self-representation, the act of photography is the central subject of the book *Naked City*, and Weegee begins his examination of what it means to look in his first two chapters, one of which explores the vulnerability of the subject, and the other, the exposed act of spectatorship.

We look first, in Weegee's scheme, at the city on Sunday morning, still asleep. Weegee's subjects appear undisturbed by his presence, and that is part of the wonder of these images: the act of photographic intrusion has been achieved with a kind of surgical precision, as if the subject were anesthetized. There is, inevitably, a fantastic effect here, reminding us of René Clair's surrealist silent film, *Le Paris Qui Dort*, in which a whole city sleeps. And, as in Clair's film, sleepers are found everywhere (except in bed): on a crowded tenement floor; on mattresses at a circus, watched over by a pair of giraffes; on a tenement fire escape (the famous picture shows eight children crowded into one such space); on the street, on staircases, on park benches—again filled to capacity; in a barber chair; in an automobile—again, six people are simultaneously snoozing. Prying into the most private of moments in this opening chapter, Weegee's camera gives us permission to stare at the human subject during his or her most vulnerable time, when the guardedness of waking consciousness is completely absent.

But if we (along with Weegee) have been relatively unconscious voyeurs in the first chapter, concentrating our gaze on the unconscious subject, the photographer steps outside that simple act in the following seven chapters, where the theme is curiosity itself and the act of visually fixating on the varieties of urban spectacle that engage the observer. Weegee has first made us accomplices in the unadulterated pleasure of looking. Now he anatomizes the act, though continuing to afford us the pleasure of our distanced (and presumptively superior) perspective. Thus the second chapter offers us two unusual sequences: in the first, two photographs are paired on facing pages: the first taken during the day, shows us a crowd contained by a policeman, watching a fire, while in the background we can see the Empire State Building; in the facing picture, taken on the night of the same day, from exactly the same spot, with the same background, we see yet another crowd and yet another policeman, and (Weegee's caption tells us) some of the same kids, watching the same fire. In the time-lapse juxtaposition, the crowd maintains a constancy of purpose, as if rendered helpless before the fascination of the catastrophe. The next two pages continue the theme of trance-like spectatorship, in a series of eight images,

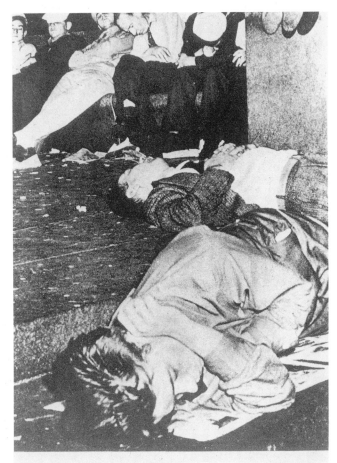

Open Air Canteen Broadway and 47th Street at five in the morning.

"Open Air Canteen" (p. 30)

four to a page, forming a symmetrically balanced grid, in which each shot reveals the deep concentration of the person watching. We don't know what they're looking at, and indeed they are probably all looking at something different. But their expressions and their gestures are nearly identical: in seven of the eight pictures, a single hand is playing with the mouth or lip, whether delicately or (in a few cases) distractedly. In the lower right hand corner of the two-page spread, a final image shows us a woman in a veiled hat who is also staring at something, but given the interference of the veil, she seemingly can't get at her mouth, and she must be content with pulling gently at the veil, a gesture of refinement that forms a coda to

Weegee's Voyeurism and the Mastery of Urban Disorder **83**

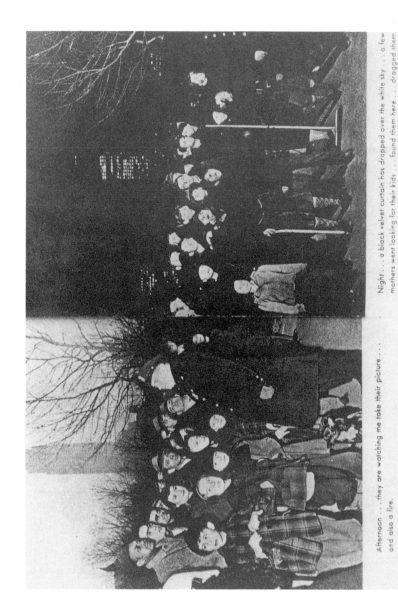

Afternoon . . . they are watching me take their picture . . . and also a fire.

Night . . . a black velvet curtain has dropped over the white sky . . . a few mothers went looking for their kids . . . found them here . . . dragged them home for supper . . . but they are back again . . . but that's the same Empire State Building in the Background . . .

"Afternoon Night" (pp. 36-37)

the series, causing us to go back again and examine how individualized were the gestures in the series and how detailed was Weegee's observation.

The next two chapters, "Fires" and "Murders," give us the heart of Weegee's news photography and include many of his most famous images. But from one chapter to the next the treatment shifts, from the thing observed to the act of observation: in "Fires," with the exception of the first picture of a burning building ("Simply Add Boiling Water," one of Weegee's own favorite photographs), the focus is on the human drama of the fire, with the images on facing pages playing ironically off one another: the rescue by a fireman of newborn kittens is matched on the facing page by the rescue of a puppy; a girl holding her violin is matched by a life-size statue of church angel holding a mandolin; a fireman carries out a painting, while in the facing image, a mannequin is rescued; a Hasidic Jew rescuing a Torah is paired with a fireman rescuing a bedraggled Santa Claus. In the following chapter, "Murders," Weegee's treatment encompasses not only the act of murder itself—with the victim shown, usually, lying face down on the sidewalk in a pool of blood—but the spectator's perspective as well. Thus, in "Balcony Seats at a Murder," the apartment house residents are pictured leaning out of their windows, looking at the

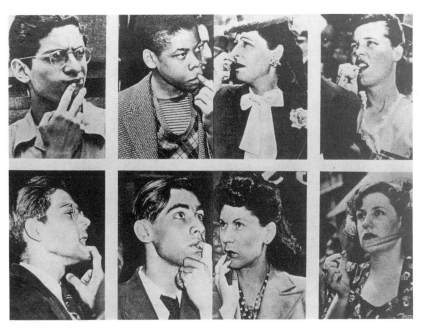

"Faces" (pp. 38-39)

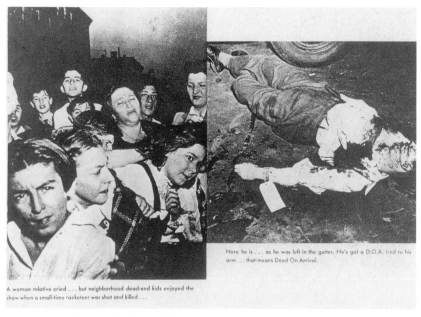

Here he is . . . as he was left in the gutter. He's got a D.O.A. tied to his arm . . . that means Dead On Arrival.

A woman relative cried . . . but neighborhood dead-end kids enjoyed the show when a small-time racketeer was shot and killed . . .

"A woman relative cried" (pp. 86-87)

scene below, which includes detectives and a corpse lying in a doorway. In three subsequent pairings, the left-hand image depicts people looking out of windows or standing on the sidewalk, staring at something, which we presume, by virtue of the layout, to be the image on the right-hand page, featuring a corpse. One such image, among Weegee's most powerful observations, shows us a grieving woman in the center of a moving crowd, jostling for a better look at the corpse; their faces, many of them children, reveal, by turns, triumphant glee, fierce anger, and demonic ferocity. For as Weegee doubtless discovered, while all corpses ultimately look alike and present certain limits to their pictorial representation, the onlookers at such street catastrophes have an infinite interest. We can look at the frozen emotions and expressions on their faces—fascination, horror, delighted connoisseurship, delicate recoil—with a sense of fresh discovery.

If the city is a kind of grand spectacle for Weegee's camera, *Naked City* enshrines the act of looking not only in its spontaneous moments—the found moment of catastrophe—but in the planned performances that draw the enthusiastic observer, the entertainments that draw out the deepest emotions of urban civilization, as Weegee records it. Just about at the dead center of the book's seventeen photographic chapters and at the emotional core of *Naked City* is a study of the phenomenon of star-worship, treated in

Sinatra appears smiling

And a girl smiles too

"Sinatra appears smiling" (pp. 116-117)

a microcosmic essay on Frank Sinatra, and this essay initiates a series of diverse treatments of audiences and entertainments that follow in four subsequent chapters.

Weegee's introductory text describes the Paramount Theater where Sinatra is performing, the long lines of teen-agers standing since the night before, the extra security and police detailed to keep order. The pictorial study then moves us through a typical performance, with four sets of open pages, each one picturing the singer on the left side and the same fan—followed through her changing emotions—on the right side in two paired photographs. Sinatra's greater size and elevated position on the page—he is photographed from below, from the fan's viewpoint—gives him the larger than life stature he possesses for the fan, who is photographed from above, looking up at her idol. In the first pairing, a smiling Sinatra is mirrored by the smiling fan, a teen-ager wearing a Sinatra bow-tie; in the next pages, as Sinatra sings "Come to Me My Melancholy Baby"—Weegee captions each Sinatra image deliberately—the girl sobs her identification. "Let Me Take You in My Arms," Sinatra then sings to the now swooning fan, her eyes closed; and at last, as Sinatra croons, "I Dream of You," the fan's half-closed eyes and smile of content express her state of exhausted happiness. The careful sequencing of the pictures, together with the accompanying captions, build to a clear conclusion: the pop star se-

duces his audience into an orgasmic ecstasy, an abandonment of self to the pleasures of pure adulation. The deepest emotions of mass culture, Weegee implies, are founded on an erotic substitution and on the sheer power of manipulation inherent in the star's personality.

In fact, Weegee had long pondered the mass audience, and his fascination with its mute exhibitions of emotion constitutes one of his deepest motivations. Weegee discovered, seemingly by accident while playing the fiddle in a Third Avenue movie theater in his early days, the power to manipulate the sentiments of the audience: "I loved playing on the emotions of the audience as they watched silent movies," he recalls in his autobiography. And he explicitly relates this power over the audience to the act of photographing: "I suppose that my fiddle-playing was a subconscious kind of training for my future photography. In later years, people often told me that my pictures moved them deeply to tears or to laughter" (*Weegee by Weegee* 27). It is an interesting connection, for it makes Weegee not only a passive voyeur of others' emotions and experiences, but an active manipulator as well, and it suggests a tempting analogy between the kinds of pictures Weegee was looking for—those with the power to excite broad emotions—and the silent movies. There is, moreover, a double voyeurism involved here: first, the intrusion on the emotions of his subjects, who are captured at a moment of peak experience; second, the excitement of a corresponding emotion in the viewer of the photograph, which is the end result.

One of Weegee's most serendipitous intrusions—featured in the next chapter, "The Opera"—was on a gala opening night, and resulted in a photograph he called "The Critic." Here, two society ladies, bedizened in furs, jewels, orchids and tiaras, beam their complacent smiles into the camera as they walk toward the entrance; meanwhile, to the right of the picture, an angry and slightly lunatic woman, clutching her pocketbook, stares at them with shrewd judgment and smoldering resentment. Clearly, the populist Weegee identifies with this viewpoint, but the irony of the camera encompasses a larger perspective, as the society ladies are oblivious to their "critic" who is in turn oblivious to the camera.

Weegee used his camera as an aggressive instrument of discovery, operating with an implicit right to invade privacy, so long as it was in a public space. In a chapter called "Pie Wagon," featuring a typical nocturnal police round-up, we witness the variety of expressions on the faces of the alleged criminals, who react with dazed surprise, or brazen indifference, or smiling seductiveness, to the presence of the camera. But the most telling photo-

These two guys were arrested for bribing basketball players . . . they gave me a lot of trouble as I tried to photograph them . . . covering up their faces with handkerchiefs.

"These two guys" (p. 170)

graphs are the ones in which Weegee's intrusion is blocked by a deliber-
ately covered face (hats and handkerchiefs are the preferred tools): here
the failure to capture the expression is converted into the photographer's
triumphant success, as the picture of their very refusal becomes more
interesting than their faces would be. "They gave me a lot of trouble as I
tried to photograph them," Weegee affirms peevishly in one caption (170),
as if his own rights had been violated. When they plead with the photogra-
pher not to take their picture (he tells us in the introductory text), Weegee
affirms, with the voice of Blind Justice, "they should have thought of
that before they went into the crime business" (160). By what right does
Weegee claim a photograph? Is he acting on behalf of the public? The
newspaper? Himself? The camera acts here as impartial judge, sentencing
its victims to embarrassed notoriety.

Weegee's camera exemplifies the twentieth century's greatest fear: the
ubiquitousness of this mechanical eye, its intrusive power to record us at
any moment. Yet this very quality—of always being there—is the source
of our narcissistic pleasure in the camera as well. If, in a moment, we may
find our private lives converted to public currency, this carries with it the
promise of notoriety, of celebrity, even if the smallest fraction of celebrity,

"Coney Island" (pp. 178-179)

as is the case in Weegee's Coney Island shots, which are featured in the next chapter. At the New York beach, enjoying a thoroughly compliant subject, Weegee offers us one of his several annual photographs of the masses, the great mob at the shore, taken from an elevated vantage point: as far as the eye can see, the densely packed crowd stretches, with standing room only. Those near the photographer are posing and smiling, waving happily, trying to distinguish themselves by any means possible from the mass of people surrounding them. As they recede from the center of the camera's eye, they grow less aware and less interested, fading off gradually into the normal oblivion of the beach. If the anonymous and impersonal crowd is at one extreme of Weegee's fascination with the masses, the pictures that follow represent the other extreme: intimate night shots of lovers embracing on the sand, oblivious to the camera's presence. (They are oblivious because Weegee is using his special technique for photographic eavesdropping: highly sensitive, infra-red film.) The concluding shot in the series is the often-reproduced one of the lone girl on top of a life-guard stand, staring out at the ocean, though Weegee has positioned her on a page facing two photographs of lovers embracing, to emphasize her isolation.

The final five photographic chapters of *Naked City* have a slightly miscellaneous quality, as if Weegee couldn't bear to leave certain things out of his first book: a sympathetic view of Harlem, including a race riot; a chapter called "Psychic Photography," which attempts unconvincingly to document the putative claims of Weegee's photographic "clairvoyance"; "Signs of the Times," which catalogues the vernacular street signs that had been attracting the modern photographer for several decades; and "Odds and Ends," which includes shots that fit nowhere else—ladies with tattooed chests, an abandoned baby, a sailor kissing a woman, a fireman in a phone booth. Apart from a final chapter consisting of inside tips on the professional life of the press photographer, Weegee ends *Naked City* with a chapter called "Personalities" that features a photograph and accompanying text that seem at first so discordant with what has gone before that the reader must be utterly nonplussed: What is a portrait of Alfred Stieglitz doing in *Naked City*?

No two photographers could in fact be more different than Weegee and Stieglitz: the former, achieving recognition through the newspapers and the sensationalist art of press photography, the latter through an obsessive devotion to the fine art of the photographic print. It was Stieglitz, after all, who had demonstrated the possibilities of photographic art to a generation that had viewed the camera as purely a mechanical medium; it was Stie-

"Alfred Stieglitz" (p. 232)

glitz who first exhibited the cubists in America, who first printed Gertrude Stein in the United States, who first persuaded the museums to exhibit photography on a par with painting. We might suppose, then, that the inclusion of Stieglitz is an act of homage: Weegee the populist pays tribute to the emblem of elite art-photography in his time, a figure who had been, in the thirties, the subject of a thick volume of tributes—*America and Alfred Stieglitz*—from the most respected artists of the day.

But if Stieglitz's presence in *Naked City* is an act of homage, it is also an act of self-assertion and challenge on Weegee's part, an effort to reach across the culture gap, from low to high. As such it anticipates Weegee's subsequent efforts to move his own work more ostentatiously into the world of modern *art* through "creative" photography. What is it, then, that seems discordant, unsettling, even offensive, about this chapter?

The chapter possesses, I think, an unusual combination of affrontery and condescension on Weegee's part. Take, for example, the initial encounter between Weegee and Stieglitz, as the photographer presents it, on a street in midtown New York. Weegee had seen Stieglitz in this neighborhood before, but one day he came up and said, with a directness bordering on chutzpa, "You Stieglitz? I'm Weegee. You may have read about me in magazines, or seen my pictures in *P.M.*" (233). No, Stieglitz didn't know him, and the press photographer seemed taken aback that Weegee the Famous was unknown to this resident of contemporary New York City. How was it possible? Was Stieglitz so out of touch with his time? We too are determining which is more surprising: that Stieglitz was ignorant of Weegee, or that Weegee—the paragon of popular culture—was respectful of Stieglitz?

For Weegee, Stieglitz was, in fact, a powerful emblem of the highest achievements of photography in the twentieth century and also, significantly, of the artist's meager rewards. Forlornly wandering the midtown area, Weegee's Stieglitz confesses himself to be a neglected figure, seemingly relegated to the trash heap of history and bypassed by the judgments of his contemporaries, who ignore his gallery. At least this is how Weegee wants us to see Stieglitz—as a pathetic figure—and the condescension implied by Weegee borders on the outrageous. Yet Stieglitz is a kind of memento mori for Weegee, who portrays the older photographer as a cadaverously distant, though dignified, figure, sitting feebly on his couch and wrapped in his black coat, his hands held arthritically and helplessly before him. Will Weegee the famous wind up this way too? Repeatedly, Weegee reminds us (tastelessly) of Stieglitz's heart condition and his imminent mortality. And at the end of the Stieglitz section, as the older

photographer seems to suffer an attack of angina, Weegee leaves the great man abruptly, as if he must suffer his fate in solitude.

Yet in a way, these two photographers—both of them enshrined by museums internationally—meet in a middle zone they each approached from quite opposite directions, the one from high art, the other from popular art. Moreover, we recall that Stieglitz, though always affirming the essential importance of quality in the photographic print, saw photography as potentially a mass art, an art for democracy, if democratic taste could be so elevated. (The comparison to Whitman was often made by Stieglitz's contemporaries.) And it was Stieglitz, surrounded by the aesthetic pretensions of the pictorialist Photo-Secession movement that he was otherwise supporting in the early 1900s, who saw in the hand-held camera a new future for photography, one that exploited the photographer's ability to seize the moment. Though Weegee did not choose to pay this particular tribute, the Stieglitzian sensibility of *the moment* is in some ways the foundation for his own, quite different populist art.

In the end, though, Weegee's photographic vision, finding its source in the mass culture of the newspapers, stands apart not only from Stieglitz but also from the most notable photographic traditions of his contemporaries, who had in their own ways tried to come to terms with the challenge of the city. Though Weegee was empathetic toward "the people," his vision lacked the consistency of purpose and straightforward technique that marked the work of the socially conscious photographers of the thirties, who excited sympathy on behalf of the economically depressed. Though Weegee in his own way celebrated the vitality of the city, he also consistently avoided the modernist vocabulary of abstraction that paid tribute to the visual excitement of skyscrapers, bridges, and the other urban vistas that Alvin Langdon Coburn, Stieglitz, and, in the thirties, Berenice Abbott had focused on. And though Weegee was fascinated by the sensationalistic side of the quotidian, he rarely captured the quiet snapshot reality of daily urban life that took form in Paul Strand's work and was carried into the thirties and forties by Aaron Siskind, Helen Levitt, and others.

Drawing its power from the clamorous demands of the newspaper, Weegee's vision in turn anticipated the post-World War II work of photographers like William Klein, with his aggressive and chaotic pictures of urban street life; Diane Arbus, with her empathetic focus on the socially deviant; or Garry Winogrand and Lee Friedlander, with their caustic and satiric views of social gaps, of private parties and public ceremonies.

Weegee's peculiar combination of toughness, sentimentality, and protective irony may have no exact counterpart in the photographic culture of

his time, but we do find an illuminating parallel to his sensibility in the work of the writer Nathanael West, a contemporary who, like Weegee, drew on the vocabulary and forms of popular culture and transformed them into more sophisticated forms. Though working in different media, both shared certain assumptions that were rooted in experience caused by the Depression: that the common language of daily life was violence, that pathos was its dominant emotion, and that satire and fantasy were one's best means of survival. For the artist emerging out of such a culture, aesthetic forms inevitably had to be dramatic and sharp in their impact, mimicking the condensed forms of newspapers and the grotesque exaggerations of the cartoon (West "Notes on Miss L." 1; "Notes on Violence" 132-133). *Miss Lonelyhearts*, West's great urban novel, features a landscape that is a bare and sterile background for the despair of his main character, whose anguish derives from his clear perception of human catastrophe and whose emotional paralysis seems rooted in an inability to do anything more than observe such misfortune from a safely spectatorial distance. West's Miss Lonelyhearts, like Weegee, panders to the masses (he is the personal advice columnist for a newspaper) even while he falls victim to the same despair that he has been trying to ameliorate through his columns. Miss Lonelyhearts tries to cultivate a hard, rocklike character, an immunity to disaster based on emotional resistance, but in the end he fails. Weegee, a kind of photographic Miss Lonelyhearts, seemingly emerged out of the very milieu he documented, yet he survived by the completeness of his irony and by achieving thereby some distance from the disasters he recorded.

Weegee's career after *Naked City* is somewhat anticlimactic, the record of an artist who was trying to capitalize on his earlier success without adequately understanding it. *Weegee's People* (1946), a collection of portraits that was published close on the heels of *Naked City*, is an innocuous and largely humorous collection of urban types, from the perfectly normal to the strangely bizarre. Each portrait exhibits some emotion, but there is a certain blandness to the collection as a whole. *Naked Hollywood* (1953), Weegee's later attempt to do for Hollywood what he had done for New York, is a disappointment of a different kind. Here, Weegee's effort to satirize the world he had tried to infiltrate and exploit resulted in a collection that combines trick photographs with realistic ones, all mostly "funny" and lacking the edge of *Naked City*. Weegee was trying in the fifties to reach beyond his original strength, lured in part by the notion that something "higher" was required of him. When, after the show at the Museum of Modern Art, the prices for a Weegee went from five dollars to five

hundred dollars, Weegee thought he ought to be making something more like "art." "With photography I would create my own world," he declared in his autobiography, not realizing that he had already done so in his earlier work. Instead, he began experimenting with trick lenses, producing distorted images of famous people and abstract, kaleidoscopic images that were supposed to look "modern" and "expressive." "In a way," he said of these trick photographs, "it is the 'missing link' for the creative and imaginative photographer," not realizing that Coburn had in 1916 briefly experimented with prismatic lenses (*Weegee by Weegee* 126; 131). He failed to recognize too that these distortions went against his natural genius for a kind of sensational realism, imagery that, however bizarre, we could trust to be "real."

Accordingly, it is *Naked City*, Weegee's first book, that one comes back to again and again, a vision of the city that has resonated for decades, a work that grew out of an obsession with looking and that in turn depicts the act of looking as the defining passion of modern urban culture. Weegee's peculiar contribution to urban photography was to define the modern city, in a way that no one had previously and no one has since, as a collection of disengaged voyeurs, of shocked and amused witnesses to the disordered spectacle of contemporary life. It was Weegee's cultural function in *Naked City* to transcend the ephemeral imagery of the newspaper and achieve a kind of emblematic revelation of mid-century urban American culture while providing—through irony and guarded compassion—a model for surviving it.

6

Documentary and the Seductions of Beauty

Salgado's *Workers*

Documentary photography has traditionally taken as its function the depiction and analysis of social distress, so that there is usually no shortage of subjects. But the genre has weakened over the years—since its point of high authority in the 1930s—through a variety of accumulating frailties: an over-use of tired conventions, a suspicion of the mythology of victimization, a presumption against the objectivity of the photographer, a skepticism about all presumably "true" reports, and not least the displacement of photojournalism by television. During the last decade, the power of Sebastião Salgado's imagery seems to have swept away these suspicions, giving him a place, in our time, that is virtually unique: photojournalists have migrated into our art museums since the 1930s, at least, but not since Walker Evans has the conjunction of a documentary and an artistic vocation been so aligned, and so universally proclaimed. He is, according to the curator of the San Francisco Museum of Modern Art, "probably the most important contemporary Latin American photographer and one of the most important artists in the Western Hemisphere" (Sischy 90). Weston Naef, curator of photographs at the Getty Museum, confirms that Salgado has created "some of the most compelling photojournalism that has been made in the last 20 years. He is an artist, using journalism as the vehicle for his art" (Wald 58). The superlatives seem appropriate, including the proposition that Salgado is

probably the most *visible* photographer of our time: through the mid-nineties, his work has been seen regularly in *The New York Times Magazine*, while his colossal exhibition, *Workers*, has momentously toured the world. Salgado's subjects have been, for nearly two decades, spectacular: starvation in the Sahel Desert, Kuwait's oil wells in the aftermath of the Gulf War, Rwanda. But it is not only what we are looking at that has drawn our attention; it is the photographer himself, and, symptomatically, *The New York Times*, when it ran a photo-story on Kuwait, featured a complementary illustrated story on Salgado.

But Salgado is problematic: as shockingly powerful as his work is, it can evoke at the same time ethical and aesthetic problems in our response, problems that have been present in his work from the beginning. While recharging the enterprise of documentary photography, he has been inadvertently raising uncomfortable questions about its function in our culture.

Though Salgado has performed as a photojournalist for nearly two decades (first with Magnum, more recently with his own agency), he has had, at least since 1977, an unusual freedom in the profession, the power to create his own schedule of assignments. One early result was the volume *Other Americas* (1986), which strikingly portrays the Indian peoples of Latin America in images that attempt, as he put it, "to dive into the most concrete of unreality in this Latin America, so mysterious and suffering, so heroic and noble." More recently (1993), Salgado presented to the world his true magnum opus, *Workers: An Archeology of the Industrial Age*. It was the product of six years work, incorporating several subjects seen previously in journalistic venues, but brought together as both a weighty volume (published by Aperture) and a major exhibition traveling the museum circuit simultaneously in the Americas, in Europe, and Asia. At once a global report on the changing nature of work and a visionary statement about the future of human life, *Workers* is a documentary layered with signification; it is also, I shall argue, the ambiguous product of a competition between an ideology of progress and an ideology of romanticism. Entering the marketplace as a critique of global consumerism, *Workers* can be read, against its own intentions, as itself a product of a visual global consumerism.

Salgado's great merit as a photographer lies in an ability to fuse myth and realism, creating what has often been called—evoking the Latin American tradition of the Brazilian-born Salgado—"magic realism." (Gabriel Garcia Marquez wrote an essay on Salgado that was originally intended to serve as part of the text of *Workers*.) Certainly the imagery of death that pervades Salgado's work—especially the justly famous series on famine in Ethiopia, not included in *Workers*—evokes that tradition: as the Uruguayan political

essayist Eduardo Galeano observes: "Salgado sometimes shows skeletons, almost corpses, with dignity—all that is left them. . . . It is a poetry of horror because there is a sense of honor" (8). But what does it mean to make a "poetry of horror"? Galeano continues: "Reality speaks a language of symbols. Each part is a metaphor of the whole. In Salgado's photographs, the symbols disclose themselves *from the inside to the outside*" (8). Another writer calls this "distilled, surreal quality" a function of Salgado's sense of time as "multidimensional, creating a vision that embodies a sense of ancient tradition indistinguishable from contemporary life" (Goldberg 10).[1]

But precisely this "multidimensional" or "metaphoric" quality—making a poetry of horror—offers a wedge into the problematic Salgado. Photographers can heroize, just as they can demonize their subjects. In either case the individual subject is erased under the sign of the metaphor. Dorothea Lange had this ability to generalize her subjects, usually to heroize them; but she was scrupulous in providing a specific historical documentation of the individual and the social moment in her captions, something Salgado does not offer us in quite the same way. An opposite effect to Salgado's, as Ingrid Sischy says, is visible in Walker Evans, in which "facts are allowed to sing for themselves" (93). I don't think facts ever do sing for themselves, but Evans' technique is in any case surely less *self-dramatizing* than Salgado's and only rarely does Evans reach beyond the level of poetic description to the level of poetic metaphor. But if Evans represents one extreme of documentary practice, the opposite extreme can be seen in Margaret Bourke-White, who freely invented the social meaning and identity of her documentary subjects. Salgado stands somewhere in between: though he has never fictionalized his subjects, he has something of Bourke-White's boldly visualizing imagination and sense of the world-historical moment.

Documentary photography has, at its best, a twofold character inherent in the very nature of its representation: it can be a record of horror, yet a "beautiful" record; and it can be a record of a particular moment in time, yet a "timeless" moment. At its best documentary exploits these complementary attributes, but the documentary photographer may still be uneasy about being called an "artist." Certainly Salgado is, and he professed embarrassment when his huge exhibition opened at the Philadelphia Museum of Art in the Spring of 1993. Though he accepts the analogy of the photographer as a creator of things, photography, for him, is more complicated than showing an "art object." "You know we go to reality, we mix with people, we express things that are ours, that are the others that are in front of us, that's part of the society that we live in." When Salgado spoke at the opening of the exhibition in Philadelphia, the audience wanted very

much, however, to see him as an artist. A member of the audience sponta-
neously offered this tribute: "I do feel, even though you say you are a
journalist, you definitely are very special and an artist. Because in looking
at your pictures I could see a Van Gogh, a Hopper, and your shapes and
your light and dark. You definitely are an artist and I can see that." The
audience responded to this accolade with immediate and warm applause,
as if the prodigal son had been brought home from his wanderings and had
been given his family's highest honor (Salgado "A Lecture" 10). I do not
mean to imply that everyone saw Salgado in such purely aesthetic terms.
Others in the audience—in the Spring of 1993—wanted to know why
Salgado hadn't gone to Bosnia, as if he might have the power, through his
camera, of somehow bringing an end to the horrors of war there. We can
attribute much to the power of photography, as Vicki Goldberg has shown,
but such hope may seem to push the limit of our magical beliefs in the
potency of the image. (Salgado's response was, "Bosnia is very important,
but there are many things happening around the world that you must know
about" [8]. In fact, Salgado's project of the mid-nineties is precisely a
record of the forced migrations, for political and economic reasons, of
populations around the world.)

Still, we can define Salgado's power as somehow the product of these
two opposite tensions in documentary—toward art and toward political
information. And always, in documentary, there is the presumption that
understanding somehow might, in the best of all worlds, lead to action.
And what must make Salgado uneasy about the grand exhibition in an art
museum is precisely the role of the art-environment in shaping our re-
sponse. The danger—and it is visible in the response of more than one
reviewer of Salgado's work—is, that the political power of the image
might be dissipated by our aesthetic response.[2] (Again, shades of Walker
Evans.) This is of course more likely to occur in a museum context—
where the original journalistic context is typically removed; but even
in magazine format the images may provoke a kind of ambivalence.
Salgado's defense is that he is expressing himself (that is, his culture) and
he is expressing the other (that is, the culture of the other): "In Latin
America, we have a very dramatic way of seeing things, of describing
things. Ethiopia is a beautiful country and the people in Ethiopia are the
most beautiful people I have seen. It would be bad if I were to use light or
composition in a bad way when I photograph them" (Plagens 59).[3]

All of these issues are at stake in Salgado's greatest sustained work so
far—the impressively ambitious *Workers: An Archeology of the Industrial*

Age. Though the exhibition has been widely seen (as widely seen as any photographic exhibition in history) I want to speak about it in its book form since that is the more permanent and universally available medium of publication and because it offers in many ways a more complex presentation of the materials than the exhibition.[4] *Workers* is, first of all, a huge project: it is four hundred pages and contains about as many images portraying conditions of labor around the world, from Brazil and Cuba to Spain and Italy, France and Poland, Kazakhstan and Azerbaijan, India, and China—and several other points in between, including South Dakota. The photographs, occupying the great middle section, are presented on the page without any captions and with a lavishness that compels our aesthetic gaze: many of the images are spread out over two pages; others are grouped in mini-galleries of a dozen images on fold-out pages. If we only look at the images—and this surely is the tendency of the average viewer of the text and the average museum-goer—the power of the visual imagery might overwhelm our attempts to make sense of them. At times formalistic, at other times panoramic, Salgado is able to incorporate significantly typical dramatic moments in his portrayals. Influenced by Bill Brandt, by Eugene Smith, by Lewis Hine, by Werner Bischof—he has added to his mastery of lighting and composition, a sense of the grotesque. For in Salgado, the content of the image is often startling, none more so than the series on the Serra Pelada gold mines, which Arthur Danto found to be "so abstracted from anything we know that you can't locate it in history. . . . You're astonished that anything like that could happen in the contemporary world. You don't have a frame to put around it, so you feel you are looking at humanity in some universal way" (Wald 59). But the text of the book, *Workers*, attempts to provide precisely that frame, that location in history, that makes some meaningful sense of individual photographs and of the whole.

Actually, the body of images in *Workers* is surrounded by two textual frames: first, an introduction, and—as a separately bound pamphlet—a set of captions. The twelve-page introduction surveys the purpose and scope of the work in a language that is rife with poetic imagery, similes, and metaphors: "Working with tobacco is sweet and gentle. It can be compared to making bread: it is ancient, meticulous, exact, unique work. . . . The leaves are collected almost ceremoniously. The baskets are lined with cloth like warm cradles, and the leaves are placed inside them like sleeping babies" (11). For the cocoa workers, "Nothing is sinful. Everything is energy and life. A powerful vigor shines form bodies that reach out to each other among the trees" (11). "Coal lies in the heart of the earth and the

Carriers form this human chain from the concession at the mine bottom to the dumping ground at top. Serra Pelada, State of Para, Brazil, 1986. All photographs in this chapter are reprinted by permission of the photographer.

heart of the earth is hot and humid" (15). At the other extreme from this poetic general introduction is the separately bound booklet of captions, which offers brief, factual descriptions of each of the pictures together with an introductory essay that frames each major story in terms of the larger economic and social contexts for the images. For example, in introducing the section on the modernization of the steel industry in France, Salgado writes: "The price paid for this massive modernization, which has made the plant one of Europe's most competitive, has been a drastic reduction in the number of workers. At one time, 20,000 workers were employed at the plant. By 1987 employment had dropped to 12,000, and plans called for the plant to stabilize around 8,000" ("Captions" 14).

The two types of text reinforce and replicate the inherent duality of the photographs themselves, at once descriptive and metaphorical.

But what of *Workers* as a whole? What of the conception and logic of the project taken all together? It is precisely in the attempt to make some meaningful sense of *Workers* as a whole, that Salgado frustrates our best efforts. I am not doubting the seriously good intentions motivating Salgado: how people make a living, or do not make a living, whether or not they enjoy the fruits of their labor, whether or not they have labor at all, these are matters of the greatest importance to our collective survival. But reading Salgado challenges us to make a whole of a text that is at once powerful and (I believe) equivocal.

The force of Salgado's analysis derives from his sense of the economic historical moment: global capitalism in the late twentieth century. Driven by a sense of change in modes of production, Salgado offers to us—as he puts it in the "Introduction"—"the story of an era. The images offer a visual archaeology of a time that history knows as the Industrial Revolution, a time when men and women at work with their hands provided the central axis of the world." (Salgado thus presents himself as a kind of preserver of a vanishing past—not unlike Edward Curtis, in some ways.) This general theme is best illustrated in the units on factory production, which feature bicycle factories in China, scooter and motorcycle factories in India, and automobile factories in Ukraine, Russia, India, and China. Here we strike what is, for Salgado, a kind of technological utopia: "Each factory pictured has a relatively low technological level, but employs a high number of workers. The final product is the result of each employee working in sequence and communion, the fruit of social labor. In the modern automobile industry, this interrelationship is vanishing with the arrival of intelligent machines and robots" ("Captions" 10). Here is the world of

Assembling the back suspension and transmission of the Ambassador. Calcutta, India, 1989.

production as Salgado would preserve it—with worker parties, siestas in aquarium-lined rooms with soft music piped in, and production in which the worker is involved in the crafting of the entire product, not just one divisible phase of it.

The section on factory production is at the ideological center of *Workers*, offering us a world that is eroding before the waves of the post-industrial future. At the same time it is colored by a kind of nostalgia for the industrial revolution itself—a time, as he puts it, "when men and women at work with their hands provided the central axis of the world." Salgado tends to idealize the factory jobs he represents for us, restoring to the worker what one had presumed was (more or less) lost in the industrial revolution: the worker's control over the job, the worker's contact with the thing produced. Surely the assembly line deprived men and women of the hand work that Salgado seems to be celebrating.[5] (Salgado is, by training, an economist, and worked professionally for years in that capacity. So one takes these implicit arguments with some seriousness.) Moreover, to celebrate the factory in general as a site of employment is all right as far as it goes, but it forgets the millions of jobs the machine eliminated as it replaced hand labor. I don't mean to be a Luddite here: it is traditionally argued that while some specific jobs were lost to the machine, others were created, and that a growing consumer economy brought on by the industrial revolution brought more and more jobs. But if you celebrate, as Salgado does, the industrial revolution, then why not also celebrate the robotization of factories previously served by workers. (This is one of Salgado's chief complaints against our post-industrial era.) It is true, many jobs are lost when these changes occur, but if Salgado can appreciate the industrial revolution, why can't he also appreciate—taking the long view of things—the post-industrial, with its potential capacity to generate employment not yet anticipated? (And is the problem really employment, anyway? Isn't the root of the problem the distribution of wealth in a world in which the trend seems to be to distribute it as little as possible.)

The section on factory production is at the heart of *Workers*, but it is only one of six units in the volume. The larger context is a broader investigation into the nature of labor in the world, one that is organized as a kind of "recapitulation" of the progress of labor from the Iron Age to the post-industrial present.[6] Salgado begins by looking back in time to the rudimentary economies of large-scale industrial agriculture—the production of sugarcane, tea, tobacco, cocoa, perfume, from Brazil and Cuba to Rwanda; Part Two depicts the fishing and animal slaughtering industries, from Spain and Italy to South Dakota. Part Three includes the idealized

factories just mentioned, as well as stories on the manufacturing of textiles and ships, along with the industrial processing of raw materials like magnesium, lead, iron ore and steel. Part Four takes us into the earth, for a view of mining coal, sulfur, and gold, from Indonesia to Brazil. (Here we see the dark, raw underside of the manufacturing processes shown in the preceding unit.) Part Five, a kind of corollary to Part Four, features oil in Baku and the wells of Kuwait. Salgado's purpose until now has been relatively consistent with the grand statement on the book's first page: "This book is an homage to workers, a farewell to a world of manual labor that is slowly disappearing and a tribute to those men and women who still work as they have for centuries." Part Six, however, moving us toward the future, features the construction of the Eurotunnel, and of a dam and canals in India. And here we're in the world of advanced technology and appropriate technology, a world of vast engineering projects that reflect an ideology of progress. Yet it's also a world where manual labor is still very much a part of the nature of work, so that Salgado's "farewell" seems premature.

The text of *Workers* places this linear history within an analytic framework that points to the political economic crisis of our time: the growing disparity between a third world (4/5 of the world's population) that is yielding its resources and products to the consumption of a first world (1/5 of the world's population). Meanwhile, the second world, the world of socialism, is "in ruins" (*Workers* 7). Salgado writes from a vaguely Marxist perspective, to be sure, but his approach is professedly undoctrinaire, and in the end, a certain sentimentality seems to undercut the linear view of history, cancelling any teleology in an equivocal affirmation of historical cycles. History, for Salgado is, "above all a succession of challenges, of repetitions, of perseverances. It is an endless cycle of oppression, humiliations, and disasters, but also a testament to man's ability to survive" (7). The optimism (and equal pessimism) implicit in this cyclical view of history virtually removes it from the realm of the political, grounding it instead in an almost mystical sense of human destiny, separate from the specific historical forces conditioning place, time, and peoples.

And here, once more, is the problematic Salgado: for this presumption mythologizes the subject, placing him or her in a world that may tell us more about the observer than the observed: Salgado writes (and the photographs support this conception), "The worker in the sugarcane fields is a warrior. The machete, his long knife, is his sword. He lives in a hostile world, the cane leaf is sharp, he must fight against the leaves, he suffers cuts, he becomes coated in the black grime of cane burned before it

Working on the cutting head of the boring machine . . . Folkestone, England, 1990.

Sugar-cutting brigades work in regions and fields where machines are impractical. Province of Havana, Cuba, 1988.

is slashed . . . "(8) The women who fish off the cost of Galicia "do not belong to this world. Their feet stand on the muddy flats of the *ria*, the wind blows in their face. What can they remember, these peasant women of the waters, as they pull the fruit of the sea at low tide? Why do they smile?" (9). Or, consider the text and photographs that represent, together, the steel plants of France: after recalling his boyhood vision of the steel factories of Brazil ("the spectacle of fire lighting up the night"), Salgado writes, "To this day, steel making is for me an almost religious exercise. And the high priest of this institution called production is the steelworker. For me, the mills are like huge, powerful gods who rule the frightening production of metal that dominates our system. . . . "(14) Salgado succeeds in making of documentary a kind of poetry of subjectivity, an exercise in the sublime. In fact, Salgado seems equally pulled toward the opposite poles of a kind of sublime primitivism, in which the worker in the field is celebrated as a force of nature working at one with nature's rhythm; and a technological sublime, in which the force of the machine assumes a god-like power, imbued with wonder, awe, and beauty. In either case, the subjectivity of the photographer engulfs the representation, driven by an emotional response that goes beyond the framework of any conceptual argument.

Does Salgado do justice to his subjects? A great part of the power of Salgado's work is the sense, as he puts it, that he is coming from inside, that he is somehow voicing the subject; and observers of his work remark on the familiarity and mutual respect Salgado engenders in his subjects. Spending from three weeks to four months with each of his stories, Salgado claims in the end to "create a relationship that doesn't disturb the people that you are photographing. And this relationship sometimes is so strong that it's not anymore that you are taking the pictures, it's the people in front of you that are giving the picture to you, like a gift, you know. It's the truth, it's a whole relationship" ("A Lecture" 10).

But if the workers have given their pictures to Salgado, they have not given him their voices. Some of Salgado's most astonishing photographs are of the Serra Pelada mines, images that seem so alien to us (we viewers of the first world) as to challenge our notion of human life fundamentally. Salgado writes of the miners, who enlist to dig a certain small plot of land down, always down into a vertical space, "Every time a section finds gold, the men who carry up the loads of mud and earth have, by law, the right to pick one of the sacks they brought out. And inside they may find fortune and freedom. So their lives are a delirious sequence of climbs down into the vast hold and climbs out to the edge of the mine, bearing a sack of earth

The flanks of the aircraft carrier Charles de Gaulle were built in the workshop and transferred by cranes to dry dock . . .
Brest, France, 1990.

and the hope of gold" (17). Yet in all of this (and throughout *Workers*) we do not get a sense of what the worker himself, or herself, is thinking; we have no idea of the subjectivities of those represented. And we hear little in Salgado's *Workers* about workers acting on their own behalf in any constructive or active way, with the exception of the labor strikes in the Gdansk shipyards. In this sense, Salgado follows the main line of the pictorial documentary tradition, excluding the subject's voice even as it represents the subject.

It is consistent with this tendency to dehistoricize and dominate the subject, that Salgado organizes his photographs with no little freedom, leaping geographical and historical and ethnic boundaries that might otherwise seem important. Thus, Brazil and Cuba are amalgamated in the section on sugarcane; textile production in Bangladesh and Kazakhstan are featured together; automobile production in Ukraine, Russia, India, and China are pictured in one unit; the shipyards of France and Poland are joined photographically; steel production in France and the Ukraine are similarly yoked. In the captions, the places are noted for each image; but in the photographic section they are fused together in layouts that make no distinction between the place of the image within a given section. In fact, the reader of the photographs who does not consult the captions or the contents can find no divisions within each of the six parts; only the six parts themselves are marked by a roman numeral as they begin. The effect is to elide the differences between the images and between the particular cultures represented, to shift our attention—within the photographic section—to the project as a flow of images rather than a structured discourse.

Salgado is certainly a virtuoso of the black and white medium, employing a range of effects: dramatic chiaroscuro; angular constructivism; strong silhouettes, a merging of flesh and material substance in the grainy surface of the emulsion. And his ability to discover the grotesque in the everyday borders on the fantastic. All of this, however, calls attention to the photograph as visual icon, and in the last analysis *Workers* seems as much about Salgado as about its epic subject.

Indeed, Salgado has reinvented the role of the heroic photographer on the epic scale, picturing the world to us in ways previously not known. There is, in much of Salgado's work, not just *Workers*, this quality of *revelation*, of shock: the photographs enlarge our sense of the world so dramatically that we find ourselves almost in awe of the feat itself. And to some degree we are made, in this process, accomplices of a kind of global consumerism; we of the first world who enjoy the fruits of Salgado's

mighty labors are as much consumers of these visual goods as we are of the raw materials and manufactured products that are otherwise created in the countries Salgado has traveled to. In some ultimate sense, *Workers* is about photography itself, about its power to create the world for us and about the heroism of photography as a medium of conquest as well as empathy.[7] And it's an open question whether Salgado's pervasive concern with the exploitation of the worker under post-industrial global capitalism buys him immunity from a similar "appropriation" of their lives.

Certainly Salgado has renewed documentary photography—renewed its power to reveal previously unimagined dramatic images with a pictorial sense not seen since Eugene Smith (who of course had quite different intentions); and while his political agenda is unquestionably progressive, his documentary mode is ultimately traditional. Standing outside of the social-economic framework that he depicts in so many ways, he is yet inside it in other ways, and his work celebrates the power of photography to feed our addiction to images, and the power of the camera to function as the fulcrum in our economy of the spectacle.

7

Documentary Film and the Power of Interrogation

Kopple's *American Dream* and Moore's *Roger and Me*

Non-fiction films rarely reach beyond a small, devoted congregation, but in recent years two works in particular have realized a mass audience—Barbara Kopple's Academy Award winning *American Dream* (1991) and Michael Moore's widely celebrated and controversial film, *Roger and Me* (1989).[1] That they have gained this wide audience speaks first of all to the fact that both films deal with the fate of the worker at the hands of the modern corporation, a subject that has been the focus of public concern for more than a decade, inflected most recently by the predicaments of post-industrialism: given the new order of global capitalism, what power can labor unions claim against management? and what responsibility have management toward workers and their communities? Yet despite these similarities in subject matter—they both also happen to deal with plant closings in the beleaguered Midwest—two films could hardly be more different, stylistically and rhetorically.

Kopple works within the relatively traditional documentary forms that Bill Nichols calls expository and observational; *American Dream* conforms to our customary documentary expectations as viewers that we are comfortably in the hands of an all-seeing, all-sympathizing filmmaker, expectations that have been part of the documentary mode since its inception in the late nineteenth century. Exercising the authority of observation (an authority that is likewise visible in ethnography, sociology, and psychi-

113

atric observation as well), the documentary filmmaker establishes an ethical norm that is implicit in the narrative and that we are asked to identify with: we are "for" the victims of oppression. But the ethics of this mode, and of Kopple's film in particular, as I hope to show, are not quite this simple. Michael Moore's *Roger and Me* is an altogether different film stylistically from Kopple's, a film that eschews the tradition of observational documentary and opts instead for a more complex rhetoric, a hybridization of (again in Nichols' terms) the interactive and the reflexive modes (32-33). Moore does not invent this mode—it has its precedents in several other projects dating at least from Kit Carson and Jim McBride's quasi-documentary, *David Holtzman's Diary* (1968)—but he carries the form well beyond its predecessors to the level of significant social commentary. What interests me especially about *American Dream* and *Roger and Me* is their concern, in quite different ways, with power, not only the power—or powerlessness—of the worker, but the power of the filmmaker. For in describing the predicament of the worker, Kopple and Moore also portray, at times inadvertently at other times explicitly, the situation of the filmmaker, and implicitly they invite our speculation on the authority and power of the documentary media.

Kopple's *American Dream* deals with the 1985 strike of the meatpackers union (Local P-9) at the Hormel plant in Austin, Minnesota, a strike that results from the workers' outrage at the accumulated cuts in Hormel's incentive programs, benefits, and hourly wages—from $10.69 an hour to $8.25. Eventually, Hormel offers to freeze wages at $10 per hour for three years (with new hires at $8), but the union rejects the offer by 93%, fueled in part by their knowledge that the company has reaped over 29 million in profits in 1984, the year the cuts begin. While this seems like a relatively clear and morally solid position for the P-9 workers to occupy—they are claiming their right to a just wage against the seeming greed of the corporation—things get more and more complicated as Kopple's film unfolds.

Four principal figures emerge as the strike progresses, each with his own constituency and goals: the soft-spoken union president, Jim Guyette, who is determined to win at any cost; a union consultant hired by Guyette —Ray Rogers—who brings unrelenting optimism to the struggle; Lewie Anderson, the parent union's chief negotiator, who works against the local in wanting to rationalize wages across the whole union in order to maintain the industry's consistency and competitiveness (Hormel is already at the top end of the scale); and John Morrison, a leading dissident worker who criticizes the local union's leadership and sides with the national. Kopple

Barbara Kopple: *American Dream.* (1992) Jim Guyette, President of Local P-9. Courtesy Miramax Films.

traces the trajectory of the strike, from its optimistic beginnings to its depressing conclusion: Hormel shifts production to other plants, and their premier product, SPAM—produced during this crisis by Hormel management —keeps rolling out of the factory. With armed escorts, scab workers enter the plants, including some of the disaffected union members who have reached the limit of their own endurance. Ultimately, the parent union cuts all benefits to the strikers (previously $40 a week), strips Guyette of his position, and negotiates a contract that fixes wages at $10.25, but only for those who cross the line. With no guarantee of job restoration to the strikers, only 20% of the workers are finally called back, and in the 25th week of the strike—400 replacements having been hired—no jobs remain.

What gives *American Dream* its power is the gradual unfolding of this defeat and the even-handedness with which Kopple serves as witness to what amounts to a tragic spectacle (as Faulkner defined it), in which the major union protagonists, all trying to do good in different ways, all fail. Union leader Guyette finds his confidence in labor's united power to be misplaced; the consultant likewise can't mobilize support to vanquish the intransigent managers, and he rides off into the setting sun like a failed Lone Ranger. Kopple's postscript tells us that the national negotiator (An-

derson) is fired from his negotiating job, but he goes on (as if to resolve the dilemma he had himself habitually faced) to lead a reform movement against union concessions. Hormel is the real winner: following the strike's conclusion, Hormel leases half its plant to another company, a shadow company, who pays their workers $6 an hour. Nothing can stop the Spam.

Kopple's *American Dream* comprises many elements that are familiar in the tradition of the strike narrative—whether fiction or non-fiction. There is the small union, pitting its force against the giant corporation and the problem of keeping the ranks together; there is the ambiguous role of the outside organizer (personified by Rogers), and the question of whether he does more good than ill. There is the moral dilemma of the dissident, who might turn scab; and the problem of feeding a family during a prolonged strike. There is the use of local law enforcement officers—not to mention the National Guard—as tools of capital. More problematically, there is the distinction between what is legal and what is moral. Guyette claims the morality of rebellion when he invokes the history of the American revolution (not itself "legal," as he points out) and the history of unionism. Against that position, sacred to the American left, Kopple posits the seeming pragmatism (cloaking self-interest) of the American right, as voiced by a Hormel secretary who is kept from her job for one day because of the striker's blockade and declares, with angry simplicity: "I don't want to discuss moralities; is what the company is doing legal?" And in the end, there is the problem of what constitutes defeat, what victory? Do moral victories transcend matters of economic survival? Or is Lewie Anderson right when he asks, "What dignity is there when you don't have a job?"

All of this takes place within the framing irony of the nature of work in the Hormel plant: the opening shots of the film establish the brutal regime of meat slaughtering, and these images of violence recur at intervals so that we may wonder whether Kopple has at times an even broader point to make about the dignity or indignity of this work in the first place. We are made to empathize with workers who are simply seeking an honest pay for an honest day's work, but that day's work happens to involve stunning, decapitating, dismembering and disemboweling all these defenseless animals. (Upton Sinclair had looked at the same dilemma of American labor in *The Jungle*, eighty years earlier: the work may be harrowing, but any job is better than no job.)

Despite its linkage to the main line of strike narratives, the overall tone of *American Dream* is markedly different from that tradition and different too from Kopple's own earlier *Harlan County* (which also won an Acade-

my Award for Best Feature Documentary, in 1976). And that difference sadly measures the distance labor has traveled in the last fifteen years. The classic ending to the strike narrative—dating at least to the thirties—represents the particular conflict as part of a longer march, an ongoing struggle that the worker is destined, even pre-destined, to win. Such was the structure of *Harlan County*, in which the 1974 coal miner's strike is placed within a historical chronicle that gives it an inevitable logic within an unabashedly progressive narrative: the miners, members of the United Mine Workers Union, stage a strike at Brookside (Kentucky) in which the moral courage of the miners—and their wives, who seem crucial to the energy and direction of the strike—is unwavering as they confront the legal violence of the corporation's gun thugs. As one old woman in *Harlan County*—a veteran of the thirties—puts it: "If I get shot, they can't shoot the union out of me." In *Harlan County*, the workers have a unity among themselves that, despite minor rivalries, seems unshakable and will, we feel, gradually gain its victories over the greed and callous selfishness of the corporation.

There is no such "happy" ending in *American Dream*: the union is shattered, the corporation—with its higher obligations to shareholders—moves forward like a juggernaut, seeking the cheapest labor market, wherever that may be. Yet Kopple, the teller, seems not to have fully recognized the point of the tale itself. Certainly her remarks about the film, in subsequent interviews, have framed it in the conventional terms of the lost battle within a longer, ultimately winning war: "Maybe you don't win every battle but each one changes you and makes you smarter," Kopple replied to an interviewer's question about the purpose of the concluding information on life after the strike. It was "meant to be moving, to be reflective about past generations and struggles, and to convey hope for the future" (Crowdus and Porton 38). Such hope is hard to find in the film itself, however. The local union seems shattered, at least as a union, the victim of a corporation that, with "the law" on its side, would stop at nothing to win its point; the major union protagonists in the struggle scatter. Precisely the unity of the coalminers is what's missing at Hormel's P-9.

Instead, what we have in *American Dream* is unionism in the trickle down Age of Reagan, when the corporation's obligations are to "shareholders" and their profits, regardless of the consequences to local economies and local communities. Under the set of incentives available to the contemporary corporation, that company profits most which most ruthlessly seeks the cheapest labor market, in whatever country. Against such odds, the Hormel workers can, at best, swallow hard and accept pay

cuts that allow them to keep their jobs—all this in the face of extravagant corporate profits and executive salaries. At worst—and it was the worst for the great majority of the Hormel strikers—they can tough it out and eventually move out, to wherever. No wonder the sad but powerful drama of *American Dream* lies in the internecine war within the union ranks as they differently come to grips with this no-win situation. This is the knife edge reality of the labor struggle in the 80's as Kopple shows it, and it accounts for the power and impact the film has had as a spectacle of contemporary labor's plight.

Yet one aspect of *American Dream* that has gone virtually unnoticed is in some ways the film's most important point, though it is a point that Kopple, understandably, is loath to admit. In telling her story, Kopple has, one ultimately realizes, as little access to the corporate management as does the union. The powerlessness of the filmmaker is analogous to the powerlessness of the union. When an interviewer, after the film's release, asked Kopple whether she had the same access to management as she'd had to labor, the filmmaker responded defensively, as if the objectivity of

Barbara Kopple: *American Dream*. (1992) The wife of a striking worker being arrested at a demonstration outside the Hormel meatpacking company's offices in Austin Minnesota. Courtesy Miramax Films.

her picture were at stake: "We have an interview with Chuck Nyberg, Hormel's Executive Vice President, and Richard Knowlton, the CEO. We also shot management press conferences and management interviews, but they always said the same thing." Of course they always said the same thing: they stonewalled Kopple's camera as they stonewalled the press and the union, mouthing platitudes from an unassailable position. So far from thinking she has been limited here, Kopple boasts about her ability to get inside the factory: "They knew who I was, but I wasn't blocked. In fact, I was one of the few people who got in the plant to film. I couldn't believe it." And she adds, not seeing the full implications, "But there weren't a lot of labor/management negotiations because the company wouldn't talk to them. They wouldn't even be in the same room with them, so they had arbitrators going back and forth" (Crowdus and Porton 38). Precisely. In the Reagan-Bush era communication between management and worker takes place ideally through an intermediary. And when, on rare occasions, they are forced into face to face talk, management has the right to say things to the worker that make a mockery of the "negotiating" table. Kopple records one such moment, when a corporate negotiator answers a member of a union negotiating team who has complained a little too long about certain issues: "If you want to come back, you keep your goddam mouth shut."

Kopple's camera is thus witness to what the filmmaker herself can hardly admit: that management controls the discourse and can exclude or limit her presence from the decision-making process as much as it can the worker's. In the face of this cinematic deficit, Kopple falls back, tirelessly, on interviews with the more accessible workers, mercilessly probing *their* feelings, scoring most triumphantly when she can capture an otherwise tough, proud worker broken down to tears by the spectacle of his own powerlessness—which is driven home by Kopple's interrogation. To a worker who is about to cross the picket line and go against his union, she asks, solicitously (and gratuitously), "Is that hard for you?" To a scab, out of work for six years, and about to report for work, she asks, "Is it hard to cross the picket line?" (Is it irrelevant that Kopple's graduate training was in clinical psychology?) At times like these, her function resembles management itself, with its power to manipulate the worker's responses.

Of course Kopple wants to expose the emotional traumas of the workers so that we might more fully empathize with them, but she will do so at the expense of other values, such as the privacy of the subject. In talking about a sequence that finally had to be cut out of the final version because of its length, Kopple unwittingly reveals the filmmaker's ruthless delight in the

medium's power to capture the authenticity of intimate emotion. She tells of sequences shot in Worthington, Minnesota (the site of an Armour plant), where a worker is shown feeling confident he can move to another job in another plant if need be, when suddenly his telephone rings: "A minute or two later he came out, looking very strange, and said, 'Cut.' *But we kept rolling as he sat down* and told his wife that he'd just been told they were selling all the Armour plants and that 'We won't be going anywhere,'" Kopple confesses [emphasis added]. "Both he and his wife burst into tears. He looked at her and said, 'What am I going to do. Meatpacking is all I know.' I shot *incredible* stuff in Worthington. . . . " (Crowdus and Porton, 38).

Where management presents a shell too hard, too sophisticated, to penetrate, Kopple turns to the union, where she can work wonders, given her friendly status: "I had trouble sometimes with the international because they'd say, 'Union meetings are sacred. You can't be in there.' But I'm very persistent, so I'd give long speeches in front of all these packing house guys as to why they should let me film their meetings. Some of them never got comfortable with it, and others sort of enjoyed it, or whatever" (37). On the question of whether or not her presence affected her subjects' behavior, adding "another dynamic to the events," Kopple straddles the issue, invoking in the end the mythology of documentary invisibility: "I guess it always does but I think that for some of these meetings we were really insignificant and that they just forgot about us" (37). Such conclusions are comforting to the documentary filmmaker (or photographer, or sociological interviewer), but they fail to take account of the real intervention that the outsider's presence entails, however well-intentioned she or he may be. As Heisenberg might have said, the results of such "objective" acts are indeterminate.

There is no question that Kopple has revealed in *American Dream* the condition of labor-management relations in this country in a way that we have not seen so clearly before. But for all its virtues, it is important to recognize that Kopple's documentary mode, is, in rhetorical terms, squarely in the mainstream of the tradition, a function that has, from its beginnings in the work of photographer Jacob Riis, offered us the implicit spectacle of a sympathetic observer, empowered by the camera technologies of observation, picturing the powerless for the information (and often entertainment) of the more powerful. Kopple extends that tradition without essentially questioning it.

Precisely the questioning of that tradition is what Michael Moore accomplishes in his brilliantly conceived *Roger and Me*. Moore's film, his

first, came out in the fall of 1989 and was met with both critical acclaim and—rare for a documentary—popular success. It seemed, in fact, a sure bet for the Academy Award, until an interview in *Film Comment* with Harlan Jacobson started its derailment by questioning Moore on what appeared to be certain factual misrepresentations. Pauline Kael's subsequent *New Yorker* review raised similar questions and attacked more particularly the film's putative assumption of superiority toward its subjects, and the movie has been slightly, though I would argue unfairly, tainted ever since. It's impossible now to discuss *Roger and Me* without taking into account some of these objections, but Moore's critics have, I think, asked the wrong questions of the film, failing to assess accurately its purpose. We *should* worry about whether Moore has violated the ethics of documentary—a question I want to come back to—but we must also observe the degree to which Moore successfully interrogates the whole premise of traditional documentary form that Kopple, incidentally, accepts.

The ostensible subject of *Roger and Me* is the plant closings of the 1980s by General Motors and their effect on the company town of Flint, Michigan. Like Kopple, Moore is sympathetic to the workers' predicament and to the whole plight of the city: throughout the film, recurring like a leitmotif, he shows us countless evictions being carried out by the local deputy sheriff—the door forced open, the victim's unavailing protests, household goods piled on the street curb, the search for a van or car. He shows us boarded up stores on main street; unoccupied houses, vacant and dilapidated; a rat population in Flint that outnumbers the human population by 50,000. He interviews a former GM employee, temporarily driven bonkers by the situation, shooting baskets outside a local mental health institution.

And to some extent Moore's story is the same as Kopple's: the worker is caught between a corporate management with nothing but profits on its mind and a national union leadership all too understanding of management's needs. At the final closing of the Flint truck assembly line, only four UAW members show up to demonstrate, as opposed to the thousands promised by the union earlier. One of Moore's workers puts the new situation of labor succinctly: "Why is the union getting weak? We're losing power. . . . Too many guys are friends with management." When Moore asks Owen Bieber (UAW President) whether a sit-down strike would do any good today in Flint—Flint was the site of the historic 44 day sit-down strike in 1936 out of which the UAW was born in 1937—he replies that the sit down is not relevant to today. "We have to accept reality that the plants are not going to remain open," he says.

What makes *Roger and Me* unusual—and what has left it open to criticism and misunderstanding—is its mix of motives, its hybridization of forms: it is part historical narrative, focussing on the fate of Flint, Michigan following the GM plant closings and dealing with the workers' plight, which invites our interest in the factual history of this "action"; but it is also part autobiography, beginning with childhood footage and first-person narration by the filmmaker himself, Michael Moore, who remains throughout the film as the central figure, in the persona of the reporter in search of his story, the interviewer in search of his subject. Jacobson questions the factual inaccuracies in the film, the distortions of chronology, and he is of course right to do so. Plant closings that actually took place over a decade or more seem to take place in a more condensed period of time, about two years. Still, none of these misrepresentations of chronology, and there are lots of others, makes any real difference to the central point of the film; no one disputes the fact of the plant closings and their effects. Moore has sacrificed historical accuracy in order to achieve the unity of satiric fiction. The exposition in *Roger and Me* is really its least important aspect: we are most struck by the filmmaker's presence as interviewer and as self-conscious maker of the film. These are the parts of the film that Pauline Kael objects to, especially what she takes to be his targeting of the working class for his satire from a position of presumed moral superiority, all the time seeming to be sympathetic to them. This is a criticism that one might think twice about, since we naturally feel that if a work is making moral judgments, it must be better than what it judges. Kael is offended at the ridiculing tone of the movie, its depiction, for example, of people working in various elite establishments who are forced (by virtue of their job) to expel Moore from the premises as he searches for Roger Smith; they are made to seem flunkies, she says. But it's hard to see the point of her criticisms: the GM workers in the film are treated consistently without a trace of condescension: their comments are pithy, their anger is controlled. "What would you say to Roger Smith," Moore asks several G.M. workers at one point. "Roger Smith?" is the reply. "I'd tell him to retire." "He should be feeling guilty," says another. "I'm sick and tired of these damn fat cats."

Those whom he does ridicule (and there are indeed many) are simply given enough rope to hang themselves with. Contrary to Kael, I don't feel sorry for Miss Michigan (and Miss America), 1988, when she says on camera, when asked how it feels to drive through Flint when so many workers have been fired from the auto plants—"I feel like a big supporter." What is all too obviously (and incongruously) on her mind is the upcoming

Michael Moore: *Roger and Me* (1989). Publicity still. Rhoda Britton holding her pet rabbit; producer and director Michael Moore, and deputy sheriff Fred Ross. Flint, Michigan. Courtesy Museum of Modern Art.

beauty contest: "Pray for my victory in Atlantic City in two weeks." And I don't feel sorry for the woman on social security who cuddles one of her rabbits (she sells them for "Pets or Meat") and coos at it with demonic good humor: "What's gonna happen to him? He's gonna be *eaten*. He's gonna be the supper on our supper table." Moments later, the rabbit is clubbed and skinned. The woman may be in need of public assistance, but so is the rabbit.

Throughout, Moore views skeptically those possessing power, both the infamous and the famous. Flint's famous son, Bob Eubanks ("The New-lywed Game") is shown at a town fair doing a local version of the big show and, off-stage but not off-camera, offers these jokes to Moore: "Why don't Jewish women get AIDS? Because they marry assholes, they don't screw 'em." Several ladies of the leisure class playing golf at the Flint country club offer Moore's deadpan camera the force of their bromidic wisdom when they say, "We have such a good welfare program here . . . they [the poor, the unemployed] just don't want to work." Again and again, Moore's satiric camera observes the absurdities of Flint's upper crust society, as in the "Great Gatsby Party"—in which the host hires several unemployed persons to pose as human statues. The new Gatsby's guests offer us further platitudes from the entrepreneur's toast book: "Get up in the morning and go do something. . . . Start yourself, get your own motor going!" How can one incriminate a filmmaker who exposes the extraordinary obtuseness of a society that holds a grand party to celebrate the opening of a new jail in Flint, including: jailhouse pajamas; dancing to "Jailhouse Rock"; lockup for the night in a brand-new cell: "We're having a fantastic time here." Moore captures the culture of a new aristocracy whose pastorals beggar the imagination of the conventional courtier playing at shepherd and shepherdess. In short, one wonders why Kael should have found Moore—whose family all have worked for General Motors or other automobile industries for generations—superior or hostile to the working class. His subject is power—its arrogance and stupidity—and his examples make the film as much an indictment of American society in general as a study of Flint's particular problems.

It is the admixture of Moore himself as a kind of comic persona in the film that has created the special virtues of *Roger and Me* and also its special problems. Seeing the traditional subject of the film (a plant closing and its effect on the community), the viewer expects "truth"; but much of what Moore delivers is not the "straight" truth of documentary, but the oblique truth of satire. And are not documentary and satire opposite modes, representing contrary motivations? We expect "truth" from docu-

mentary; we don't expect it in quite the same literal way from satire. "Documentary satire" is almost, then, an oxymoron, unless we are willing to admit it as a strikingly original hybrid—which is what I would argue is the case with *Roger and Me*; and once we view the film as "documentary satire," Kael's problems become merely peevish.

What makes *Roger and Me* work is the unabashedly autobiographical nature of the film, its whimsical self-indulgence and seemingly absurd structure—the quest for an interview with Roger Smith, the chief executive of General Motors.[2] At the center of *Roger and Me*, glowing with a kind of negative aura and repellent charisma, is Roger Smith, chairman of General Motors, whose refusal to be interviewed by Moore for his documentary makes him the defining "presence" of the film, all the more tantalizing for being absent virtually throughout. As Moore tries literally to find his subject, he keeps approaching the goal only to be thrown off the field unceremoniously by Smith's various guards and gatekeepers. Moore's tracking effort is carefully documented on film: in the General Motors main headquarters, given the runaround by public relations staff, Moore fails to get into the elevators and off the ground floor; at the Grosse Pointe Yacht Club he is shown the door; likewise he is ushered out by an officious manager at the Detroit Athletic Club. He can't even get to talk with the company's "spokesperson" on the last day of the Flint plant. Pointing his camera at her (inside the building) from his position outside, Moore records her line: "It's a very sad time," she says, simulating feeling. "A very private personal time." And when Moore presses her to speak (she is, after all, GM's "spokesperson"), she says "You don't represent anybody. You're a private interest and I will not speak to you." "We're citizens of the community," Moore protests, unavailingly. (The keyword, "community," seems almost an anachronism here.) The "spokesperson" signals to her police force to escort Moore, once more, from the private property of a publicly owned corporation. Moore does get an open mike during a GM stockholder's meeting, posing as a shareholder; but when Smith recognizes his man—evidently he has not been ignorant of Moore's persistent efforts—he quickly closes the meeting before the dazed filmmaker can utter a word. (Is he really dazed? It's hard to tell.) Moore's camera picks up the chit chat immediately afterwards: "I think he didn't know what the hell to do," Smith and his associate murmur to one another conspiratorially.

Moore does succeed, finally, in achieving a face-to-face confrontation with Roger Smith when he corners the executive, following the latter's unctuously avuncular Christmas speech at a General Motors party. It is the climax we think we've been waiting for, and it is appropriately an anti-

climax, a reiteration of the film's point about the powerful and the power-less. "Will you come to Flint and see the evictions that are going on as a result of GM's plant closings," Moore asks, like Parzival who has at last found the Holy Grail. "I'm sure GM didn't evict them. I don't know anything about it," the Grail replies, and shuffles off disdainfully.

In all of this game of cat and mouse, Moore is making, implicitly, a powerful point about documentary form. Too easily, for a hundred years, creators of documentary (in various media) have made the powerless their subject. Arriving on the scene with still camera, movie camera, or tape recorder, that is, armed with the accoutrements of technologically ad-vanced civilization, the documentarian has essentially given no choice to his subject whether to comply or not with his efforts. Often the efforts are presumed by the creator to be for the benefit of his subject, and sometimes the point is driven home to the subject in the form of money payment. Exposing the "plight" of his subject, the creator of the documentary feels virtuous and we, the viewer, likewise feel the glow of virtue, even if we do nothing, and say only that our "attitude" has changed. By pointing his camera at the unequal power and authority of those making the decisions, Moore turns the tables on the traditional documentary form: he himself, the man with the camera, becomes the "powerless" subject (and serves as an analogue of the powerless worker as well).[3] Showing us a Roger Smith who doesn't "have to" be subjected to Moore's camera, who is savvy enough to avoid it or powerful enough to wall himself off with guards and "spokespersons," Moore is making a devastating point about democracy and industrial policy: the powerful do not have to speak to "us," they owe us nothing. Kopple is much more traditional in this respect, directing her inquiries to the victims only, asking the strikers, "How do you feel?" Moore is essentially not interested in how the worker "feels," or how "hard" it is to undergo this process; when Moore shows us "victimized" workers, he is not working to solicit our empathy: all that is assumed. Instead, Moore acts as a satirist and critic, exposing the moral failures of the powerful by placing them before the camera's deadpan gaze, accom-panied by Moore's own disarmingly ingenuous interlocutory style.

The closest Moore comes to Smith, in a way, is through his lobbyist, Tom Kay, who seems quite willing to talk with the filmmaker, although what he has to say may seem slightly biased: "I'm sure Roger Smith has as much social conscience as anyone in this country." (We learn in a satis-fyingly ironic postscript that Kay ultimately loses his own job.) But actu-ally Kay also supplies a point that the film does not attempt to refute—"GM has *no* obligation to Flint"—and it's a telling one, threatening in

some ways Moore's whole premise: Why this heavy burden of guilt imposed on GM? In a free market economy, where no incentives exist for industry to remain in a given locale, where in fact the incentives go the other way—to relocate in the cheapest labor market—we can see the point. (The greater good of the international consumer must, so the argument goes, outweigh the temporary losses of the individual worker and the community—or even the country.) So what if Flint now has the highest crime rate on the continent? GM is trying to compete profitably in a world market; *that* is its purpose, not to supply jobs to Flint workers. And it doesn't serve Flint if GM goes out of business altogether. If what is happening in Flint is symptomatic of what is happening all over America, the fault lies with forces that are much larger, even, than General Motors, which functions within an economic system it did not create. Moore's neglect of the macro-economic issue in his film may be a more serious problem finally than the worries about chronology, although to address it would have blunted his criticism of General Motors.

And yet, implicit in *Roger and Me* is an even larger social economic point, though it must be drawn out of it: that the same high-handed evasiveness on the part of Smith and the GM management generally, is *the whole problem* in the first place: American corporate management have not ever listened to the man or woman on the assembly line, have not wanted to acknowledge that they even have a human presence. Following the logic of Taylorism as defined by American industry ("a great art form" someone calls it at the Flint "Gatsby party"), the worker is a cipher, most valued when he most approaches an automaton. From such attitudes, quality control circles (and quality cars) do not come. And it has taken the example of the Japanese system, with its greater attention to what the worker on the line can contribute to the whole system, to teach American industry—slowly—something. Moreover, GM did in fact help create the larger forces, by lobbying for laws that promote its own corporate self-interest. And if we accept the legitimacy of GM, we accept as legitimate the destruction of our national economy in the name of "profit"; we accept the destruction of our communities in the name of creating private wealth. What ends can possibly justify these means?

Finally, where Moore goes far beyond Kopple is in creating an image of American life in the late twentieth century, in which the shift from an industrial to a post-industrial economy is fumbled miserably with an awkwardness and absurdity that is both funny and pathetic: Flint tries desperately to survive the demise of its industrial base by creating itself, again, as a tourist attraction, that is, by turning the production of consumer goods

Kopple's *American Dream* and Moore's *Roger and Me* **127**

into a *story* about the production of consumer goods. But it doesn't work. Consumerism and artifice, the creation of an economy of the "simulacrum," as Jean Baudrillard would put it, collapses in on itself. The rabbit is eaten for supper. The last car rolls off the assembly line. "I cannot come to Flint," says the corporate Pecksniff.

Kopple shows us that there are no easy victories, possibly no victories at all, for labor to celebrate at the end of the twentieth century. Moore shows us why: the corporate Father has turned out his sons and shut the door on their imploring voices. Bearing witness in their quite different ways, Kopple and Moore help us a little, at least, to understand such things or to clarify what we won't accept. Kopple's camera reveals the nature of powerlessness and gives it a voice; but it conceals the awful silence of the powerful. And that silence, absurd in its pomposity, infuriating in its Kafkesque reticence, is exactly what Moore shows us. We have no power against it, except ridicule and irony.[4]

8

Writing Posthistorically

Krazy Kat, Maus, and the Contemporary Fiction Cartoon

The cartoon or comic strip has been exploited in various places in contemporary practice, ranging from the high art examples of Lichtenstein and Warhol to the wholesale appropriation of Annie, Batman, Snoopy, Superman, and Dick Tracy by the captains of popular culture, who have retailed their images on stage, screen, lunch boxes, and T-shirts. And while the connections between visual arts and popular culture have received increasing attention (including a recent Museum of Modern Art show), the literary dimensions of the phenomenon have been barely noticed. Two recent fictional examples—Jay Cantor's *Krazy Kat* and Art Spiegelman's *Maus*—demonstrate the peculiar appeal of the comic strip for the contemporary novelist, and though their work was widely celebrated when it first appeared, these writers have as yet received little serious commentary, nor have they previously been linked in discussion. By joining them here, I mean to call attention to the special vitality of the hybridized forms they have invented and to define the new space they have cleared in the literary marketplace. I also want to argue that they have—in a landscape of postmodern irony—stood out conspicuously for a literature that positions the subject psychologically and morally in history, thus pointing fiction in a healthy social direction.

The attraction of the cartoon for American intellectuals and artists goes back to the twenties and thirties, when they began to identify a vitality in

graphic design that was associated with the energy of mass art forms, along with a freedom of improvisation. One thinks, for example, of some of the stylized verbal descriptions of William Faulkner, deliberate distortions of movement, evocations of caricature that remind us that Faulkner was himself a skilled amateur cartoonist (Inge 79-99). Or consider Nathanael West's notion of *Miss Lonelyhearts* as "a novel in the form of a comic strip," the chapters to be "squares in which many things happen through one action" ("Some Notes on Miss L." 1). West abandoned the idea of using a visual model with incorporated speech balloons but kept the notion of free temporal movement within the short chapters of the book and drew upon an imagery of violence that was inspired by the rough action of the cartoon idiom. More recently, Don De Lillo, Donald Barthelme, and especially Max Apple have drawn indirectly on various aspects of the cartoon—a simplified and vigorous imagery, grotesque characters, a logic of surprise, visual signs integrated with text—to break up the highly wrought and relatively smooth narrative surfaces of modernist fiction.

What distinguishes the work of Cantor and Spiegelman is that the cartoon is not merely a source to draw upon, it is indispensable to the conception. The authors of *Krazy Kat* and *Maus* have created narratives that fuse the comic strip and the novel in hybridized forms that have no real precedent. In appropriating cartoon culture Cantor and Spiegelman are not critiquing ready-made images by standing outside of the commercial mainstream; neither are they exploiting fixed associations. On the contrary, they have joined the mentality of the cartoon world with the complexity of high art, aiming at a broader based audience, a middle space between high and popular culture. Yet, significantly, they arrive at the middle from different directions: Cantor, from the high art side, is writing a "cartoonized novel" in the tradition of the experimental work; it is avant-garde fiction that reaches toward a larger audience through cartoon-based characters and the pressure of social concerns. Spiegelman, in contrast, is writing a "novelized cartoon" from the low art side of the comic book, though as an avant-garde underground cartoonist he is coming from the high end of the cartoon world. The struggle within their respective works between avant-garde elements and popular modes forms a major subtheme for each author.

Yet, what makes these works significant is that both *Krazy Kat* and *Maus* embody a seriousness of purpose that goes against the essential lightness of the cartoon mode, for both are attempting a literature that bridges the political and the personal and establishes an exemplary posture

toward twentieth-century history. In different ways, each responds to the challenge that contemporary artists have faced since World War II—of creating an art that can somehow encompass events of an exorbitant violence that seem to render superfluous the imagination and that question the very function of art. Given that seriousness of purpose, the use of the cartoon tradition, with its inevitable connotation of "the funnies," seems all the more significant.

Let me begin with Cantor, whose *Krazy Kat* goes beyond West's example in explicitly incorporating the visual mode of the comic strip as a governing structural device. *Krazy Kat* is Cantor's second novel, following *The Death of Che Guevara* (1983), a long, semifictionalized treatment of the Argentine revolutionary that is, at least superficially, worlds apart from the comic antics of Coconino. Yet *Che Guevara* is likewise a technical tour de force and also represents a re-creation of a universe outside everyday realism. If that novel is ultimately a book about a willed revolution and the possibility of utopia, so too in a way is *Krazy Kat*.

Cantor draws explicitly on George Herriman's long-running comic strip, *Krazy Kat* (1913-1944), admired for decades by such artists and intellectuals as E. E. Cummings, Gilbert Seldes, and Robert Warshow, among many others. For Warshow, writing in the forties, *Krazy Kat* was the best that the comic strip had produced, emblematic of a lumpen culture that disdains "respectable" culture, not in this case by an uncompromising nihilism (cf. the Marx Brothers) but more obliquely by a "complete disregard of the standards of respectable art." At the heart of Herriman's strip is an obsessive triangular relationship between a cat, a mouse, and a dog: Krazy Kat loves Ignatz Mouse (reversing the expected animosity between these creatures); meanwhile, Ignatz constructs his life around tormenting the Kat (reversing the usual timidity of mice before cats). Each strip culminates in the mouse's hurling a brick at the Kat's head, which Krazy—equating compulsion with passion—inevitably takes as confirmation of Ignatz's love. Throughout the series, Offisa Pup (a dog who happens to be in love, protectively, with Krazy) attempts to apprehend the malevolent mouse, sending him with regularity to the jail house. With endless variations on the passions of pursuit, Herriman's strip exploits tensions between love and hate, cruelty and protectiveness, and sign and referent (brick = valentine).

In creating a self-contained aesthetic universe largely impervious to history, Herriman's strip seems essentially modernist, the product of an imperial imagination. Yet everywhere Herriman anticipates the promiscuous confusions of postmodernism: his characters speak a dialect that

fuses eclectically ethnic accents and Joycean portmanteau words; in visual terms, the Southwest setting of the strip—destabilized desert spaces, mesas, cacti—adapts a surrealistic vocabulary to the cubistic angular style and layout of the cartoon page. Yet another anticipation is Krazy's androgyny: though romance is the constant theme, we look at Krazy with nonchalant uncertainty as to his or her sexuality. (For the sake of consistency, I am going to refer to Krazy as "she.")

Cantor's borrowings from Herriman's *Krazy Kat* are both incidental and profound (for a recent collection of *Krazy Kat*, see McDonnell et al.). Each of the strips in the Herriman series uses a single technical motif—letters, dialogue, or fantastic dream—and from this structural consistency Cantor's *Krazy Kat: A Novel in Five Panels* derives its form, each of the five narrative units, or chapters, having a similar formal consistency. Cantor has also explicitly borrowed from his source: printed as the chapter "title page" before each fictional "panel" is a cartoon from a Herriman strip, to which Cantor has added his own twist. The opening chapter, "The Gadget," features a frame in which Krazy Kat reclines in the foreground while a mushroom cloud erupts in the background. Krazy says, "Ogosh—Ogosh—What a joyliss day." The Kat seems here to be responding to the atom bomb test, which is the subject of the chapter that follows. But the 1918 cartoon that is the source features a Kat who is disconsolate because Ignatz Mouse, her beloved, is nowhere in sight. A volcanic eruption in the background catapults a rock at Krazy's head, which she happily and typically interprets as Ignatz's particular love-sign. Without the original source we may think Herriman has uncannily anticipated the atomic age, but Cantor's borrowing is a trompe l'oeil which plays on the visual ambiguities inherent in Herriman's relatively abstract drawings.

These panel-pages at the start of each chapter—along with a sprinkling of drawings at other points in the text—remind us of the Coconino landscape of Herriman's original comic strip, interfusing the narrative with the trace of the quaintly surreal two-dimensional Southwest of the original. Above all, Cantor has taken his lead from Herriman in the verbal texture of his fiction—the linguistic freedom and polymorphous play, the puns and dialect jokes—while also exhibiting radically updated intertextual references that encompass American culture from high to low, from Freud and the Marquis de Sade to Cole Porter and Rodgers and Hart. But Cantor's special originality is in bringing the Coconino world into contact with the real—and awful—world of the twentieth century otherwise outside the purview of the comics. The premise of Cantor's *Krazy Kat*, announced in a prologue, immediately raises the problem: following Krazy's witnessing of

Jay Cantor: *The Gadget* (panel one) from *Krazy Kat*. Reprinted with special permission of King Features Syndicate.

the atomic bomb test at Alamogordo (Krazy's natural habitat is the Southwestern desert), she falls into a deep depression and inertia. The basic plot of Cantor's novel is the effort by Ignatz and company to motivate her to return to work and thereby keep the comic strip world going.

The seed of *Krazy Kat* can be found in Cantor's earlier work, *The Space Between*, where he discourses on the nature of violence and revolution, both as writing and action, on the terrorism of the modern state, and on the corresponding obligation of the writer to remake the world by speaking directly. In the middle of a rumination on Beckett and the curse of "incurable optimism," we find this forecast of things to come: "Krazy Kat hopes that someday Ignatz Mouse will love her (him); much ingenuity must be used in reinterpreting the meaning of the brick that conks her on the head" (113).[1]

But if aggression be an act of love, the door is open to a host of awful possibilities, and Cantor's ingenious interpretations constitute the psychological—and the political—crux of *Krazy Kat*. Thus, when Krazy first sees the atomic testing in the desert, she translates it into her familiar terms: *The Gadget was an amazing new device to deliver a brick to her head!*" (18). And seeing the scientists in the flesh, this feline Miranda falls in love with Oppenheimer and with the whole crew of bomb-builders: "O, wonder! . . . How Beautiful men are! . . . And what a brand-new desert that's got good looking stuff like this on it" (21). But when Krazy Kat learns of the destructive power of the bomb, her depression is compounded by guilt and confusion, as Ignatz—posing as Oppenheimer—writes fan letters to Krazy in which he blames the Kat for inspiring Oppenheimer, on the grounds that just as "the Mouse's bricks became bouquets," so the bomb would bring about world peace. Ignatz's goal here is to end Krazy's depression and so allow her, and the entire Coconino crew, to return to work in the comic strip.

But Ignatz's ambitions go beyond the mere flat comic strip: the intricate plot of *Krazy Kat* encompasses Ignatz's diabolically contrived efforts to transcend the familiar two dimensions, the lowly flatland of popular culture, and attain to the roundness of high art. Ignatz explains his intentions to Offisa Pup: "Like other immigrants and their children . . . I'm ready to give America a big Chanukah present back—a new image of the self. But this time why lock ourselves up in the pop-culture ghetto? Why not strut uptown to the mansion of high art, of roundness, and say that our gift to America could rank with Eugene O'Neill's or Henry James's? America *needs* a truly *democratic* high art. America needs the round comic strip!" (60-61). The notion of a hybridized art thus overcomes the liabilities of the

extremes: if popular culture is in one ghetto, a "prelapsarian playpen" (85), unable to bring about social change, avant-garde art is in another, equally sterile realm, "divorced from real poor people's lives" (139). The cultural business of the artist is to help us assimilate our generation's catastrophes —the Bomb and the Holocaust—by asking questions that help us re-imagine and rediscover "what we might truly worship" (Cantor, "Interview" 7).

If Krazy Kat is one such god for Cantor, it is because of her ability to improvise, just as Herriman improvised a daily strip for decades, ringing endless changes on the same theme, expanding the essential enigma of the Kat and Ignatz. Or, as Cantor's Ignatz puts it, pointing to a Rauschenberg painting, "the high arts want to be open to improvisation, like the popular ones. See, this picture is like a city dump, no above or below, no better or worse, no richer or poorer" (213).[2] Krazy and Ignatz do, at the end of the novel, achieve their "roundness" as performing artists, with Krazy, the embodiment of our time's androgynous sexuality, singing and Ignatz accompanying her/him on the piano. Cantor gives them—via a review in the press—the blessing of having achieved thereby a sublime artistic incarnation: "Kat and Ignatz live, as we all do, in the acceptance *and* anxiety of their sexuality, in the knowledge of change, *and* in the flat, unchanging, relaxing dream of innocence. It is a painting and a *flag*" (242).[3] This is the utopian core of Krazy Kat, an image of self-transformation through an art that embraces contradiction and vicissitude, an art that is likewise a means of refashioning culture.

Yet the last image of the book is straight out of Herriman's original strip: the deserted mesa, the metamorphosing backgrounds, "the small, empty stone building . . . with a faded wooden sign over the door: JAIL" (245). Cantor's Krazy and Ignatz may have escaped from the jail of popular culture, from the two-dimensionality of the cartoon world, but they have entered the fallen world of "real" characters who can experience "real" death. The conclusion of *Krazy Kat* cannot escape a certain elegiac tone, as if mortality may be too high a price to pay for the triumph of art.[4] *Krazy Kat* has many trompe l'oeil elements in it, but none as pervasive, or as easy to miss, as this: in offering us the transformation of lowly cartoon characters into mainstream artists, Cantor is writing an inverted allegory of his own artistic ambition, which is to transform an avant-garde, experimental work into a hybridized work that creates its own space in the realm of a middle culture. Cantor opens up the mansion of high art that Krazy and Ignatz, from off the streets of popular culture, have been struggling to get into.

Despite the excellent reviews greeting *Krazy Kat*, whether Cantor will

occupy the space of a middle culture to which he aspires is uncertain. That ambition, woven ironically into the novel, places the author in a posture assumed many times previously by the American artist, who has long dreamed of an art that would unite popular and high culture and that would bring together the political and cultural strains in America.[5] First enunciated by Whitman, this dream of art has been echoed in the early twentieth century by Van Wyck Brooks, Lewis Mumford, William Carlos Williams, and more recently Norman Mailer. Transporting the popular heroes of Herriman's strip into the world of Marx, Freud, Hollywood, Patty Hearst, the Bomb, and the Holocaust, Cantor's *Krazy Kat* implicitly tries to answer the question it raises at the outset: "How would the next generation tell its stories?" For Cantor, the artist is part prophet and part shaman, and Herriman's comic strip, with its longstanding popularity, provides a ready-made theme for an exploitable entry into the American imagination.

Cantor's use of the cartoon mode allows him to engage in an extravagant narrative action bordering on dreamlife, even nightmare. At one point in his ingenious "psychoanalysis" of Krazy Kat, Ignatz shaves Krazy's tail: "[M]y son Irving jammed it [the tail] into a light socket; and I stuck a bulb in her mouth to check the current. That made a nice kat lamp" (64). Cantor is alluding to the popular humor of feline sadism that is the obverse of our culture's sentimentalizing of the cat; he is also alluding to Nazi experimentation with the Jewish body. (Though Cantor does not make much of it, Krazy is depicted as a quasi-Jew in *Krazy Kat*, and her victimization at the hands of the obsessed Ignatz echoes the larger theme of the novel: the deeply twinned and codependent feelings of love and hate, an ambivalence that can be both personal and political.) The violence of the comic strip, with its typically indestructible characters, can inure us to the vulnerabilities of human flesh as we become inadvertently adjusted to the possibilities of mutilation, even as we distance ourselves, through the detachment of the stylized cartoon-fiction world, from the Nazi history.

Art Spiegelman's *Maus*—which is a "graphic novel," a book-length sequential narrative using pictures, a cartoon-book—functions in a quite different way: where the typical cartoon desensitizes us to violence, Spiegelman sensitizes us, despite the fact that he traps his characters within visual stereotypes that threaten to destroy their sensibilities (Witek, 96-120). *Maus* is a frame story, with an external narrative enfolding an inner one: in the surrounding story, Art Spiegelman, a cartoonist, is writing a cartoon-fiction about his father Vladek, a refugee from Nazi Europe now

living in Rego Park, Queens. The inner story is Vladek's. Part biography, part autobiography, part history, part novel, *Maus* straddles genres; yet in dramatizing self-reflexively the act of its own composition, it also claims formal kinship with modernists like Gide, Joyce, Nabokov, and Faulkner. Above all, *Maus* is committed to its function as an authentic, factual record of the Holocaust and thus immerses the reader in the banal particularities of the story of survival. The several diagrams in *Maus*—of bunkers, hiding places, Nazi concentration camp designs—function as graphic signs, maps, of lived space, where every detail has possible vital significance.[6]

The story within the frame, the story Vladek tells his son, is in the beginning a tale of the father's growing success: his surviving army service, his starting out in business, his marriage to the daughter of a wealthy businessman (Anja), and eventually his acquiring a factory of his own. Shrewd and competent, Vladek finds success following success. But with the invasion of the Nazis into Poland, *Maus* quickly becomes a tale of the father's desperate struggle for survival—first his keeping the family together, then his hiding in order to avoid deportation, his discovering ingenious solutions to the problems of hunger and cold, and eventually his fleeing from one hiding place to another. Finally, there is betrayal and capture, for *Maus* ends as Spiegelman's parents are brought at last to Auschwitz: "And we knew from here we will not come out anymore" (157). Or so it seemed, for we know that *Maus* is, as the subtitle tells us, "a survivor's tale" and that Vladek and Anja will eventually live in the U.S. But there is no "happily ever after" in this story, for we also know that Anja will commit suicide and that Vladek will live tormented by his memories and by his survival, a legacy passed on to his son, who has struggled with his own demons.

Vladek's survival is, as I have mentioned, only one of the stories of *Maus*. What adds a crucial dimension to the novel is the frame surrounding that tale—the relationship between father and son and the process of transmitting the story from one to the other, so that the book as a whole asks, what does it cost to survive? (Money earned, objects bartered, objects saved, and money used to buy life are constant motifs.) That question is implicit in the opening panels of the book, a kind of prologue, in which the young Art is left behind by his friends when his skate breaks, thus eliciting his father's pronouncement: "Friends? . . . If you lock them together in a room with no food for a week . . . THEN you could see what it is, friends!" (5). And the question appears throughout with a careful counterpoint of the frame narrative against the inner one: after Vladek talks about having to clean out stables for the Germans, he orders his son to clean up the

cigarette ash on the carpet; talking about the jewels he used while in hiding to barter for comestible goods, Vladek leads his son to the Rego Park bank where his safe deposit box holds his papers and valuables, including a few old things from the war. Above all, the war has marked the present mentality of Vladek—his hoarding of junk of all kinds, his resigned grief at the loss of his first son during the war, his continued mourning after his wife's suicide. When Art discovers that his father, who picks up used telephone wire, had long ago burned his wife's diaries—thus destroying the inscription of memory—the son delivers an ultimate judgement on the father: "God DAMN you! You—you MURDERER! How the HELL could you do such a THING!!" (159).

Thus the postwar years, Spiegelman suggests, in many ways duplicate, uncannily recapitulate, the perversities and deformities of the war. The cost of survival is a loss of the vital self. Spiegelman had earlier worried that his father—transformed into a stereotypical miser by the urge to survive—would appear simply unbelievable as a character in his fiction. Now the son's verdict, delivered in the last frame of *Maus*, for the moment at least reduces Vladek to the level of his wartime oppressors: "Murderer." Yet Spiegelman the artist obviously has a larger empathy for his father than Art Spiegelman the cartoon character, and the reader can see the irony of the son's bitter judgement, mindless as it is of the desperation with which the father seeks an oblivion.

The most startling feature of *Maus* is that Spiegelman the cartoonist draws himself and the other Jews in the fiction as mice, while the Nazis are drawn as cats and the Poles as pigs. To discuss *Maus* without mentioning its graphic form—as I have been doing—is to misrepresent it completely. But I mean to suggest by doing so a surprising aspect of the work: the reader comes to forget that these are cats, mice, pigs and soon begins to view them instead as human types. Yet the animal rendition functions as an ongoing metaphor that gains in significance as the narrative progresses.

The rationale for this visual typology is at least twofold: first, as the epigraph to *Maus* (quoting Adolf Hitler) ironically suggests, the Nazi ideology itself was dehumanizing, one that turned its victims into less than human beings: "The Jews are undoubtedly a race, but they are not human." Second, in telling *Maus* from the Jews' perspective, Spiegelman is representing the world in the simplified but starkly authentic way the victims of the Nazis experienced it: the Jews were like mice to the terrifying cats of the Nazis; many of the Poles were, to the Jews, like pigs in their comfortable complacency. The world was a theatre of stereotypes, of masklike signs of danger or indifference. The cartoonist Harvey Pekar—who writes

Art Spiegelman: *Maus: A Survivor's Tale (p. 113)*. Reprinted by permission of Pantheon Books, a division of Random House, Inc.

his own quite different kind of "adult" comics—has attacked *Maus* for these insulting caricatures, arguing that they are dehumanizing to begin with and that in showing these Polish pigs behaving admirably (as they indeed sometimes do), Spiegelman is sending us a mixed message. That may be true, but so much the better: The complexity of the characterization adds to the authenticity of the narrative and healthily undermines the stereotypes.

The drawing of the animals in *Maus* are carefully muted and stylized, a relatively neutral mode that Spiegelman arrived at after experimenting with more literal animal depictions. Along the way to the final version, Spiegelman tested his own version of the mice-Jews against the "real" world of animals: thus, an early version of chapter three appeared in *Raw* magazine in 1982 (*Raw* 4), which included a reproduction of a 1937 *Life* magazine cover (1 March 1937) featuring laboratory mice huddled together in a helpless mass. (Spiegelman substituted "Maus" for "Life" in the upper left corner.) After coming to "know" the mice of *Maus*, it is something of a shock to see these real lab mice, so dumb looking and expressionless, such faceless victims. One sees them without their "humanity," and it is a measure of how readily we come to take this humanity for granted that, at a point late in the text when Vladek and his wife are in hiding underground, the scurrying rats around them evoke a fear that seems perfectly plausible to the reader. In contrast to these large, ugly rodents, the mice-Jews are drawn with subtlety and economy, their postures and expressions suggesting vividly and movingly their human feelings. (This does not mean that Jews necessarily appreciate *Maus*; the depiction of Jews as mice can be offensive to those who see only the drawings without reading the story.) It is precisely the tension between the animal drawings and the references to them as Nazis, Jews, Poles that makes *Maus* work.

The drawings, however, must not pull us away from the text. Accordingly, Spiegelman employs an intentionally understated visual vocabulary in *Maus*, as compared to his other work. Nevertheless, *Maus* functions subtly as a visual construction: crucial elements in the narrative are discovered only in the drawings, so that individual frames must be read in detail. Meanwhile, the arrangement of squares and circles on the page as a whole creates an opposite effect, a constantly varying visual pattern, reminding us of the artifact of cartoon construction.

But a large factor in successfully engaging the reader is the verbal text itself, for Spiegelman has an accurate ear for Yiddish-American speech and skillfully uses the hand-drawn letters of the cartoon to emphasize

intonation. Here is Vladek talking to his son, explaining why he is always pedaling his exercise bicycle, a motif that runs throughout the volume: "It's good for my heart, the pedaling. But tell me, how is it by you? How is going the comics business?" (12). Time and again, Spiegelman achieves his effects through understatement, placing a restraint on the exorbitant grief of his father's story that in turn heightens the effect. Allowing the cartoon imagery to express the nuances of these dramatic moments, Spiegelman can achieve an intensity and economy that might otherwise be found only in theatre. But the close analogy is to realistic cinema, as Spiegelman carefully controls the point of view—the "camera angle" of the reader—constructing a narrative that is as much the product of visual signs as verbal.

In moving the cartoon into the realm of serious political and psychological issues, Spiegelman is offering a kind of art that reaches outside the relatively constricted boundaries of the comic book audience, with its steady appetite for marvels and fantasies and for the extravagant depiction of crime, violence, and war. His work is part of a larger underground comix movement (spelled thus to mark the difference from conventional comics) which, stemming originally from *Mad* magazine's fifties' satirical view of American culture, gained momentum during the seventies. The underground comix created an audience for cartoons that could range from the pseudopornographic antics of *Zap* and the artfully unkempt satires of Robert Crumb to the more cerebral vaudeville of Pekar, whose assertively working-class orientation and introspective ruminations have been appearing in an autobiographical series called *American Splendor*.[7] But with *Maus* Spiegelman has reached well beyond the audience of the underground cartoonists.

The creation of a new audience for the cartoonist has, in fact, been one of the prime motivations behind the construction of *Maus*, as Spiegelman made clear in an interview in 1981, when he talked about the founding of *Raw* magazine as a vehicle for underground cartoonists whose work—however diverse in other respects—consistently featured well-designed graphics and who as a group had not yet found a coherent presentation, a niche in the market. (For years, *Raw* was printed on oversize paper and in high quality color, making it more marketable in bookstores and newsstands than in comic book stores.) His aim, Spiegelman said, was to reach people "who don't go into comics specialty shops, don't browse underground comics racks, and aren't already predisposed to comics but could be if the right material were presented to them" (Spiegelman and Mouly 108). The exclusions in this definition of audience are as interesting as the

inclusions: Spiegelman and Françoise Mouly (his co-editor and wife) are interested in neither the popular *Marvel* audience nor the audience at the other extreme, the elitist gallery market with its appetite for unique prints. They are designing *Raw* for some sort of "middle": "Though we are doing a printed magazine, we're not doing a mass media magazine. We are trying to fall somewhere in between. A unique object, yet not a unique object. There's 5,000 of them, it's available to most people who want it. At this point, to us, that's a pretty satisfactory solution" (123).[8]

However satisfactory a circulation of 5,000 might have been for *Raw*, Spiegelman aimed for an even larger audience for *Maus*, an audience that came when the chapters that had been published serially were brought together into the volume published by Pantheon in 1986. If the hybrid form of the novelized cartoon is something new, it is not necessarily the new thing that an audience raised on Mickey Mouse will buy, and indeed the shadow of Mickey—shallow, brazen, successful—stands behind these victimized Jews of Spiegelman's *Maus* as a kind of implacably taunting anti-mouse. It is all the more ironic, therefore, that when Art's proud father contemplates his son's possible success as a cartoonist, he should see him as a second Disney, although Vladek's own estrangement from the mainstream prevents him from easily remembering that name: "Someday you'll be FAMOUS, like . . . what's-his-name? . . . the Big-shot cartoonist" (133).[9]

The conclusion of *Maus* promised a sequel, which began to appear in 1986 as chapter installments in *Raw*; confirming that a tail could wag a dog, *Maus* carried *Raw* into the trade paperback marketplace, where it was published in a downsized version by Penguin. (Where a book-size *Maus* had previously been inserted into the large-format *Raw* in a separate binding, the graphic comics of *Raw* became at this point all of a size—*Maus* size—as further proof of the latter's dominance.) As if to acknowledge the wider audience for *Maus*, Spiegelman printed at the start of chapter eight in the Penguin *Raw* (renumbered as chapter two in *Maus II*) a brief summary of the earlier volume, together with a miniaturized reprint-cum-synopsis of chapter seven (chapter one in volume two). In 1991 the completed sequel, *Maus II*, with chapters one through five (the last not previously published) appeared.

The continuation of *Maus* is not only the continued story of Vladek and Anja and their separate incarcerations in Auschwitz and Birchen but also of Art's history of this relationship with his father. The frame does not take over the inner story, but it occupies more space, enacting the son's oedipal displacement of the father, as Art comes increasingly to measure himself

against his father, whose influence and power have so mightily engendered his own creativity. And, as Vladek grows increasingly ill, we see his son dealing guiltily with the burdens of his father's mental and physical condition. Spiegelman's honesty in presenting his own resentment and bafflement at his father's demands for attention—even as the cartoonist knowingly and single-mindedly exploits his parent's memory of the past for his own purposes—is remarkable. Moreover, in *Maus II* a major subtheme emerges: for the children of survivors, life is lived under the sign of the Holocaust, a posthistory in which everything is put against a gold standard of Holocaust authenticity. At the outset of chapter one Art talks at length with his wife, Françoise, about his own acute sense of privilege—and guilt—in not having suffered what his parents went through; he also feels, as an artist, inadequate to the enormity of the representation he is undertaking: "There's so much I'll never be able to understand or visualize. I mean, reality is too COMPLEX for comics. . . . So much has to be left out or distorted" (16). As chapter two opens, we learn of Vladek's death (in 1982) and of Art's creative paralysis: the success of *Maus* has brought the cartoonist a plague of offers from publishers, TV, and movies, but the cartoonist is feeling depressed, haunted by images of Auschwitz corpses, increasingly infantilized by the demands of the commercial world—which reduce him literally, in the beautiful economy of cartoons, to a squalling infant, crying for his Mommy. In this reduced state he visits his psychiatrist (himself a survivor), who finally gets him back on track, and the story of Vladek can again resume.

What also occupies Spiegelman in part two is the whole conception of the Jew as mouse. Chapter two begins with the artist experimenting with different animal characterizations for his wife, Françoise, who is French, but whose conversion to Judaism, she argues, should qualify her to be drawn as a mouse. (Art imagines illustrating her conversion as a transfiguration, under the blessings of a rabbi, from frog to mouse.) Later in that chapter the issue of visual representation is again self-reflexively brought up, as Art observes that his psychiatrist's place "is overrun with stray dogs and cats" and wonders, in an inserted voice-box, "Can I mention this, or does it completely louse up my metaphor?" (43). There is a coy quality here, a too obvious joking, that marks the cartoonist's self-consciousness, but more significantly, in the prologue that begins this chapter, Spiegelman draws himself as wearing a mouse *mask*. Likewise, the other characters in this section—TV personnel, entrepreneurs, psychiatrist—are all drawn with animal masks. The self-consciousness of the stereotypes is acknowledged here, along with the implication that the whole structure of masking

entails an inauthenticity for Spiegelman (in the late twentieth century) markedly different form his father's more authentic assumption of the mouse identity. Yet in the scenes following this prologue that include Art and Vladek, Spiegelman draws himself as a mouse and not as a man with a mouse mask. The death of Vladek, Spiegelman seems to suggest, has left Art with a general feeling of inauthenticity, a shaken identity in which his Jewishness is felt as a mask.

That sense of living posthistorically surfaces again in the stunning final pages of chapter two, when Art and Françoise (visiting Vladek in the Catskills) sit on the porch outside Vladek's rented cabin, while inside the survivor moans frighteningly in his sleep. Still, Françoise says, "It's so peaceful here at night. It's almost impossible to believe Auschwitz ever happened." The concluding frames show Art, feeling eaten alive by bugs, blasting the insects with an insecticide spray: their corpses litter the porch. Thus in the changed reality of postmodernism do we pass from nightmares to petty annoyances, from gas chambers to spray cans, from corpses to dead flies. The ironic disproportion between past and present emphasizes the disjunction between father and son, but it also draws a line of separation between the anguish of Art and the relative insouciance (albeit sympathetic) of Françoise. To live posthistorically is to live in a kind of security and freedom, but it is not, as Spiegelman depicts it, a liberation from the past, rather a more acute reckoning with its full burden.

The point is made most directly in chapter three of *Maus II*, when Art asks (not for the first time) for letters and other documents of the war time, and receives this rebuke from his father, who has thrown them away: "All such things of the war, I tried to put out from my mind once for all . . . until you rebuild me all this from your questions" (98). It is the son's burden, not the father's, to examine, if not to relive the past, and these lost documents, especially the destroyed diaries of his mother, continue to obsess him. The last page of *Maus II* puts the case most poignantly, and puts it to rest: As the father is driven by the son deeper into his memory, recalling at last his ecstatic reunion with his wife Anja after the war, he says, "More I don't need to tell you. We were both very happy, and lived happy, happy ever after" (136). We know already that Anja committed suicide in 1968, but Spiegelman's tombstone drawing at the bottom of the page—a double stone for Vladek and Anja—reminds us. The father's farewell to his son is also filled with irony, for in the last frame, Vladek, exhausted from his efforts at recall, says: "I'm tired from talking, Richieu, and it's enough stories for now." However much Vladek may have wished to escape the past, it has not been possible (Richieu was his first son, killed

during the war as a child): and the burden of that confusion of past with present is lived by the second son, the guilty survivor of his parents' war years, as well. Or rather, one might say that the labor of art has been to somehow erase that burden, to dedicate himself to some restoration of meaning to the past: *Maus II* is dedicated to Richieu, who appears there, visually, in an actual photograph on the dedication page, the image having been preserved from the European holocaust by his Polish governess. For Spiegelman the cartoonist, whose work is now over, the end of the book is also a kind of epitaph for himself, as he signs off at last on these years of work by adding his own line, under his parents' tombstones, "Art Spiegelman 1978-1991."

The irony of *Maus*, like that of *Krazy Kat*, relies upon the foregrounding of incongruities that variously undermine our secure sense of history and our place in it. If, following Cantor, we take the cultural task of the writer to be the assimilation of world-historical events, then *Krazy Kat* and *Maus* do so in ways that problematize history, interrogating our own relationship toward the past. Against our tendency to distance ourselves from the Bomb and the Holocaust, both Cantor and Spiegelman imply our psychological complicity. As Cantor has put it in a recent interview, we "must re-understand ourselves as people who are capable of such acts and find out what within us has led to those acts" (6). In different ways, Cantor and Spiegelman suggest our ambivalent psychology of bombs and bouquets, love and murder, survival and suicide.

Where they differ from each other most tellingly is in their psychoanalytic orientation: Cantor, writing out of a utopian political orientation inherited from the teachers of the sixties generation (Nietzsche, Herbert Marcuse, Norman O. Brown), creates a tale about the perpetual remaking of the self and about the need to encompass the fullest definition of wholeness—the complexities of sexual identity, of love and renewal, along with the impulse toward destructiveness and death. Spiegelman, more pessimistic in a classic Freudian sense (and more classically modernist as well), writes out of a compulsion to understand the heavy weight of the past as both a public and a private burden. There is no joy of renewal in Spiegelman's universe: there is understanding and at best acceptance. Cantor's revolutionary utopianism is, in this respect, the opposite of Spiegelman's conservative pessimism. Yet both writers, drawing upon and expanding the limits of graphic comic literature, are working outside the boundaries of the suspensive irony defined by Alan Wilde as characteristic of postmodern fiction, an irony in which "an indecision about the mean-

ings or relations of things is matched by a willingness to live with uncertainty, to tolerate and, in some cases, to welcome a world seen as random and multiple" (44). With their hybridized inventions, Cantor and Spiegelman are attempting to occupy a cultural middle zone in which the reader is brought back into the catastrophes of twentieth-century history in a way that calls for a healthy self-interrogation and self-renewal along with a reckoning of guilt and that takes us finally well beyond the usual pastiches of postmodernism and the forever disappearing self.

9

Understanding Disneyland

American Mass Culture and the European Gaze

Scholarly interest in the impact of American mass culture on Europe has reached a sort of high water mark in the nineties, the climax of nearly five decades of post-World War II influence. Perhaps the strongest symbol of that influence was the opening, in 1992, of Euro Disneyland, which promised (or hoped) to extend a sovereignty in popular culture that had already been felt for decades in print and film to the culture of tourism. (Ten million French children read the weekly *Le Journal de Mickey*.) With Euro-Disney, it would no longer be necessary to go to the United States—at least for Disney. Nor was it any longer necessary to go to the U.S. for fast food: in 1991 McDonald's opened more restaurants abroad (427) than it did in the U.S. (188), and its top ten restaurants were now in foreign countries. Coca Cola, in the early nineties, already earned 80% of its profits outside of the United States (Shapiro). Yet what is it that we Americans were selling the world? Soft drinks, hamburgers, and Mickey Mouse—along with our formula movies and T.V. shows, which likewise feature soft drinks, hamburgers, and Mickey Mouse. No wonder the response of the European intellectual community to Euro-Disney was at least ambivalent: the specter of Ronald McDonald and Donald Duck holding hands, together erasing national cultures, enforcing an "American" culture so defined—it was enough to trouble the intellectual's sleep.[1]

And indeed, just these fears were voiced on the occasion of Euro Dis-

neyland's opening in April 1992. One writer, Jean Cau, rejected the $4 billion dollar park as a "horror made of cardboard, plastic and appalling colors, a construction of hardened chewing gum and idiotic folklore taken straight out of comic books written for obese Americans." Another, novelist Jean-Marie Rouart, lamented the transformation from craft to industrial culture—as if it hadn't begun 100 years ago—and warned with fresh indignation that "if we do not resist it, the kingdom of profit will create a world that will have all the appearance of civilization and all the savage reality of barbarism" (qtd. in Riding). Behind these reactions and giving them special force was the sense that this was a material invasion, a violation of France, of Europe, on its own native grounds. It's one thing to have American mass culture safely in America—you go there if you want to, it's *there*, safely outside one's native country. It's another thing to have it on the European continent itself, capturing the mentalities of millions, seducing them through the endless tuneful repetition of "When You Wish Upon a Star." But what star is it, exactly, that is leading them on? Is it the same that the American has been following? And why are so many following it?

We need to understand Disneyland because so many, here and abroad, seem to want it. And we need to see, as I hope to show later, why it is not only hugely popular, but a fateful symptom of postmodern culture. To better understand Disneyland, however, we need to consider first the broader range of popular culture of which it is a part.

Two of the most prescient and influential observers of American culture in recent years, European or American, have been Jean Baudrillard and Umberto Eco, and it is with their work—specifically Baudrillard's *America* (1986) and Eco's *Travels in Hyperreality* (1986)—that I want to begin.[2] For both Eco and Baudrillard the concept of "hyperrealism" is central to a description of contemporary American culture. Looking at a wide range of phenomena in popular culture—from wax museums, to ghost towns, to living historical museums, to museums featuring art reproductions (the *Pieta*, *The Last Supper*)—Eco perceives a civilization of replicas that has resulted from an "unhappy awareness of a present without depth" (31). And he theorizes that these replicas have arisen as a response to the vast space of the continent, as part of a nation's effort to close distances by constructing ubiquitous replicas of itself (53). Thus evolving as a reaction against the cultural deficiencies of both time and space, Eco's reproductions function, not as incitements to authenticity (as one might imagine in some ideal cultural utopia) but as fully satisfying surrogates.

Baudrillard's America, like Eco's, is one of replications, which he too sees as a people's efforts to construct "a past and a history which were not their own and which they have largely destroyed or spirited away. Renaissance castles, fossilized elephants, Indians on reservations, sequoias as holograms etc" (*America* 41). These things are reconstructed, he goes on, as "*something more real*. And this indeed is the perfect definition of the simulacrum" (41). Where Eco keeps his focus on material reality, Baudrillard extends his sweeping gaze to encompass a much wider array of cultural forms and expression. And everything, he avows, is "destined to reappear as simulation. Landscapes as photography, women as the sexual scenario, thoughts as writing, terrorism as fashion and the media, events as television" (32). Clearly, Baudrillard goes much farther than Eco in defining a culture that is itself delusional: the "fantasmagoria and excess which we locate in the mind and mental faculties have passed into things themselves" (86). In Baudrillard's own mind, at least, the cities and deserts are fully continuous with the movies (56). Space is not *overcome* by the replication, as it is for Eco; instead, the deserts are the quintessence of America—"The inhumanity of our ulterior, asocial, superficial world immediately finds its aesthetic form here, its ecstatic form" (5). Yet Baudrillard positively revels in the emptiness of the American space and in the heat of travel across the desert: like a half-crazed philosophical monk, he seeks there the purity of abstract salvation.

America functions, vis-à-vis Europe, as a kind of deliberate oxymoron for Baudrillard: it is a sign of the primitive, yet also a sign of the future.[3] "The fascinating thing is to travel through it as though it were the primitive society of the future" (7). Yet there seems no possibility, no danger, of Europe becoming America (Baudrillard wrote before Euro Disneyland). "The gap is too wide. There isn't just a gap between us, but a whole chasm of modernity. You were born modern, you do not become so. And we have never become so" (73). For that matter, Baudrillard's attraction for America, no matter how strong, can finally not overcome the distance of his intellectual's gaze: it is tiresome to search for works of art in America, "it is the lack of culture that is original," and when "the Americans transfer Roman cloisters to the New York Cloysters, we find this unforgivably absurd." Baudrillard subjects America to a European gaze that transforms it into a cultural bimbo, intellectually vapid yet alluringly Actual. Disneyland is magnificent *because* it is naive, it is kitsch, "astonishing in its nonsensicality" (101).

Eco's definition of American culture vis-à-vis Europe is, by comparison, considerably more generous. In Disneyland, Eco writes, we "enjoy

the conviction that imitation has reached its apex and afterwards reality will always be inferior to it" (46). To Baudrillard the Disneyland crowd "pretends to be taken in" to "avoid feeling too disappointed" (55-56). Eco, by contrast, sees Disneyland everywhere confessing, even flaunting its illusions (Cf. the company's pride in its "audio-animatronics" research), and the crowd is "meant to admire the perfection of the fake" (44).

But the clearest difference here is that where Baudrillard proclaims the stupendous novelty of Disneyland, isolating American culture from Europe, proclaiming its possibly prophetic role yet at the same time its distance from the essence of Europe, Eco *connects* the two cultures, offering us a view of America that assimilates it to the popular European sensibility. He notes, for example, that the European tourist's pilgrimage to the *Pieta* is no less "fetishistic than the American tourist's pilgrimage to the Pieta of Forest Lawn" (39). And the Goethe Institute too must share the European guilt in producing sacred replicas—having, in the absence of originals, remade Man Ray's spiked flatiron and Duchamp's bicycle wheel. Even Eco's identification of the saving function of American culture—its serving as the Last Beach of European culture as the latter sinks into barbarism—finds its parallel with European practice, which since the middle ages has accumulated "classical reminiscences with incredible philological nonchalance" (37).

Above all, Eco connects the technology of replication in Disneyland and the wax museums with the innate human pleasure in imitations, offering an abundance of parallels in European aesthetic experience—from the neo-classical waxworks of the Museo della Specola in Florence to the flayed muscles of St. Bartholomew in anatomy lecture halls, from the "hyper-realistic ardors of the Neapolitan crèche" to the "polychrome wood sculptures of German churches and city halls" (14). The response to the *representation* as if it were the real thing is part of the pleasure we take in the reproduction (in whatever medium).[4]

If indeed Disneyland is exploiting a level of popular response that has been a part of European aesthetic and ritual for hundreds of years, then we can't regard the newest European installation of Mickey Mouse as the criminally wicked invasion of mass culture into the once-virtuous land of High Art that many have pictured it to be. Instead, Eco establishes a more complex linkage between Europe and America, based on a shared lineage. And along with this more involved view, Eco refuses the easy conspiracy theory that sees mass culture as the product of a dominant hegemony, a merry band of captains of consciousness. As Eco reminds us, looking at American culture in its representative character and implicitly countering

the Frankfurt School, the mass media are part of a total surround: "Who is the producer of Ideology? . . . There is no longer Authority, all on its own (and how consoling it was!) . . . All are in it, and all are outside it: Power is elusive, and there is no longer any telling where the 'plan' comes from" (149). "Once upon a time," he continues, "there were the mass media, and they were wicked, of course, and there was a guilty party. Then there were the virtuous voices that accused the criminals. And Art (ah, what luck!) offered alternatives, for those who were not prisoners of the mass media.

"Well, it's all over. We have to start again from the beginning, asking one another what's going on" (150).

What *is* going on?

Eco leaves us more with the question than the answer, yet the sweeping generality of the question seems appropriate as we take a closer look at Euro Disneyland and at the larger culture it represents. And one of the most striking facts about the new European installation, reflecting a practice that had already begun in Florida, is the fusion of high and low culture that Disney enacts, a fusion that we see as a characteristic sign of postmodern culture. Thus, Disney has commissioned such architects as Robert Stern, Michael Graves, and Frank Gehry to design its hotels, making it in fact one of the major patrons of postmodern architecture. (Robert Venturi, Aldo Rossi, and Gwathmey and Siegel are scheduled for future projects.) Does this make Euro Disneyland high art? low art? or something inexplicable in between? You now have, in Europe, the huge Newport Bay Club modelled on a turn-of-the-century Rhode Island resort hotel; a Hollywoodized Wild West town, called Hotel Cheyenne in which the French employees greet guests by saying "Howdy"; a woodsy mountain retreat designed by French architect Antoine Grumbach as an environmentally correct space, called Sequoia Lodge; and a sprawling mesa-like structure, the Hotel Santa Fe, designed by Antoine Predock and featuring a Trail of Artifacts, a Trail of Legends, a Trail of Infinite Space, smoking volcanos, cactus gardens, and a giant drive-in movie screen over the entrance. Predock, who was inspired by Wim Wenders' film, *Paris, Texas*, wanted to keep the screen blank to symbolize the desert space—perhaps he was also inspired by Baudrillard; but Disney drew the line here, insisting on something, some sign other than the open signifier: Clint Eastwood is now on the screen (Rockwell). Perhaps it is just here that we draw the line between Disney and "high art"—in Disney's intolerance for ambiguity or irony, its need to fill the empty spaces with *something*, some recognizable signifier. In any case, the newly constructed Disneyland is surely symptomatic of a

convergence of spheres, if not an erasure of the boundaries between the playful, historically allusive tendencies of postmodern art and the playful, thematically allusive nature of Disney.

And we might recall that Disney's ambitious marriage of socially esteemed high art and the lowly, marginalized popular arts announced itself as early as the 1930s, in one of the "Silly Symphonies" cartoons, called *Land of Music*, in which Disney had constructed a Romeo-Juliet tale concerning a highly cultivated violin-princess who lives in the "Land of Symphony" and a saxophone-prince who lives in the "Isle of Jazz." After braving the perils of sea and parents to affirm their love for one another, the couple finally marry, with the blessings of their single parents, who have also fallen in love along the way. The two lands, previously separated by a "Sea of Discord," are now joined by a "Bridge of Harmony," thus effecting the fusion of cultural realms that Disney would extend even farther in the less schematic but even more influential Disney-Stokowski hybrid, *Fantasia*.

Nor is Disney the only eclectic in the realm of contemporary culture. What is going on generally is a crossing of previously separated realms, a hybridizing of the arts and commercial culture, and I want to sketch in the breadth of this phenomenon before returning again to Disney. Nothing could seem farther from the healthy family entertainment of Disney than the deliberately wicked sexuality of Madonna, yet the extremes meet in the new zone of money and culture. Signing a contract in the early nineties with an advance of $60 million from Time Warner, Madonna described her multi-media entertainment company as an "artistic think tank," a cross between the Bauhaus [sic] and Andy Warhol's Factory.

If we cannot keep Disney safely in the world of Bambi and Dumbo, and Madonna safely in the world of aestheticized sexuality, neither can we keep the other arts (high, low, popular, or esoteric) within any aesthetic cordon sanitaire. In fact, strategies of appropriation, together with the transgressing of traditional aesthetic and taste categories, characterize the whole spectrum of postmodern practice, thus erasing the modernist commitment to an art of authenticity. A few examples will suffice to suggest the range of what's happening: at the level of museum and gallery culture, Sherrie Levine rephotographs Walker Evans, signing her own name to works that are—except for her signature—duplicates of Evans' masterpieces. Meanwhile, Cindy Sherman exhibits a myriad of photographic self-portraits, each one a "facsimile" of a different representational image, from television and movie culture to Medieval and Renaissance portraits.

Both Levine and Sherman are, through their work, deliberately interrogating concepts of authenticity and offering critiques of our saturated image-culture. Their own signatures serve as notice of their ironic intentions.

But in the sphere of popular culture, the subterfuge borders, at times, on hoax, and the signature itself is called into question. Rap groups, for example, habitually "sample" pieces of soundtracks from existing albums —that is they steal them for their own creative uses without paying copyright fees. In response to legal challenges by the copyright owners, the artists and their lawyers defend the practice as integral to the nature of the hybridized art form, adding that the payment of fees would make it impossible to produce rap records: as one recent news report put it, "pure rap music requires the use of pre-existing material to be authentic" [sic] (Rule). Authenticity here is obviously still a word, if not a value, but its meaning has shifted from its earlier context: to be authentic in the context of postmodern popular culture is to embrace a heterogeneity of sources, including components of industrialized mass culture, and to transform them into some new thing.

Disputes like these recent ones over creative ownership are not entirely new, as Jane Gaines's 1991 study—*Contested Culture: The Image, The Voice, and the Law*—makes clear. What is new is that in the contemporary world such issues have become fully constituent parts of our aesthetic currency, examples of a new cultural Gresham's Law, in which the counterfeit representation is more interesting than the real thing.[5] The very hallmark of excellence in popular culture, as Jim Collins has argued, is not to be "original" in the sense of "original genius" but to be eclectic (16-27).

We may identify, then, a ruling technique in contemporary culture: the technique of substitution, of appropriation, of counterfeit representation, a technique that has even invaded the sacred precinct of representational media that begin with an assumption of reliability and objectivity—I mean, news television.

During the Gulf War of 1991, for example, Americans and others receiving the telecasts around the world watched in amazement as the superior technology of the Patriot missiles searched the skies for the disgraceful Scud missiles and, with unvarying accuracy, destroyed them. Only now we know that these video reports and the supposedly veridical footage aired on the screen were somewhat exaggerated, that the degree of accuracy of the Patriot was more like 10% than the initial report of 80%. (A Congressional study could confirm only one actual kill.)[6] Even more pernicious, because part of a more general practice, is the use of "video news releases"—footage created by a private political or business concern and

fed freely to network and local news stations for their more convenient and more economical use. The problem is that such footage, with its own point of view built into it, is being broadcast with no indication of its origin, and accompanied by the station's own announcers, as if with the imprimatur of objectivity one would customarily associate (or might once have associated) with CBS or ABC or NBC. Approximately 80% of the news directors in the U.S. admit to employing video news releases at least several times a month, and the figures are rising.

What is going on? as Eco asked. America is a very confusing place, one in which the progressive erasure of the boundaries between fact and fiction, documentary and speculation, is itself a casual "fact" of life, if that is the right word.

What can we say of the politics of such a nation, conditioned to accept such erasures in the overlapping spheres of news and popular culture? The election of Ronald Reagan—who incidentally was one of the principal television hosts when Disneyland opened its magic doors in 1955—seems certainly logical, if not inevitable. And none other than Reagan's two-term understudy, George Bush, pinpointed exactly Reagan's strength—and his own relative weakness—when he at last found himself running for president: In August of 1988 he predicted (wrongly) that the race would be close, and when he was asked if it was necessary in the post-Reagan television age to be a good actor as well as a good politician, he replied, with a disingenuousness that would soon give way as the campaign heated up,

> "Can't act. Just have to be me," he said. "I can't be as good as Ronald Reagan on conviction. There's nobody like him at conveying what it is like to strongly feel patriotism and love of country. I can't imitate the President."
>
> (*New York Times* 8 Aug. 1988)

Observe that Bush is saying nothing here about particular convictions. He is talking about being "good on conviction," that is, good at impersonating conviction. Bush recognizes, and honors, Reagan for what he is: a conveyor of emotions, a model, an actor. What he himself can't imitate, he laments, is the President's facsimile of conviction. (Which may be one reason why Bush had to resort to Willie Horton for help.)

I am suggesting, in short, that at the levels of art, entertainment, news, and politics, we are already well enrolled in an *age of facsimiles*. What makes Disneyland central to any consideration of contemporary culture is its paradigmatic status: fusing high and low culture, mastering the ruling techniques of appropriation and replication, Disneyland employs life-like

robots (playing both historical and legendary roles), bigger-than-life cartoon characters, optical illusions, controlled visual experience of all kinds, and an assemblage of hotels that evoke a full range of exotic environments and architectures. (It is only a matter of time, one imagines, before Disney features "virtual reality" environments, simulating real life experience through computer-controlled illusions created within a room or a helmet.)

We are talking about American culture, I would argue, as a culture of escapism, in flight from the difficult burden of discriminating truth from fiction, the real thing from the imitation, poverty of means from poverty of mind. But escape *to what*? Let me step back from the negative critique and propose instead a critique from the viewpoint of social psychology and the implied politics of public space. Looking at the problem through the eyes of the magnetically drawn visitor, I want to ask, not what's wrong with Disneyland, but what's right with it?

Disneyland satisfies, I would argue, several of the deepest needs in contemporary culture that are otherwise not satisfied: the need for order, for mastery, for safety, and for adventure. What is it like to be in Disneyland? We walk down ordered paths and streets, carefully landscaped and scaled to give us a sense of variety and discovery. Architectural focal points capture our gaze as we move, pulling us from place to place. We travel passively through landscapes, on water, on rails, on wheels, surveying the whole of the contained space with a sense of mastery, a sense of the overall coherence of the total world. Or else we enter the enclosed spaces of buildings, riding on vehicles that give *us* the central dramatic role: we are at once passive and active. We no longer move through an amusement park space of roller coaster rides that jolt us kinetically;[7] instead we glide effortlessly through narratized spaces in which, as Karal Ann Marling has suggested, the spectator is cast in the role of movie star (197).

The sense of mastery over adventure that Disney provides makes successful children of us all and carries with it the traces of Disneyland's origin in Walt Disney's own need for mastery and his turning to sources in his own past, his own childhood, for that feeling. In fact, as is well known, Disneyland began in Walt's obsession with model railroads (he had a huge scale model built in his own garden, permitting him to ride around like an oversized child) and in his desire to recreate the imagined charm of his boyhood home town—Marcelline, Missouri. Main Street, Disneyland is Main Street, Marcelline, writ both large and small: large because of the obvious elaboration and commercial exfoliation of the enterprise; small because Disney's designers scaled the buildings to 7/8 actual size on the

ground floor, with increasingly shrinking dimensions as you look up to the second and third stories. Thus is mastery achieved.

But Disneyland is obviously far more than the fulfillment of a personal obsession: it is the synthesis of communal rituals and entertainments going back hundreds, even thousands of years: the ancient religious festivals, the medieval mystery plays, the secular fairground with its rides, amusements, and sideshow freaks of nature; the panorama, diorama, and other optical illusions that enthralled the 18th century; the trade exhibitions, going back to the mid-19th century, with their boastful displays of products and technologies. Closer to our own time, Walt Disney was influenced by his own immediate experiences—at the 1939 New York World's Fair and at the Chicago Railroad Fair of 1948. The latter, especially, provided a kind of model for Disney, since it incorporated, along with trains, environmental displays of the Old West, the Wild West, Old New Orleans, a tropical beach, and the future of transportation technology. As Marling importantly observes, "All that was missing was a narrative, a story that tied together, somehow, all the stops on the itinerary" (8). Which is precisely what Disney provided, with an implicit narrative that encompassed a mythos of mastery: Main Street, which is the entry point to Disneyland, represents the ultimate value, the stability of small-town life in a settled, yet thriving community. Surrounding it, we can project both a spatial and temporal progression that contextualizes and "explains" the Main Street core: thus, Frontierland represents the past, the stories of settlement, of taming the land and winning it from the "Indians," of what lies historically behind Main Street; Adventureland represents the larger world beyond the United States, a zone of danger that is ongoing, a farther frontier; while Tomorrowland, represents the ultimate frontier for us to master, outer space. Fantasyland occupies a special realm, a kind of unconscious or basement level for the mythos of the human realm, for it features the stories of fear, struggle, transformation, and conquest transposed to the level of the unconscious, of fantasy, of the fairy tale.[8] (It is interesting that in translating Disneyland to Europe, Disney eliminated Tomorrowland and substituted "Discoveryland"—featuring Leonardo da Vinci, H.G. Wells, and Jules Verne. Is this the result of seeing Europe as a more traditional, a more literary culture, one more interested in the history of discovery than in its future?)

Disneyland in all its incarnations represents a dream of order—a coherent space in which every inch has been planned, both aesthetically and semantically. As such, it stands pointedly opposed to the vagaries of development that the American geography, especially urban and suburban geog-

raphy, has experienced, where accidents of investment, happy or unhappy conjunctions of rails, roads, elevated lines and bus routes have shaped the environment. Is Los Angeles one giant freeway? A checkerboard of parking lots? Is New York a dense mass of skyscrapers sitting on a clogged mass of gridlocked streets? There are few cities or towns in America that can boast the aesthetic coherence of Disney's parks.

But we cannot understand Disneyland without looking at another major component of the contemporary landscape: the shopping mall. For since 1956, when Victor Gruen's first fully enclosed mall, Southdale, was built outside of Minneapolis, the mall has increasingly overtaken commercial retail space in the United States. And what it offers is similar to Disneyland—a coherent space, an ordered environment, with mastery over the chaos of the city.

Disneyland and the malls are offering something that Americans, and now possibly Europeans, seem very much to want—a planned space, an environment free from crime and disorder and homeless vagrants. These new spaces not only have these civic virtues, but nearly unlimited opportunities for consumption and/or fantasy, because they are *private* spaces. Privately owned, privately developed, privately operated, they have the power to exclude the chaos of contemporary life. They also, not coincidentally, have the power to exclude political demonstrations and other functions of the political marketplace. (Powers that are presently being tested by the courts.) In the malls, it is always a holiday—Easter, Halloween, Christmas, Thanksgiving. In effect, they are utopian spheres that operate as free attractions to the public, places to visit. (And they have their increasing counterparts in places to live—private condominium communities that exclude outsiders by virtue of their security fences and armed guards [Crawford].)

But what's right about Disneyland is also what's wrong with it, namely the privatization of public space. Disneyland, and the malls, are filling a desperate need in the public sphere that is, through no real fault of their own, making the public sphere even worse. Directly in competition with Main Streets all over the country, the malls are in fact rapidly eliminating them, and in the process are accelerating the decay of towns and cities that had previously enjoyed a modicum of useable urban space. Through their growing and successful efforts, the public community, the place where political differences can be democratically resolved, is being further eroded. If we can virtually insulate ourselves from poverty, homelessness, hunger, even drunkenness (since alcohol is prohibited in Disneyland), so much the

Understanding Disneyland **157**

better for those who can afford the price of admission and so much the worse for the rest. For there seems to be an inverse relation involved here: public life, with its inequalities of fortune, gets worse as private life gets better.[9]

In this sense Disneyland (or the malls) are not first causes of the distress in postmodern public life. But it is one of the many ironies of the contemporary period that in saving Main Street for the private sphere, we are destroying Main Street for the public realm. And it is another irony that the country that for decades has despised communism and all it stands for (and can hardly believe its effortless victory now), the country that for decades has been suspicious of any government efforts to plan its economy, has been enthralled, since World War II, with the most successful planned spaces in the world—Disneyland and the malls. If we Americans like Disneyland so much, one wonders, why don't we plan the rest of our public space?

But all of this may make us wonder why Disneyland was considered necessary, or even possible, in Europe. If the grid of the American city has long since turned to gridlock, that is surely not the case with Paris, which stands closest to Euro Disneyland geographically yet functions as an environment that has been planned with splendor for centuries and supplies none of the force of contrariety that fuels the American visitor to Disney's worlds.[10] Experiencing Disneyland in Europe surely contextualizes the experience in a way that is quite different from America's theme parks: in the United States, Disneyland serves the function, among other things, of an escape into a realm of imagined European culture—the castles, the European fairy tales, figures of royalty, the ersatz European restaurants, etc. That corresponding function could hardly be served in France, within a stone's throw of the chateaux of the Loire Valley. And indeed in the first years of its opening, Euro Disneyland has done poorly, evidence of a possibly gross miscalculation—though many factors are involved besides the ones noted here and in any case it may be too early to tell its ultimate fate.

But it is tempting to speak prophetically nevertheless and to say that to the extent that Euro Disneyland does succeed it may signal for Europe the beginning of the demise of public space, of the responsibility of community life, that is already well under way in America. The danger lies not in Disneyland and the cultural pollution it may bring; the danger lies in having possibly already created an environment where Disneyland is necessary. More likely, however, Disney may fall victim to the global colonizer's hubris, having failed to understand deeply enough the differences

between American culture and European culture. If that is the case, we may conclude that the peculiarly symbiotic relation between what is inside and what is outside the magic kingdom holds primarily for America. It may be, then, as we enjoy one of Disneyland's comforting rides through a maddening dark cavern filled with tiny international dolls singing "It's a Small World," that we are truly and finally in America.

10

Technology, the Imagination, Virtual Reality, and What's Left of Society

Considered abstractly, the words "technology" and "imagination" seem to exist in tension, if not in opposition to one another. Technology entails the application of scientific principles to practical ends, like building a bridge or constructing a canal; the imagination exalts the freedom of thought, whimsy, and feeling without respect to such ends. Put the imagination and technology together, in their most *extreme* forms, and you invent a Rube Goldberg contraption—a twenty or thirty step operation, involving bells, sponges, string, cats, birds in cages, catapults, alarm clocks and humidity, all designed, let us say, to light a cigar. Goldberg's cartoons—in which the extravagant imagination of a Professor Lucifer Gorgonzola Butts employs a baroquely conceived technology to achieve some practical goal otherwise reachable by quite simple means—were extremely popular in America during the early decades of the century. During this time, when technology and its ability to "save" labor and time seemed both miraculous and slightly absurd, Goldberg signalled a culture's characteristically humorous accommodation to forces that were in any case unstoppable. In Goldberg's hands, practicality, if not sheer logic and the laws of nature, seemed always to be defeated by the triumphant misalliance of technology and the imagination.

But the opposition of the two, though a reflex of popular thought, is more an accident of history than a natural or logical necessity: both tech-

nology and the imagination are ways of constructing and ordering the world, and in the human production of artifacts—whether of stone, metal, words, sounds, paint—both faculties are more or less *always* employed. Before the Romantic period, beginning around 1800, when the opposition became somewhat formalized, science and poetry were easily encompassed within the same intellect and served parallel social functions: both were measured and both were utilitarian, and their products confirmed or displayed an order that was presumed to be inherent in the natural world. Benjamin Franklin and Jonathan Edwards, commonly taken as paradigms, respectively, of the practical and the religious intellects, were in fact *both* deeply interested in science *and* in aesthetics, and these two pursuits, for both of them, were part of a coherent way of understanding the world. David Rittenhouse's physical model of the known universe, the orrery, was itself such a product of the conjoined artistic and technological imaginations, a product that seems unforced, almost "natural." Thomas Jefferson's imagination—architectural, mechanical, musical, literary—seems again a natural fusion of the coherent intellectual world of the eighteenth century.

With the explosion of new forms of energy in the nineteenth century— initially in the steam engine, later on in electricity—the technological imagination burst the bounds of classical restraint and took on the myriad shapes of a romantic dream: everything was convertible, ingenious, a world of camouflaged forms and inventions. The technological imagination at that time was in some ways a wilder, more romantic imagination than that of the poet, who was still trying to hold on to a moral aesthetic that could speak of social obligations and spiritual exercises. Emerson was certainly curious about technology and did not look away from the machine, but his transparent eyeball was more intuitively receptive to the spiritual reality of the natural world; Thoreau had the scientist's interest in the structure and materials of the organic world, but his characteristic move was, of course, to get beyond the fact to its more resonant symbolic meaning.

Only in Whitman, perhaps, do we find the poet responding to the world of technology on its own terms, or at least trying to. Whitman is resisting the division of culture into two separate realms, the practical-technological-material (one realm) and the poetic-spiritual-emotional. The more technology took on the character of the inevitable tool of capitalist expansion, the more autonomous it became, an always progressing force, virtually an unchallenged ideology. Art and the imagination, in this changing order, became relegated to the margins, serving the role of an idealizing, softening, "civilizing" force, turning its back on technology, pretend-

ing it didn't exist and that the world of art was a separate sphere of idealization. Not content to be relegated to the margins of culture by the juggernaut of technology, Whitman construed a role that was central to the evolving definition of American civilization. Thus Whitman insisted that the poet's mission is accomplished not at all by ignoring technology (in the manner of the conventional traditional poets who dominated the genteel magazines), but rather in conspicuously incorporating it.[1] Whitman himself quite conspicuously incorporated it on the occasion of the opening of the American Institute's 1871 Exhibition, hailing the arrival of the new technological muse in lines that have lived with a kind of awkward immortality:

> I say I see, my friends, if you do not, the illustrious emigré, (having it is
> true in her day, although the same, changed, journey'd considerable,)
> Making directly for this rendezvous, vigorously clearing a path for
> herself, striding through the confusion,
> By thud of machinery and shrill steam-whistle undismay'd,
> Bluff'd not a bit by drain-pipe, gasometers, artificial fertilizers,
> Smiling and pleas'd with palpable intent to stay,
> She's here, install'd amid the kitchen ware!
>
> *Song of the Exposition*

But even forgetting these lines (unfortunately one cannot) Whitman's rhetorical mode is characteristically *celebratory*; the products of the new manufacturing excited the poet, as did the factories and foundries turning them out, along with the working classes of the cities who produced them. And greater poems, like *Crossing Brooklyn Ferry*, would invoke the new materials of the technological civilization less directly but with no less enthusiasm, even with sublimity.

However strong Whitman's sense of what America "demanded"—a poetry that incorporated "science and the modern"—that demand was not heard again until the 1920s, when the Modernist artists embraced science and the machine with something between enthusiasm and fatalism. By then, of course, what Whitman had perceived as the future, had become the indisputable character of the present: America was a machine civilization, as its skyscraper cities, its great bridges, its automobiles, its tunnels, visibly testified; and even the home—with its vacuum cleaners, sewing machines, its radios, electric irons, and toasters—had become a technological environment. And "unless poetry can absorb the machine," as Hart Crane put it, "i.e., *acclimatize* it as naturally and casually as trees, cattle, gal-

leons, castles and all other human associations of the past, then poetry has failed of its full contemporary function." But what he meant by this was not in any way "pandering to the taste of those obsessed by the importance of machinery" but rather surrendering, "at least temporarily, to the sensations of urban life," making of machinery not the object of romantic celebration but part of a naturalized discourse, "as spontaneous a terminology of poetic reference as the bucolic world of pasture, plow, and barn" (Crane 261-262). Which is indeed what Crane at his best achieved, as in the famous lines from "Brooklyn Bridge" ("Down Wall, from girder into street noon leaks,/ A rip-tooth of the sky's acetylene") or as in this description from "The Harbor Dawn": "And then a truck will lumber past the wharves/ As winch engines begin throbbing on some deck."

Crane's intentions were to "modernize" the language of poetry, to bring the sensibility of the poet into the technological age. John Dos Passos carried the process one step farther, in proclaiming that the writer was, himself, a kind of engineer. Establishing a structural *analogy* between technology and writing, Dos Passos declared, before the American Writers' Congress in 1935, that the writer was involved in a process of "discovery and invention . . . not very different from that of scientific discovery and invention." Dos Passos himself, as Cecilia Tichi has demonstrated in *Shifting Gears*, invented the most elaborate novel-machine of its time, a four-part mechanism of fictional narratives, biographies, newsreels, and autobiographical fragments. And, consistent with this achievement, Dos Passos defined the writer "in his relation to society" as "a technician just as much as an electrical engineer is" ("Writer as Technician" 169). Dos Passos wanted to borrow the authority of technology, with its promise of rational solutions to social problems; he also wanted to define the writer, before this politically conscious audience, as a worker, albeit a professional worker.[2]

But Dos Passos expanded on the writer's role in the technological age in a way that moved him close to Ezra Pound's dictum that the writer must purify the language of the tribe. The successful literary work, Dos Passos affirmed, will have an influence "on ways of thinking to the point of changing and rebuilding the language, which is the mind of the group." We get a clear sense of what exactly needs rebuilding in a passage like this, from *42nd Parallel*, which renders the stream of consciousness of J. Ward Moorehouse, a budding advertising writer, as he dictates to his secretary while on board a train: "American industry like a steam engine, like a highpower locomotive on a great express train charging through the night

of old individualistic methods." And later on, unable to sleep, "words, ideas, plans, stock quotations kept unrolling in endless tickertape in his head" (241). Clearly, "the mind of the group" needed rebuilding. As Pound had said, "Use no superfluous word, no adjective which does not reveal something. . . . Consider the way of the scientists rather than the way of an advertising agent for a new soap" (106-107).

But for Dos Passos, the aesthetic ideal of the scientist was coupled with the moral authority of the prophet; the writer, as Dos Passos declared, laid claim to an authority that recalled Whitman's injunction: "At this particular moment in history, when machinery and institutions have so outgrown the ability of the mind to dominate them, we need bold and original thought more than ever. It is the business of writers to supply that thought, and not to make of themselves figureheads in political conflicts" ("Writer as Technician" 81). But there is this significant difference: in Whitman's injunction that poetry "inspire itself with science and the modern" there is little sense that machinery and institutions have "outgrown the ability of the mind to dominate them." Dos Passos was engaged with technology at the level of cultural definition that Whitman insisted upon, but the world he inhabited was a different one. Nevertheless, he spoke with the hope that the poet-legislator (for the writer had gone beyond the mere technician at this point) might possess the special power of the imagination to win back from the machine what had been taken away, to dominate the force of technology which otherwise dominates our minds and bodies. (Needless to say, Frederick Winslow Taylor, the father of Scientific Management, is not one of Dos Passos' heroes.)

By the 1930s, when Dos Passos wrote his *U.S.A.* trilogy, technology had come to seem, for some, the last hope for a rational civilization. (The most hopeful, during the Depression, gave their allegiance for a short time at least to engineer-turned-social prophet Howard Scott, founder of the Technocracy movement.) But Dos Passos' warning—that the machine had outgrown our ability to dominate it—was certainly prophetic of the post-World War II attitude. By then the optimism of the Depression—which was the dominant tone of the 1939 World's Fair—had given way to a sense of forces set loose beyond human control.[3] For the imagination in the latter half of the twentieth century a full accounting of technology cannot omit the hitherto inconceivable excesses of violence that marked World War II and its furious conclusion; the redundancies of the consumer world and the factories that produce them; the nuclear reactors and their waste products; the massive oil rigs and fragile oil tankers; the invisible chemicals in our air, our soil, our water. If the eighteenth century intellect was comfortable

with technology it was because, by and large, it was a technology that was dominated by the imagination and by relatively limited economic goals. The imagination has had, certainly in the latter part of our own century, to deal with technology of a different order, technology that is conceivably alien to human purposes. How do we accommodate to that?

Precisely these issues are at stake in Norman Mailer's *Of a Fire on the Moon* (1970)—the story of the first moon landing—which in many ways brings to a climax this whole line of thinking, in both its positive and its negative aspects. Can the imagination understand, let alone dominate, technology? Or is the machine overwhelming and even stupefying in its power. The question is a metaphysical one, but also a social question: for it is not just a matter of something abstract like "technology," it is a question of the individuals who create it, a question, then, of who controls it and for what purposes, of who owns it. These are the problems Mailer explores in *Of a Fire on the Moon*, where the imagination achieves a noetic intensity, aspiring to the deepest kind of direct intellectual apprehension of what is still one of the most stupendous achievements of technology—the landing of human beings on the moon. As Mailer declares at one point: "The horror of the Twentieth Century was the size of each new event, and the paucity of its reverberation" (40).

Mailer tells this story twice (redundancy being the first principle of complex systems), the first time from the point of view of the reporter-observer describing the character of place (Houston, Cape Kennedy) and persons (astronauts, NASA personnel); and the second time from the point of view of the technology of the flight itself, with detailed excursions into systems design and the drama of the landing. (Mailer's college degree was in aeronautical engineering, though his heart was never in it; his mother wanted him to study something practical.) But throughout, the subject is the capacity, or incapacity, of the artist to encompass the magnitude of space technology, the power of language itself to describe a reality so new. Mailer realizes this as soon as he sees the VAB—not the name of a deodorant or soft drink, as he assures us, but the Vehicle Assembly Building, where the rocket is being put together—and detects an inversion in the "normal" relationship between art and technology: "The great churches of a religious age had names: the Alhambra, Santa Sophia, Mont-Saint-Michel, Chartres, Westminster Abbey, Notre Dame. Now: VAB. Nothing fit anything any longer. The art of communication had become the mechanical function, and the machine was the work of art. What a fall for the ego of the artist. What a climb to capture the language again" (58). But Mailer's ego being itself of monumental scale, his problem is not so much

to rebuild it as to suppress it in order better to understand what was before him: "Do not dominate this experience with your mind was the lesson—look instead to receive its most secret voice" (58). Seeing the VAB with his mind thus open, Mailer realizes "he was standing at least in the first cathedral of the age of technology, and he might as well recognize that the world would change, that the world *had* changed, even as he had thought to be pushing and shoving on it with *his* mighty ego. . . . Yes, this emergence of a ship to travel the ether was no event he could measure by any philosophy he had been able to put together in his brain" (57-58).

One can only think of *The Education of Henry Adams* as a comparable moment in our cultural history, and possibly Mailer was thinking of Adams himself, when he invoked Mont-Saint-Michel and Chartres. Adams had realized, at the end of the last century, that science was changing the world in barely comprehensible ways. Ruminating on the Chicago Exposition of 1893, with its vast displays of machinery, steam engines, and dynamos, Adams saw the various manifestations of the new mechanical power and asked "for the first time the question whether the American people knew where they were driving" (343). And later, at the Paris Exposition of 1900, Adams gains from his friend Samuel Pierpont Langley, an astronomer and one of the pioneers of aviation, an insight into the new science of multiple universes that can serve throughout the twentieth century: "physics stark mad in metaphysics" (382).

Mailer, whose book is itself a kind of "Education of Norman Mailer," is not less obsessed with the metaphysics of physics and with the borderlines between insanity and sanity. The astronauts appear the most conventional of human creatures from the outside, epitomes of WASP restraint, yet their mission is nothing if not extravagant: "They lived, it was evident, with no ordinary opposites in their mind and brain. On the one hand to dwell in the very center of technological reality (which is to say that world where every question must have answers and procedures, or technique cannot itself progress) yet to inhabit—if only in one's dreams—that other world where death, metaphysics and the unanswerable questions of eternity must reside, was to suggest natures so divided that they could have been the most miserable and unbalanced of men if they did not contain in their huge contradictions some of the profound and accelerating opposites of the century itself." Just as our century was the most "soul-destroying and apocalyptic" of centuries, so the astronauts "had personalities of unequaled banality and apocalyptic dignity" (51).

This contradiction opens up into a gap between the astronauts' language

and their experience: they are Americans, for whom everything good or OK is "great." The possibility of being left on the moon—the possibility of being left on the moon!—is a "contingency"; being lost in space is "a wider variety of trajectory conditions." Words, Mailer says, were there "to suppress emotional symptoms" (32). One of the few moments free of jargon is when Neil Armstrong makes his first steps on the moon ("One small step for man; one giant step for mankind") and even here, we might observe, the rhetoric of the moment barely rises to the occasion, though the effort is all too obvious. The point of going to the moon surely wasn't to *say* something on the moon, it was to get there. But what does getting there *mean*, if not what we say about it? What *was* the significance of the voyage, Mailer ponders: was it an expression of God's will to "employ us to reveal His vision of existence *out there*"? (And therefore we couldn't wait until astronauts could speak like Shakespeare.) Or was it "a meaningless journey to a dead arena" so that people could "engage in the irrational activity of designing machines which would give birth to other machines which would travel to meaningless places," because we did not have the "wit or charity" to solve our real problems on Earth?

The contradictions Mailer explores are, after all, at the center of his assessment of American technology: the Apollo project represents the triumph of American corporate power, a vindication of American enterprise, national willpower, the victory of a segment of America Mailer had been at war with for years and, incidentally, an affront to the counterculture of the sixties that Mailer takes personally. Yet as a hundred reporters line up on a sweltering night at the Cape waiting to put coins into a malfunctioning iced-drink vending machine, the larger perspective asserts itself: "Shoddy technology, the worst kind of American shoddy, was replacing men with machines which did not do the work as well as the men." The abominable food trailer, Mailer decides, is the true product of the "smug and complacent VIPs" in the stands waiting for the launch on this night at the Cape. "This was the world they created, not the spaceship" (89).

Mailer was writing in 1970. From the perspective of twenty-five years later, we may wonder whether American shoddy has not itself overcome space technology: the Challenger explosion; the disappearance of the Mars Observer; the flawed Hubble Space Telescope; the malfunctioning antenna on the Galileo, bound for Jupiter; the predictable delays in space shuttle launchings; clock failures in weather satellites. Taking stock of American technology for the contemporary writer has meant, increasingly, coming to terms with such shoddiness. And coming to terms with it has meant, at least for some, employing a kind of irony that acknowledges what it cannot

avoid, resigning itself to a humor of tolerance in order to avoid outrage: "There can no longer be any question of 'disposing' of it [trash]"—Donald Barthelme writes in a locus classicus from his novel, *Snow White*— "because it's all there is, and we will simply have to 'dig' it—that's slang but peculiarly appropriate here. . . . It's that we want to be on the leading edge of this trash phenomenon, the everted sphere of the future."

Barthelme, who served as our fragmentary encyclopedist for the sixties and seventies, situates his characters at a juncture he calls, to use the title of another story, "At the End of the Mechanical Age," a time when "blackouts, brownouts, temporary dimmings of household illumination," are signs of Divine indifference rather than displeasure. We exist in a state of indecision as Barthelme's story opens, but we need only to relax and we will find at least *tentative* answers:

> I went to the grocery store to buy some soap. I stood for a long time before the soaps in their attractive boxes, RUB and FAB and TUB and suchlike, I couldn't decide so I closed my eyes and reached out blindly and when I opened my eyes I found her hand in mine. (272)

Such epiphanies are temporary, however, for the narrator (Tom) and his cleansing Muse, Mrs. Davis, accept one another as merely substitutes for the dreamed *ideal mate*, and their marriage will soon end in an amicable divorce. Tom's true love and future happiness is represented by a dream-figure named Maude who, in this myth for our age, first gave names to the tools that we use: "It was Maude who christened the needle-nose pliers. Maude named the rasp." At the end of the mechanical age, in Barthelme's vision, we survive by our trust in electricity and by our faith that new names will be given to describe our condition. Yet, like Yeats before him, who worried (in retrospect) about what would be lost at the advent of the Christian era, Barthelme too worries that the center will not hold: lacking Yeats's lofty voice and heroic vision, Barthelme simply affirms, with the deadpan of the American in a world of shoddy hardware, "The center will not hold if it has been spot-welded by an operator whose deepest concern is not with the weld but with his lottery ticket." Living in a world of poor spot welds, of imminent disasters, the immanent spirit, the Holy Word, is pronounced—if at all—with tongue in cheek. We are, in Barthelme's influential contemporary vision, both relaxed and anxious about our future: intensely curious, obliged to notice and absorb everything, and hopeful in a vague way that some future bliss will replace our present malaise.

Surviving at the end of the mechanical age—and the beginning of the post-industrial electronic age—is also the subject of Don DeLillo's *White*

Noise (1985), which takes us virtually to the feasible limit of the American imagination's effort to encompass technology. In a world buzzing with information, trivia, misinformation, media ads, computer screens, television screens, deceptive packaging of all sorts, our sensory perception breaks down: we exist in a media-induced solipsism so complete that the main character's simple question to his son—"Is it raining?"—solicits a lengthy disquisition from the bright fourteen year old on the impossibility of our ever knowing anything with certainty.

Situating his characters in the midst of a technological disaster (an airborne toxic event), saturating them in an obsessive fear of death, De Lillo shows us a world in which sunsets are mesmerizing and highways are anxiously scanned "as if for a sign." The only security in such a world lies in the familiar products of the supermarket, the junk that surrounds our lives as consumers. But at the end of the novel, when the shelves have been suddenly and arbitrarily *rearranged*, there is no reason, no sense in the world:

> The scouring pads are with the hand soap now, the condiments are scattered . . . [Men and women] turn into the wrong aisle, peer along the shelves, sometimes stop abruptly, causing other carts to run into them . . . There is a sense of wandering now, an aimless and haunted mood, sweet-tempered people taken to the edge. [They inspect the packages for contents and prices.] But in the end it doesn't matter what they see or think they see. The [check out] terminals are equipped with holographic scanners, which decode the binary secret of every item, infallibly. This is the language of waves and radiation, or how the dead speak to the living. And this is where we wait together, regardless of age, our carts stocked with brightly colored goods. (326)

With that image of a moving line creeping slowly to the check out point in a supermarket, the patrons disoriented, irrelevant, consuming desperately to achieve a sense of security, yet not quite knowing what it is they are consuming, De Lillo concludes his vision of the modern world that is at once hilarious and sombre, a Last Judgment done in contemporary street clothes.

The problem remains: If anything, the problem for the imagination of encompassing, let alone making sense, of the contemporary technological world becomes more baffling, more hilarious, more frightening, every day. Consider the amalgamation of representation and reality that has taken place under the influence of "virtual reality" technology, through which computers can simulate, on a personalized screen that is often attached to

the head, some three-dimensional environment. From their first applications for training pilots and police, these have now become tools for constructing high-tech art environments. If we define reality, for our purposes, as what we believe to be true in our direct experience, then virtual reality is an illusory double. As Michael B. Spring puts it, following Webster's Dictionary, virtual reality is "'a fact or real event that is such in essence, but not in fact.'" And he adds, "if the term *virtual reality* is not an oxymoron, it comes very close" (6).

But we must extend the concept of "virtual reality" beyond its literal technological embodiment. It is, I think, becoming for contemporary culture a pervasive system of representation, almost an ontology. I have been keeping a file for the past six years or so of news items that seemed strange to me, strange in a new way, and I would put them in a folder marked, at first, "Postmodern Reality," though I now call this folder "Virtual Reality." The clippings are taken mostly from the *New York Times*, commonly taken as our contemporary journal of record, though it might better be called The Journal of Virtual Reality. Consider these examples from my folder: The Titan Missile Museum in Green Valley, Arizona, was a state-of-the art military complex until the Titan 2's were dismantled, all except one, which remains in a silo but has been "rendered impotent," to use the military technology. "The only thing we can't do is launch it," said a spokesperson ("Missile Museum"). Or consider, for another example, the Italian firm of Mario Meselli, which constructs *models* of military aircraft. American jet fighters are his most popular ones, to be used as fakes, as decoys, by various military regimes around the world, or as training targets (Simons). During the 1993 summer we learned that the test of the Star Wars missile defense system was rigged by heating the target warhead and thus making it 10 times more attractive to the destroying missile. Caspar Weinberger said the test was intended to be "as realistic as possible" (Weiner). A similar goal of "realism" was sought by a martial arts instructor, who planned to "shoot" one of his students at a conference on terrorism being held at a synagogue, then have 12 other students wearing military uniforms rush into the synagogue firing blank shots into the air. The event was ultimately canceled after protests by the Israeli Consulate, despite the sponsoring rabbi's defense of it. Terrorism can happen anywhere, he said. "We want to give kids a sense of what reality is like" ("Teen-Agers").

What *is* reality like? At Universal Studios, in California, a three-block long theme park-shopping mall called "Citywalk" recreates the architectural and touristic highlights of Los Angeles, all within a walkable space, and thus saving people the trouble of driving countless miles through the

chaotic urban sprawl and riot-torn neighborhoods of the real Los Angeles (Gollner). The pursuit of the unreal is by no means restricted to the United States: in Japan, where much of the natural coastline has been filled in or paved over, Wild Blue Yokohama, an artificial beach with plastic palm trees, sand made of concrete and rubber, and waves made by machine, is attracting thousands of people who can ride six-foot waves on the hour. An indoor ski center has also just opened (Pollack).

Nor is literary culture immune to the infectious standard practices of "virtual reality." Admirers of Forrest Carter's best-selling *Education of Little Tree*, an inspiring, heart-warming autobiography of an orphaned Cherokee Indian, have recently discovered that it was written by the late Asa Earl Carter, a Ku Klux Klan terrorist and fascist anti-Semite. Joe McGinniss admits to fabricating the life of Edward Kennedy in his "biography," *The Last Brother*; and Alastair Reid, the *New Yorker* writer (long before Janet Malcolm) defends the practice, in non-fiction writing, of going "much further than the strictly factual" (Dowd, "A Writer").

For the artist who is finely tuned to this cultural condition, the notion of "mimesis" takes on new meaning: mimesis of *what*? "Reality"? "Virtual Reality"? Television—the new standard of "reality"? (Tichi, "Twentieth Century"; Tichi, *Electronic Hearth* 148-54). No wonder the television set itself has become the *material* of art, most strikingly in the work of Nam June Paik, with his looped and inter-looped multiple television sets creating alternate environments for us to stand in and under. For Paik, "the cathode ray will replace the canvas," just as collage technic had previously replaced oil paint (qtd. in Bukatman 61). Photographer Sherrie Levine exhibits prints of recognized masterpieces by Walker Evans as her "own" work, appropriations that deliberately subvert the "value" of the unique original. But do photographs have the value of "originals" in the first place? (Walter Benjamin of course said no.) Do Sherrie Levine's reproductions have value as "originals"? Perhaps they do.

The conceptual artist J.S.G. Boggs meticulously creates currency that is not counterfeit, but looks so much like the real thing that the Secret Service has seized his ersatz bills. (Boggs looks back to William Harnett and John Peto, nineteenth century painters of trompe l'oeil, as past masters of the counterfeit art.) Meanwhile, Robert Coover's hyperfictioneers rewrite John Barth's *Lost in the Funhouse* on their computers, creating computer-based narratives with Borgesian forking paths at every step, thus placing the fictional story in an aleatory hyperspace in which chance permutations govern the creation of a deliberately unstable world.

Some at least can make space for themselves in such a world by exploit-

ing precisely the technological world of virtual reality. Electronic mail, for example, lacking the signs by which we interpret people's identity, has allowed participants to create whatever identities they desire. The unemployed actress Carol Ann Francis was recently unmasked as her own personal manager, Ann Hollingsworth. Using telephone answering machines and a deliberately aggressive voice, Francis would play the fictitious Hollingsworth over the course of three years so successfully that she managed to get Francis several jobs. Francis explained that "it was never my intention to mock or dupe anyone. . . . It came out of a desperate need to survive." To survive, we might add, in an industry in which millions are spent to "authenticate," down to the last thread and morsel of food, the supposed "reality" of historical subjects.

Where technology ends and the imagination begins in the culture of virtual reality is an endlessly open question, and our daily experience comes uncomfortably close to confirming Baudrillard's description of our imploded world, in which images of reality replace experience and real things become translated into digital information for our computer screens. Does power reside in ourselves at this point, or, as Baudrillard would argue, in the technology itself? (*Forget Foucault*; Bukatman 72-74).

But *The New York Times*—the Journal of Virtual Reality—is also interested in this problem. In 1994, in the wake of increasing talk about merging telephone and cable in a new Clintonian Information Superhighway, it asked four writers to "give us their visions of the information future." The results were mixed: to James Gleick, author of the best-selling book on chaos, the "global Internet . . . has suddenly become the most universal and indispensable network on the planet." It is—as he puts it in terms that serve to domesticate it within our cultural history—the newest "wild frontier." Less enthusiastically, Bill McKibben (author of *The Age of Missing Information*, about contemporary television), finds the superhighway image exactly what's wrong with the future—it's "flat, uninteresting, repetitive." To Neil Postman, author of *Technopoly*, the superhighway is strewn with trash: "information has now become a form of garbage. We don't know what to do with it, have no control over it, don't know how to get rid of it."

The most interesting response and in some ways the most troubling, was Robert Coover's. (Coover had, a few weeks before, written a lengthy essay in the *Times Book Review* exploring the range of hyperfiction.) Digitalization, he says, "has so far had a democratizing effect on cultural exchange, greatly empowering the individual user." It must become, he argues, even more universally accessible. This sounds good. But Coover concludes in a

more disquieting way, disquieting most of all because he seems unaware that it is so: "Digital convergence," as he calls it, "is the new standard by which literacy must be judged, and for a time whole nations . . . will in effect be made newly illiterate. They need not remain so: this is easier to overcome than hunger or drought. New tasks for future Peace Corps: wire up the global village."[4] Precisely because it is easier to overcome than hunger or drought, one feels, the new information technology is so attractive. The only problem, which we've succeeded in once more evading, is that we are still left with hunger and drought. If technology seems, for the past hundred and fifty years at least, to have become autonomous in its drive and its imperatives, we must not forget that it is we, paradoxically, who have made it so. We can't stop asking, living as we do, after the machine, What's left of society?

In short, it is not technology that we, as a society, need to worry about: it is the imagination, and it is the social function of the imagination to give an exact account of technology, making us as aware as we *can* be of where we are going, and where we are blundering. One reason the camera, in its documentary function, has become so central to our century is that it has seemed an instrument to make us see what we might otherwise not see or not want to see. (I won't recapitulate the problematic nature of this function, as discussed in several of the previous essays.) The problem with virtual reality is that it creates a technological mode that approaches a cognitive habit, in which the distinction between what is real and what isn't becomes (literally) immaterial. If such distinctions cease to mean anything to us, then we've traded fantasy for reality, and the epistemological ground of our experience, already eroded by contemporary philosophy, yields all too easily to a politics of illusion. It's difficult not to place too heavy a burden on the artist in these circumstances as a kind of social doctor, but it confirms a persistent sense that art—whatever else it is—is a way of knowing and that we need to know.

NOTES

Introduction

1. We might view the twentieth century, in this context, as a reaction against what Lawrence Levine has described in *Highbrow/Lowbrow*—the institution of a "culture" around the turn of the century that helped insure social control, erecting standards that were to insulate the fine arts from the marketplace and from popular culture. The essays in this volume all argue, explicitly and implicitly, the erosion of these standards.

Chapter One. The Artist Looks at the Machine: Whitman, Sheeler, and American Modernism

1. Those in the nineteenth century who stood on the other side of the issue, that is, who celebrated the machine and its power, also saw the world of science and poetry as absolutely separate, and did not shrink from denigrating the latter: The arts, as one machine-enthusiast put it after visiting a mechanics association exhibition in 1869, "are only of themselves an imitation, or, at most, an idealization, of the outside of things, only a surface expression of ideas. There is an element of falsity runs through them all." Machinery, on the other hand, "is not imitation, but the embodiment, of real forces, laws, and principles, which are made to act" (Kimball 323-24). Kimball uncannily anticipates one of Henry Ford's guiding principles, profit through pragmatism: "Ideas are of themselves extraordinarily valuable, but an idea is just an idea. Almost any one can think up an idea. The thing that counts is developing it into a practical product" (Ford with Crowther 3).

2. For a definition of the "vernacular" in American material culture, beginning in the nineteenth century and extending into the twentieth, see Kouwenhoven 12-42; 204-209.

3. Scott Hammen states that the Rialto managers added Whitman after the film's completion (6-7). Jan-Christopher Horak argues that the lines must have been inserted by Sheeler and Strand, given how well they match the visuals and how carefully selected they are from Whitman's several poems (8-15).

4. Ford was the subject of a mock-adulatory mini-biography by Matthew

Josephson in *Broom* (137-142); and John Dos Passos, possibly inspired by Josephson's approach, incorporated a Ford biography into *The Big Money* ("TIN LIZZIE").

5. Ford, who was an amateur ornithologist, was encouraged in his Emersonian study by John Burroughs, the naturalist.

6. Gramsci saw Ford rationalizing production and gaining the "consent" of the worker through force (breaking unions) and persuasion (higher wages): "Hegemony here is born in the factory and requires for its exercise only a minute quantity of professional political and ideological intermediaries" (278-279).

7. Of the few examples in nineteenth century art of the technological sublime, the most notable is John Ferguson Weir, *Forging the Shaft* (1877), an illustration of which can be found in Williams 211. Weir's treatment emphasizes the struggle of man with the machine.

8. Hine: "Cities do not build themselves, machines cannot make machines, unless back of them all are the brains and toil of men. We call this the Machine Age. But the more machines we use the more do we need real men to make and direct them" ("The Spirit of Industry").

9. In the *Power* series, commissioned by *Fortune* magazine in 1938, Sheeler portrayed one "primitive" example of machine-generated power—a water wheel—and five contemporary examples: an airplane propeller (*Yankee Clipper*, 1939), the wheels of a locomotive (*Rolling Power*, 1939), a hydroelectric turbine (*Suspended Power*, 1939), a streamlined steam power plant (*Steam Turbine*, 1939), and the transmission tower of the Hoover Dam (*Conversation—Sky and Earth*, 1940). The series is not without its ambiguities, but *Fortune* consistently described the works in mystical and religious terms, as hallowed symbols of modern technology.

Sheeler was criticized, in a 1939 review by Elizabeth McCausland, for ignoring the harsh realities of factory conditions and the pollution they spread. "Sheeler, one feels, retreats from the impact of human life and comforts himself with the pure science of 'Euclid bare.'" ("Charles Sheeler Show at Modern Art Museum"). I am grateful to Gail Stavitsky for sharing this, and other sources relating to the reception of Precisionism, with me.

10. Sheeler avowed in an interview in 1954, "I don't believe I could ever indulge in social comment," and then added, "Maybe industry is our great image that lights up the sky. . . . The thing I deplore is the absence of spiritual content" (Wight 28; 31).

11. The artist in the painting is drawing the crayon version, *Interior with Stove* (1932), pictured in the photograph. That drawing is, in turn, based on a 1917 photograph, *Interior with Stove*. Lucic notes these details, though her conclusions are different from mine. "These pre-existing pictures are unrelated to Sheeler's immediate surroundings; the 'reality' depicted on the easel

was already present as an image in the artist's mind before he began the work" (Lucic 137).

Chapter Two. The Camera and the Magic of Self-transformation in Buster Keaton

1. One of Keaton's shorts, *Daydreams* (1922), derives its comedy from precisely the disparity between Buster's dreams of success (ambiguously certified in his letters home) and the reality of failure in the city. And though Buster struggles throughout to make a living, the film ends on a grim image that suggests, more generally, the all-compelling Wheel of Fortune: Buster, pursued by the police, lands on a ferryboat, where he takes refuge on the turning paddle wheel, which becomes very shortly a trap. He struggles for a while to stay above water on the turning wheel, but eventually simply holds on rigidly, thereby submitting himself to the rise and fall, in and out of the water, of the inexorable machine.

2. I shall be concerned throughout this piece chiefly with the films as we see them on the screen. For information regarding the techniques by which many of the effects here discussed were achieved, see Blesh; Robinson. It should be noted that both books, along with their often very informative accounts of the films, contain certain inaccuracies. A more ambitious, philosophical, and occasionally obfuscating discussion can be found in Lebel.

3. One exception is the vertical movement of the camera, tracing Buster's running up and down the stairs of his rooming house; filmed from outside the building's exposed interior, the sequence provides an emphatically comic perspective on Buster's compulsive ascent and descent.

Chapter Three. Lewis Hine and the Art of the Commonplace

1. I had the advantage, in preparing this essay, of using a videodisc of Hine negatives in the collection of the George Eastman House, and I want to thank my colleague Robert Weinberg for generously making his copy available to me. I also want to thank Andrew Eskind, of Eastman House, for kindly supplying various other information regarding the Eastman collection.

2. "His innocence, naivete and simplicity saved him when a more complicated nature might have gone under during years of neglect and lack of recognition" (McCausland, "Portrait of a Photographer" 502; 503).

3. See "A Camera Interpretation of Labor," 43: "Into all his work Mr. Hine gets an interpretive angle. Indeed, he terms himself an 'interpretive photographer.' A picture which has beauty without significance means little to him. Merely to place a worker before his machine and transfer the likenesses of worker and machine to a photographic plate is not what Mr. Hine considers his job." Judith Mara Gutman, in a pioneering study of Hine, does emphasize the

importance of "interpretation," though she doesn't develop the idea systematically (18; 27-29).

4. See, for examples, the record of negatives (videodisc) available at the International Museum of Photography, George Eastman House.

5. Published a few years after her earlier appraisal of Hine, McCausland's encyclopedia piece is somewhat more appreciative of Hine's artistry, though she continues to insist, condescendingly, that Hine's methods were "intuitive" ("Lewis W. Hine" 1979-83).

6. See, for example, Hine's illustrations for "Climbing into America."

7. See the photo-essay by Hine, "Southerners of Tomorrow." By 1920, the urgency and explicit context of some of these images had been drained from them, and one young girl standing before a row of bobbins could be captioned, in an appreciation of Hine's artistry, "Goddess of the Machine: Art and the cotton-mills are not two disparate ideas if Mr. Hine conveys his message here with his little cotton-spinner" (Hine, "Treating Labor Artistically" 34).

Chapter Five. Weegee's Voyeurism and the Mastery of Urban Disorder

1. "I've never known a better name or a better photographer," Weegee wrote with his usual modesty in his autobiography (34). The name was given him by some admiring colleagues at the Acme photographic service, where he'd worked for a dozen years.

2. Clement Greenberg perpetuated this divided reading of Weegee, when he concluded by comparing the latter favorably with Cartier-Bresson, whose works Greenberg saw as too "frozen": Weegee, by contrast, had "a sharper sense of life and movement and variety." Yet Weegee is, for Greenberg, "an unsophisticated artist," lacking in pictorial values, "demotic" (8-9).

A major retrospective of Weegee's work was held at the International Center of Photography in 1977, with an accompanying volume (Stettner). Also see Talmey, Coplans, Laude.

3. Weegee noted in his autobiography the preference of his earliest customers on the Lower East Side—while he was an itinerant pony photographer—for bluntly contrasting black and white images, and "nice white, chalky faces" (*Weegee by Weegee* 18).

4. The erotic nature of the photographer's attachment to his camera, as well as the idea of the camera as itself an erotic instrument, was captured as early as 1915 in Picabia's famous cartoon *Ici, c'est ici Stieglitz* (illustration in chapter one) depicting Alfred Stieglitz as a camera whose extension bellows curves away (exhausted?) from the projecting "ideal."

Chapter Six. Documentary and the Seductions of Beauty: Salgado's *Workers*

1. See also Strauss: "Eschewing entirely the vaunted 'objectivity' of photography, Salgado breathes new life into the documentary tradition" (96).

2. See Ingrid Sischy: by beautifying tragedy "he anesthetizes the feelings of those who are witnessing it" (92). Cf. Arthur Danto: "You feel as though you should have some moral position, moral reaction, but the images are so fascinating that in some way it takes that away from you" (Wald 72).

3. Salgado is frank in asserting the overdetermined nature of his (and any photographer's) passion, "Each photographer has a way to photograph. You photograph with all your past, with your ideology, with your future, with your father, your mother, with all things; in the end you just have one way to photograph. In my photography there is a lot of romanticism, of dramatic light; it comes from all my life. It's a kind of instinctive thing: When you shoot you are showing yourself. Inside this book [*Workers*] you can read more or less my life: you can see what I have in my mind, but I can have only this in my mind. I choose to do social photography, but I do it with my life, with my past. That means, if it is beautiful, it's O.K. If not, it is O.K. I can only do it this way. There is no difference between my work of twenty years ago and today. You don't think about a nice frame, or lighting: it's automatic. We cannot do it two different ways" (Telephone interview).

4. One fact must be observed about the exhibition: it presented the images in the organizational form found in the book, but with much greater variety of size and format. Thus, for each featured "industry" there were one or two very large format reproductions (approximately 3 feet by 5 feet), sometimes ostentatiously grainy; and there were a number of smaller format reproductions, none smaller than approximately 12 by 17. The text for each segment was concentrated into a single wall chart, reproducing much of the information, in condensed form, that can be found in the text. A relatively small number of the images in *Workers* were previously reproduced in Salgado's 1990 volume, *An Uncertain Grace*, which featured twenty-one photographs in a unit called "The End of Manual Labor, 1986—." Within that section, the images are grouped without any real sense of coherence or continuity, except for the first seven, which present the Serra Pelada mine. *An Uncertain Grace*, unlike *Workers*, contains no captions or introductions by Salgado himself.

5. It's interesting to compare Salgado's whole approach to the visualization of the factory with his great predecessor in the photography of labor, Lewis Hine. Hine deplored conditions of labor in the textile mills, mines, and factories that Salgado celebrates. When Hine does celebrate the worker, it was the individual's mastery over the tools of construction and production that he acclaimed—an Empire State Building, a dynamo—rarely the work of the assembly line.

6. Cf. Salgado: "The ultimate goal is to create a visual document of the various manufacturing processes still viable around the world today. . . . Our underlying assumption is that civilization is experiencing the last phases of a transition from mechanized work to a post-industrial era. . . . What we have witnessed as the dislocation of heavy industry from the greater to the lesser

developed countries will end in the complete termination of centralized, heavy industry in favor of highly diversified technologies utilizing to an ever greater extent localized resources" ("Proposal").

7. Cf. Salgado's conclusion to the preface to *Other Americas:* [speaking of one of his friends, Supo, who maintains a village church in Ecuador] "Once, when we were returning from a long walk to another village, Supo took advantage of our isolation and the darkness of the night, to make a demand of me: I must tell the people in heaven of his good behavior in this vale of tears, for he was absolutely sure I was an emissary of the divinities, sent to his village to photograph and describe" (13). Yet another angel, handsomely underwriting the huge *Workers* project, has been Kodak.

Chapter Seven. Documentary Film and the Power of Interrogation: Kopple's *American Dream* and Moore's *Roger and Me*

1. I want to thank Jay Ruby for sharing his thoughts about Kopple and Moore with me as I was getting started on this project. Thanks also to Robert C. Allen, whose comments on a shorter version of this essay provoked further thought; and to Jane Gaines and Maren Stange, co-panelists at the American Studies Association session where a version of this paper was first presented, for comments during discussion.

2. The autobiographical form has been used before in a documentary film, and also with great comic effect. See, for example, Ross McElwee's *Sherman's March* (1985), a film that begins as a documentary about Sherman and the South and soon develops into a quest for the filmmaker's soulmate. Another antecedent of Moore is Mike Rubbo's *Waiting for Fidel*, which portrays the filmmaker's failed pursuit of his subject (after having been promised an interview).

3. I do not mean to argue that Moore is literally powerless. Clearly, he is the filmmaker, creating a product with a clear point of view, guiding our judgment through the manipulation of his materials. Moore's power is a relative one: relative to Smith, in the situations depicted on film, it is nil; relative to Smith, in the movie theater, it is triumphant.

4. Unfortunately, the short sequel to *Roger and Me*, created in the wake of the film's success is an embarrassing piece of self-congratulation on Moore's part, suggesting that Moore's compulsive self-revelation has not only a luminous side but a self-destructive component as well.

Chapter Eight. Writing Posthistorically: *Krazy Kat*, *Maus*, and the Contemporary Fiction Cartoon

1. Cantor continues to be fascinated with the Freudian and Nietzschean reading of our ambivalence toward the death instinct and violence ("Patriarchs" 91).

2. See Donald Barthelme's similar sense of the city as a model for a fiction

of irregular rhythms and fragments: "New York City is or can be regarded as a collage, as opposed to, say, a tribal village in which all of the huts (or yurts, or whatever) are the same hut, duplicated. The point of the collage is that unlike things are stuck together to make, in the best case, a new reality" ("Interview" 51-52).

3. For a fuller discussion of these ideas, see Cantor, "Patriarchs" (14, 91).

4. One might compare *Krazy Kat*'s essential seriousness in this respect with the pervasive comic irony of a work that is otherwise similar in its romp across the borders of fiction and reality, *At Swim-Two-Birds* (1939) by Irish writer Flann O'Brien. See Orvell, "Entirely Fictitious."

5. On the search for a "middle" ground in American culture, see Orvell, *Real Thing* 168-171. On the history of the American intellectual's response to popular culture, see Ross; compare the more typically aloof attitude of the European modernist, as described by Huyssen.

6. Spiegelman's literal adherence to facts—the seeming antithesis of the cartoon's freedom—characterizes *Maus* in general, though it is most visible in an earlier cartoon, *Prisoner on Hell Planet*, which is about the suicide of Spiegelman's mother and which is inserted within the story *Maus*, at a moment when the earlier cartoon is "discovered" and read for the first time by Spiegelman's father. In *Prisoner* Spiegelman uses stylized but easily recognized human beings as his characters, basing their appearance upon the actual originals: as "evidence" of its "authenticity" Spiegelman reproduces at the beginning of the cartoon a photograph of the artist's mother—with son. Even the family doctor in *Prisoner* is drawn after an actual Rego Park physician at the time and bears the same name.

7. On Pekar, see Witek 121-56; for an illustrated history of underground comics, see Estren.

8. Only a decade after that 1981 interview, some of those ambitions are being fulfilled: following the great success of *Maus I* and *II*, Mouly was hired as art editor at *The New Yorker*; under her direction, *The New Yorker*, which has changed in other ways as well, has achieved a new graphic identity as a quasi-underground comix outlet.

9. Spiegelman plays with Mickey again in *Maus II*, using an epigraph from a 1930s German newspaper that begins: "Mickey Mouse is the most miserable ideal ever revealed." By the end of the passage, Mickey has become Jewish, thus serving, willy nilly, as kin to Spiegelman's mice: "Away with Jewish brutalization of the people! Down with Mickey Mouse! Wear the Swastika Cross!"

Chapter Nine. Understanding Disneyland: American Mass Culture and the European Gaze

1. McDonald's does attempt to integrate some local foods into their regional menus—Kiwi Burgers in New Zealand, "Oriental" chicken salad in, of all places, Germany—but mostly consumers want the real thing, the American

hamburger. (Which is why India, with its avoidance of beef, has yet to host a McDonald's.)

2. Kroes (226-239) places Baudrillard and Eco within a tradition of European commentary on America that emphasizes the latter's dual characteristics—as "harbinger of future trends in store for Europe" and "corrupter of European values and cultural standards." Against the American's consumer society, with its flattened surfaces, Kroes's critics posit a European society of depth, silence, and reflection. Kroes argues that while both Eco and Baudrillard are fascinated by America's unspoiled values and modernity, they both finally pull back from its degeneracy, affirming a traditional European sensibility of depth. I agree with Kroes on many points, though I want to emphasize in my own reading some of the differences between Eco and Baudrillard. My thanks to David E. Nye for calling my attention to this essay.

3. Jonathan Crary sees Baudrillard's ecstatic endorsement of America as the logical fulfillment of the latter's view of history, in which Baudrillard posits the beginning of modernity in the political revolutions of the late 1700s; with the overthrow of the aristocracy and their system of hierarchical signs and interdictions between social classes, new signs are needed of the proof of the happiness the revolution would generate: America becomes in this view a culture of proliferating signs and counterfeits, all challenging the aristocracy's monopoly (12).

4. Eco anticipates to some extent the argument of David Freedburg, who argues that pictures are "ontological events," not merely objects of aesthetic consciousness (76; 360).

5. It is one thing to learn that a single cartoon cell from a 1934 Mickey Mouse short ("The Orphan's Benefit") is expected to bring $120,000 at auction; it is another to learn that a Soho gallery will host an exhibition of more than 200 pieces from a collection of paint-by-number artworks, some of which were originally purchased for 25 cents (*New York Times*, 12 April 1992, Section 2-33 and 16 April 1992, C-3).

6. My thanks to Kathleen Hall Jamieson for sharing her information on this point with me. Further distortions in the television record regarding the destruction of Iraqi fixed and mobile missile sites are detailed in Miller. Cf. Baudrillard: "Nothing deceives, there are no lies, *there is only simulation*, which is precisely the facticity of facts" (85).

7. Thanks to David Nye for this point, in conversation.

8. Cf. Marling's slightly different interpretation of the structure of Disneyland, along an axis that increases the spheres of capitalism (200-201).

9. For a discussion of Disneyland within the context of an evolving global culture of simulations, see Sorkin 205-232. Sorkin's excellent volume came to my attention after I completed this essay. Disneyspace is explicated from a far more sympathetic viewpoint in King 116-140.

10. I am grateful to John Dean, of the University of Strasbourg, for making

this point during the discussion of this paper at the conference of the Netherlands American Studies Association, June 1992.

Chapter Ten. Technology, the Imagination, Virtual Reality, and What's Left of
 Society

1. "America demands a poetry that is bold, modern, and all-surrounding and kosmical, as she is herself. It must in no respect ignore science or the modern, but inspire itself with science and the modern. It must bend its vision toward the future, more than the past" (Whitman, *Democratic Vistas* 503).

2. For more on this point, see Orvell, "Literature and the Authority of Technology" 169-175.

3. There is an apt foreshadowing of this attitude in William Dean Howells' famous confrontation with the great Corliss Engine at the 1876 Centennial in Philadelphia: "It rises loftily in the centre of the huge structure, an athlete of steel and iron with not a superfluous ounce of metal on it; the mighty walking-beams plunge their pistons downward, the enormous fly-wheel revolves with a hoarded power that makes all tremble, the hundred life-like details do their office with unerring intelligence." Howells then describes the mechanic attending the giant machine, as the engine's "slave who could crush him past all semblance of humanity with his lightest touch" (85-86).

4. All quotes from *New York Times* 24 October 1993: 4:16.

WORKS CITED

Adams, Henry. *The Education of Henry Adams*. New York: Modern Library, 1931.

Agee, James and Walker Evans. *Let Us Now Praise Famous Men*. 1941. Boston: Houghton Mifflin Co., 1988.

Aitken, Hugh G. J. *Scientific Management in Action: Taylorism at Watertown Arsenal*. 1960; Princeton, N.J.: Princeton UP, 1985.

Barthelme, Donald. "At the End of the Mechanical Age." *Sixty Stories*. New York: E.P. Dutton, 1982. 272-279.

———. Interview. *The New Fiction: Interviews with Innovative American Writers*. With David Joe Bellamy. Urbana: U of Illinois P, 1974. 45-54.

Baudrillard, Jean. *America*. Trans. Chris Turner. London and New York: Verso, 1988.

———. *Forget Foucault*. Trans. Nicole Dufresne. *Foreign Agents Series*. Fleming, Jim and Slyvere Lotringer, eds. New York: Semiotext[e], 1987.

Blesh, Rudi. *Keaton*. 1966. New York: Collier, 1971.

Boorstin, Daniel. *The Americans: The Democratic Experience*. New York: Random House, 1973.

Brooks, Van Wyck. "America's Coming of Age." *Three Essays on America*. 1915. New York: E.P. Dutton, 1970.

Bukatman, Scott. *Terminal Identity: The Virtual Subject in Postmodern Science Fiction*. Durham: Duke UP, 1993.

Cantor, Jay. *The Death of Che Guevara*. New York: Knopf, 1983.

———. "An Interview with Jay Cantor." With Ken Capobianco. *Journal of Modern Literature* 17.1 (1990). 3-11.

———. *Krazy Kat: A novel in Five Panels*. 1987. New York: Collier, 1988.

———. "The Patriarchs." *Tikkun* 5.4 (1990). 11-14 et seq.

———. *The Space Between: Literature and Politics*. Baltimore: Johns Hopkins UP, 1981.

Coles, Robert. *Children of Crisis*. Boston: Little Brown, 1967.

Collins, Jim. *Uncommon Cultures: Popular Culture and Postmodernism*. New York: Routledge, 1989.

Commons, John R. "Wage Earners of Pittsburgh." *Charities and the Commons* 21 (6 March 1909): 1054-55.

Condit, Carl. *American Building: Materials and Techniques from the First Colonial Settlements to the Present.* Chicago: U of Chicago P, 1968.

Coplans, John. Introduction. *Weegee's New York: 335 Photographs 1935-1960.* Munich: Schirmer/Mosel; New York: Grove, 1982.

Crane, Hart. "Modern Poetry." *The Complete Poems and Selected Letters and Prose of Hart Crane.* Ed. Brom Weber. Garden City: Anchor, 1966.

Crary, Jonathan. *Techniques of the Observer: On Vision and Modernity in the Nineteenth Century.* Cambridge: MIT Press, 1990.

Crawford, Margaret. "The World in a Shopping Mall." *Variations on a Theme Park: The New American City and the End of Public Space* Ed. Michael Sorkin. New York: Hill & Wang, 1992. 3-30.

Crowdus, Gary and Richard Porton. "*American Dream*: An Interview with Barbara Kopple." *Cineaste* 18.4 (1991).

Curtis, James C., and Sheila Grannen. "Let Us Now Appraise Famous Photographs: Walker Evans and Documentary Photography." *Winterthur Portfolio* 15, 1 (Spring 1980): 1-23.

De Lauretis, Teresa, Andreas Huyssen, and Kathleen Woodward, eds. *The Technological Imagination: Theories and Fictions.* Madison: Coda P, 1980.

De Lillo, Don. *White Noise.* Viking Penguin, 1985.

Dos Passos, John. "Against American Literature." *New Republic* 14 Oct. 1916. *John Dos Passos: The Major Nonfictional Prose.* Ed. Donald Pizer. Detroit: Wayne State UP, 1988. 36-38.

———. *The Big Money, U.S.A..* Boston: Houghton Mifflin, 1946.

———. *42nd Parallel, U.S.A..* Boston: Houghton Mifflin, 1946.

———. "The Writer as Technician." *John Dos Passos: The Major Nonfictional Prose.* Ed. Donald Pizer. Detroit: Wayne State UP, 1988. 169-172.

Dowd, Maureen. "A Writer for The New Yorker Says He Created Composites in Reports." *New York Times* 19 June 1984: A1.

———. "King Newt and His Court Explore Virtual America." *New York Times* 11 January 1995: A1.

Eco, Umberto. *Travels in Hyperreality.* Trans. William Weaver. New York: Harcourt Brace, 1986.

Epstein, Jean. "The New Conditions of Literary Phenomena." *Broom* 2, April 1922.

Estren, Mark James. *A History of Underground Comics.* Rev. ed. Berkeley: Ronin, 1987.

Evans, Walker. *Walker Evans: Photographs for the Farm Security Administration, 1935-1938.* Introduction by Jerald C. Maddox. New York: Da Capo, 1973.

Fitzgerald, F. Scott. "The Diamond as Big as the Ritz." 1922. *Babylon Revisited and Other Stories.* New York: Scribners, 1960. 75-113.

Ford, Henry with Samuel Crowther. *My Life and Work.* New York: Doubleday, 1923.

Freedburg, David. *The Power of Images: Studies in the History and Theory of Response*. Chicago: University of Chicago Press, 1989.

Gaines, Jane M. *Contested Culture: The Image, the Voice, and the Law*. Chapel Hill: U of North Carolina P, 1991.

Galeano, Eduardo. "Salgado, 17 Times." Trans. by Asa Zatz. *An Uncertain Grace: Photographs by Sebastião Salgado*. New York: Aperture, 1990.

Goldberg, Beth. "Humanity and the Camera's Eye." Rev. of *An Uncertain Grace* at San Francisco Museum of Modern Art. *ArtWeek* 15 Nov. 1990. 10.

Gollner, Philip M. "Mall That Imitates Life." *New York Times* 27 June 1993: V3.

Gramsci, Antonio. "Americanism and Fordism." *An Antonio Gramsci Reader*. Ed. David Forgacs. New York: Shocken, 1988.

Greenberg, Clement. "Four Photographers." *New York Review of Books* 1:11 (23 January 1964): 8-9. Rpt. in *History of Photography*. 15 (Summer 1991): 131-132.

Gutman, Judith Mara. *Lewis W. Hine and the American Social Conscience*. New York: Walker and Co., 1967.

Hales, Peter Bacon. *Silver Cities: The Photography of American Urbanization, 1839-1915*. Philadelphia: Temple UP, 1984.

Hammen, Scott. "Sheeler and Strand's *Manhatta*: a Neglected Masterpiece." *Afterimage* 6 (January 1979): 6-7.

Heap, Jane. "Machine-Age Exposition." *Little Review* (Spring supplement, 1927): 36.

Hearings Before the Special Committee of the House of Representatives to Investigate the Taylor and Other Systems of Shop Management Under the Authority of House Resolution 90. (1912); Rpt. in *An American Primer*. Ed. Daniel Boorstin. New York: New American Library, 1966.

Hersey, John. Introduction. *Let Us Now Praise Famous Men*. By James Agee and Walker Evans. Boston: Houghton Mifflin Co., 1988.

Hine, Lewis. "A Camera Interpretation of Labor." *The Mentor* 14 (Sept. 1926): 42-47.

———. "Climbing into America." *The Survey* 22 (17 April 1909): 111-114.

———. "Immigrant Types in the Steel District." *Charities and the Commons* 21 (2 Jan. 1909): 581-88.

———. "Photography in the School." *Photographic Times* 40 (Aug. 1908): 227-232.

———. "The Silhouette." *Photographic Times* 38 (Nov. 1906): 488-490.

———. "Social Photography, How the Camera May Help in the Social Uplift." *Proceedings, National Conference of Charities and Corrections* (June 1909). Rpt. as "Social Photography," Trachtenberg 109-114.

———. "Southerners of Tomorrow." *Charities and the Commons* 23 (Oct. 1909): 3-9.

————."The Spirit of Industry." *Men at Work*. 1932. New York: Dover Publications, 1977.

————. "Treating Labor Artistically." *Literary Digest* 67 (4 Dec. 1920): 34.

Homer, William Innes. *Alfred Stieglitz and the American Avant-Garde*. Boston: New York Graphic Society, 1977.

Horak, Jan-Christopher. "Modernist Perspectives and Romantic Desire: *Manhatta*." *Afterimage* 15 (Nov. 1987): 8-15.

Howells, William Dean. "A Sennight of the Centennial." *Atlantic Monthly* 38 (1876). Rpt. in *Democratic Vistas*. Ed. Alan Trachtenberg. New York: George Braziller, 1970.

Huyssen, Andreas. *After the Great Divide: Modernism, Mass Culture, Postmodernism*. Bloomington: Indiana UP, 1986.

Inge, M. Thomas. *Comics as Culture*. Jackson: UP of Mississippi, 1990.

Jackson, Kenneth T. *Crabgrass Frontier: The Suburbanization of the United States*. New York: Oxford, 1985.

Jacobson, Harlan. "Michael and Me." Interview with Michael Moore. *Film Comment* 25.6 (Nov.-Dec. 1989): 16-26.

James, Henry. *The American Scene*. 1907. Bloomington: Indiana UP, 1968.

Josephson, Matthew. *Broom* 5 (Oct. 1923): 137-142.

Kael, Pauline. "The Current Cinema: Melodrama/Cartoon/Mess." *The New Yorker* 8 Jan. 1990.

Kaplan, Daile. *Lewis Hine in Europe: The Lost Photographs*. New York: Abbeville, 1988.

Kasson, John F. "The Aesthetics of Machinery." *Civilizing the Machine: Technology and Republican Values in America, 1776-1900*. New York: Grossman, 1976. 139-180.

Kimball, John. "Machinery as a Gospel Worker." *Unitarian Christian Examiner* (Nov. 1869): 323-24.

King, Margaret J. "Disneyland and Walt Disney World: Traditional Values in Futuristic Form." *Journal of Popular Culture* (Summer 1981): 116-140.

Knight, Arthur. *The Liveliest Art*. New York: Mentor, 1957.

Koukol, Alois B. "The Slav's a Man for A' That." *Charities and the Commons* 21 (2 Jan. 1909): 589

Kouwenhoven, John A. *The Arts in Modern American Civilization*. New York: W.W. Norton, 1948.

Kroes, Rob. "Flatness and Depth: Two Dimensions of the Critique of American Culture in Europe." *Consumption and American Culture, European Contributions to American Studies*. Eds. David E. Nye and Carl Pedersen. Amsterdam: VU UP, 1991. 226-239.

Lacey, Robert. *Ford, The Men and the Machine*. Boston: Little, Brown, 1986.

Laude, André. Introduction. *Weegee*. Paris: Centre National de la Photographie; New York: Pantheon Books, 1986.

Lebel, J.P. *Buster Keaton*. 1964. Trans. P.D. Stovin. New York: A.S. Barnes, 1967.

Levine, Lawrence. *Highbrow/Lowbrow: The Emergence of Cultural Hierarchy in America*. Cambridge: Harvard UP, 1988.

Lewis, Oscar. *The Children of Sanchez*. New York: Random House, 1961.

Lozowick, Louis. "The Americanization of Art." *Machine Age Exposition. Little Review* May 1927. Rpt. in *The Prints of Louis Lozowick: A Catalogue Raisonné*. Janet Flint. New York: Hudson Hills, 1982.

Lucic, Karen. *Charles Sheeler and the Cult of the Machine*. London: Reaktion Books, 1991.

Lyon, Danny. *The Bikeriders*. New York: Macmillan, 1968.

———. *Conversations with the Dead*. New York: Holt, Rinehart & Winston, 1971.

———. *The Destruction of Lower Manhattan*. New York: Macmillan, 1969.

McCausland, Elizabeth. "Charles Sheeler Show at Modern Art Museum." *Springfield Republican* (8 Oct. 1939).

———. "Lewis W. Hine." *The Complete Photographer* 6 (20 July 1942): 1979-83.

———. "Portrait of a Photographer." *Survey Graphic* 27 (Oct. 1938): 502.

McCleery, William. Foreword. *Naked City*. 1945. New York: Da Capo Press, 1985. 6-7.

McDonnell, Patrick, Karen O'Connell, and Georgia Riley de Havenon. *Krazy Kat: The Comic Art of George Herriman*. New York: Abrams, 1986.

Mailer, Norman. *Of a Fire on the Moon*. Boston: Little Brown, 1970.

Maloney, Russell. "Portraits of a City." *New York Times Book Review* (22 July 1945): 5.

Marling, Karal Ann. "Disneyland, 1955." *American Art* 5-1/2 (Winter/Spring 1991). 168-207.

Miller, Mark Crispin. "Operation Desert Sham." *New York Times* 24 June 1992: A21.

"Missile Museum Attracts Thousands to Arizona Site." *New York Times* 8 February 1987.

Mumford, Lewis. *The Golden Day*. New York: Boni and Liveright, 1926.

Nichols, Bill. *Representing Reality: Issues and Concepts in Documentary*. Bloomington: Indiana UP, 1991.

Nye, David E. *Electrifying America: Social Meanings of a New Technology*. Cambridge: MIT Press, 1990.

Orvell, Miles. "Literature and the Authority of Technology." *Literature and Science as Modes of Expression*. Ed. Frederick Amrine. Kluwer Academic Publishers, 1989.

———. *The Real Thing: Imitation and Authenticity in American Culture, 1880-1940*. Chapel Hill: U of North Carolina P, 1989.

————."Technology and the American Dream." *Technology Review* Oct. 1980. 20-27.

————. "Entirely Fictitious: The Fiction of Flann O'Brien." *Journal of Irish Literature* 3 (January 1974): 93-98. Rpt. in *Alive Alive O!: Flann O'Brien's At Swim-Two Birds*. Ed. Rudiger Imhof. Dublin: Wolfhound Press; Totowa, N.J.: Barnes & Noble, 1985.

Paul, George F. "With a Camera in Mexico." *Photographic Times* 38 (Sept. 1906): 387-92.

Pekar, Harvey. "*Maus* and Other Topics." *Comics Journal* 113 (1986): 54-57.

Plagens, Peter. "The Storm of the Eye." *Newsweek* (8 April 1991): 59.

Pollack, Andrew. "To Surf and Ski, the Japanese are Heading Indoors." *New York Times* 15 June 1993: A12.

Pound, Ezra. "A Few Don'ts." *Prose Keys to Modern Poetry*. Ed. Karl Shapiro. New York: Harper and Row, 1962.

Price, Reynolds. "Neighbors and Kin." *Aperture* 115 (Summer 1989): 32-9.

Pultz, John and Catherine B. Scallen. *Cubism and American Photography*. Williamstown: Sterling and Francine Clark Art Institute, 1981.

Riding, Alan. "Only the French Elite Scorn Mickey's Debut." *New York Times* 13 April 1992: A1.

Robinson, David. *Buster Keaton*. Bloomington: Indiana UP, 1969.

Rockwell, John. "Euro-Disney Opening." *New York Times* 4 April 1992: C13.

Rosenberg, Nathan. *Technology and American Economic Growth*. White Plains, N.Y.: M.E. Sharpe, 1972.

Rosenblum, Walter, Naomi Rosenblum, and Alan Trachtenberg. *America and Lewis Hine, Photographs 1904-1940*. Millerton, New York: Aperture, 1977.

————. "Review of *Weegee's New York*." *exposure* 23 (Summer 1985): 40.

Rosenfeld, Paul. "Stieglitz." *The Dial* April 1921. Rpt. in *Photography: Essays & Images*. Ed. Beaumont Newhall. New York: Museum of Modern Art; Boston: New York Graphic Society, 1980.

Rosengarten, Theodore. *All God's Dangers: The Life of Nate Shaw*. New York: Alfred A. Knopf, 1974.

Rosler, Martha. *3 Works*. Halifax: The Press of the Nova Scotia College of Art and Design, 1981.

Ross, Andrew. *No Respect: Intellectuals and Popular Culture*. New York: Routledge, 1989.

Rourke, Constance. *Charles Sheeler: Artist in the American Tradition*. New York, 1938.

Rule, Sheila. "Record Companies Are Challenging 'Sampling' in Rap." *New York Times* 21 April 1992: C18.

Ruby, Jay, ed. *A Crack in the Mirror: Reflexive Perspectives in Anthropology*. Philadelphia: U of Pennsylvania P, 1982.

Salgado, Sebastião. *An Uncertain Grace: Photographs by Sebastião Salgado*. New York: Aperture, 1990.

———. Captions (accompanying booklet). Salgado, *Workers*, 3-23.

———. Introduction. Salgado, *Workers*, 7-19.

———. "A Lecture." Ed. Stephen Perloff. *The Photo Review* 16 (Fall 1993): 10.

———. *Other Americas*. New York: Pantheon, 1986.

———. "Proposal of the Project to the Magazines." Unpublished ts. Philadelphia Museum of Art. 1992.

———. Telephone interview. 13 Dec. 1994.

———. *Workers: An Archaeology of the Industrial Age*. New York: Aperture; and Philadelphia: The Philadelphia Museum of Art, 1993.

Scott, Miriam Finn. "At the Bottom." *Everybody's Magazine* 27 (October 1912) 540.

Shapiro, Eben. "Overseas Sizzle for McDonald's." *New York Times* 17 April 1992: D1.

Simons, Marlise. "Firm's Fake Weapons Have Real Use." *New York Times* 25 January 1993.

Sischy, Ingrid. "Photography: Good Intentions." *The New Yorker* 9 Sept. 1991. 89-95.

Smith, Terry. *Making the Modern: Industry, Art, and Design in America*. Chicago: U of Chicago P, 1993.

Sorkin, Michael. "See You in Disneyland." *Variations on a Theme Park: The New American City and the End of Public Space*. Ed. Michael Sorkin. New York: Hill & Wang, 1992. 205-232.

Spiegelman, Art. Interview. With Harlan Ellison. *The Masters of Comic Book Art*. Videotape. Ken Viola Production, n.d.

———. *Maus: A Survivor's Tale*. New York: Pantheon, 1986.

———. *Maus: A Survivor's Tale II: And Here My Troubles Began*. New York: Pantheon 1991.

———. "*Maus*, Chapter 8, Mauschwitz (Time Flies)." *Raw* 2.1 (1989): 123-62.

——— and Françoise Mouly. "Jewish Mice, Bubblegum Cards, Comics Art, and Raw Possibilities." Interview with Joey Cavalieri. *Comics Journal* 65 (1981): 96-125.

Spring, Michael B. "Informating with Virtual Reality." *Virtual Reality: Theory, Practice, and Promise*. Westport, CT: Meckler, 1991.

Stange, Maren. *Symbols of Ideal Life: Social Documentary Photography in America, 1890-1950*. Cambridge: UP 1989.

Stebbins, Theodore E. Jr., and Norman Keyes, Jr. *Charles Sheeler: The Photographs*. Boston: Little, Brown and Co., 1987.

Stettner, Louis. *Weegee*. New York: Alfred A. Knopf, 1977.

Stidger, William L. *Henry Ford: The Man and His Motives*. New York: George H. Doran Co., 1923.

Strand, Paul. "Photography and the New God." *Broom* 3/4 (1922). Trachtenberg 144-151.

Strauss, David Levi. "Epiphany of the Other." *Artforum* (Feb. 1990): 96.

Sussman, Aaron. "The Little Man Who's Always There." *Saturday Review of Literature* 28 (28 July 1945): 17.

Tagg, John. *The Burden of Representation*. Amherst: U of Massachusetts P, 1988.

Talmey, Allene, ed. *Weegee*. New York: Aperture, 1978.

Tashjian, Dickran. *Skyscraper Primitives: Dada and the American Avant-Garde, 1910-1925*. Middletown, Conn.: Wesleyan, 1975.

"Teen-Agers in Atlanta Told of 'Terrorist' Raid." *New York Times* 8 February 1987.

Tichi, Cecilia. *Shifting Gears: Technology, Literature, Culture in Modernist America*. Chapel Hill: U of North Carolina P, 1987.

————."The Twentieth Century Television Reality." *Technology and the Imagination: An Ongoing Challenge*. Acts of the Biennial Conference of the Italian American Studies Association. Venice: Edizioni Supernova, 1994. 3-15.

————. *Electronic Hearth*. New York: Oxford, 1991.

Trachtenberg, Alan, ed. *Classic Essays on Photography*. New Haven: Leete's Island Books, 1980.

————. "Essay." in Rosenblum 118-137.

Veblen, Thorstein. "The Discipline of the Machine." *The Engineers and the Price System*. 1921. *The Portable Veblen*. Ed. Max Lerner. New York: Viking, 1948. 335-348.

————. "The Technicians and Revolution." *The Engineers and the Price System*. 1921. *The Portable Veblen*. Ed. Max Lerner. New York: Viking, 1948. 438-465.

Vos, George W. "Art and Machinery." *The Soil* I (1916): 17.

Wald, Matthew L. "The Eye of the Photojournalist." *New York Times Magazine* (9 June 1991): 58.

Warshow, Robert. "The Legacy of the 30's." *The Immediate Experience*. New York: Atheneum, 1974. 33-48.

Weegee. *Naked City*. 1945. New York: Da Capo Press, 1985.

————. *Weegee by Weegee: An Autobiography*. New York: Ziff Davis, 1961.

Weiner, Tim. "General Details Altered 'Star Wars' Test." *New York Times* 27 August 1993: A19.

West, Nathanael. "Some Notes on Miss L." *Contempo* (15 May 1933): 1-2.

————. "Some Notes on Violence." *Contact* I (1932): 132-33.

Whitman, Walt. *Democratic Vistas. Leaves of Grass and Selected Prose by*

Walt Whitman. Ed. John Kouwenhoven. New York: The Modern Library, 1950.

————. *Song of the Exposition. Leaves of Grass and Selected Prose by Walt Whitman.* Ed. John Kouwenhoven. New York: The Modern Library, 1950.

Wilde, Alan. *Horizons of Assent: Modernism, Postmodernism, and the Ironic Imagination.* 1981. Philadelphia: U of Pennsylvania P, 1987.

Wight, Frederick S. "Charles Sheeler." *Charles Sheeler: A Retrospective Exhibition.* Los Angeles: Art Galleries, U of California, Los Angeles, 1954.

Williams, Hermann Warner Jr. *Mirror to the American Past: A Survey of American Genre Painting, 1750-1900.* Greenwich, CT: New York Graphic Society, 1973.

Witek, Joseph. *Comic Books as History: The Narrative Art of Jack Jackson, Art Spiegelman, and Harvey Pekar.* Jackson: UP of Mississippi, 1989.

INDEX